CW00731824

SLIPKNOT

DYSFUNCTIONAL FAMILY PORTRAITS

PAUL HARRIES

**OMNIBUS
PRESS**

LONDON • NEW YORK • PARIS • SYDNEY • COPENHAGEN • BERLIN • MADRID • TOKYO

Exclusive Distributors
Music Sales Limited,
14/15 Berners Street,
London, W1T 3LJ.

Music Sales Corporation
180 Madison Avenue, 24th Floor,
New York,
NY 10016,
USA.

Macmillan Distribution Services
56 Parkwest Drive
Derrimut, Vic 3030,
Australia.

Printed in the EU

A catalogue record for this book is available from the British Library.

Visit Omnibus Press on the web at www.omnibuspress.com

Limited edition prints of the images in this book are available from www.paulharries.com

For
Amanda, Max & Lydia.

In memory of
Paul Gray & Ashley Maile.

I'VE ALWAYS BEEN fascinated with photography. It seems like the only way to actually time travel. We are always able to look into the past and reminisce about those moments in time. When a photo is taken in the present we can reflect on the here and the now. By looking at the past and the present, we can only imagine the future.

For over ten years, Paul Harries has been gathering the past and the present. Paul has been there from the beginning, and has taken some of my favourite shots through the years of my brothers and me in The Nine. It is a privilege to be able to take part in this collection showing many years of what in my opinion is the greatest band of all time, Slipknot. Paul is a fantastic photographer because not only does he possess the obvious things, which are the eye, and the patience to capture the moments, emotions and ideas behind the shots, but he also possesses the patience to deal with rock stars and their daily circumstantial events, which are not always positive. I am honoured that Paul Harries has been one of the few photographers I've known that has helped to document my life, being one of nine members in Slipknot from the very beginning. He has watched us grow and I have watched him grow over the years, through our mutual evolution and time travel. I can't wait to see what the future has in store and I know that when we take those steps towards the future he will be there, camera in hand, to capture the continuing evolution of The Nine. I've said it before and I'll say it again: Paul is a fantastic photographer, a great artist and a dear friend that has been part of our fabric from the beginning.

Thank you Paul for always being there to capture the emotions of a band that seem almost impossible to capture and showing what makes rock n' roll time travel special. This collection, 15 years in the making, will be very special for everyone involved as they are all pieces of a larger puzzle still remaining to be put together. And Paul is one of the people helping put together that puzzle.

Paul, you're a true peer and a friend, and I thank you on behalf of legions of maggots all around the world whose walls are adorned with your photos. And I would like to personally thank you from The Nine, Slipknot.

#6 CLOWN.

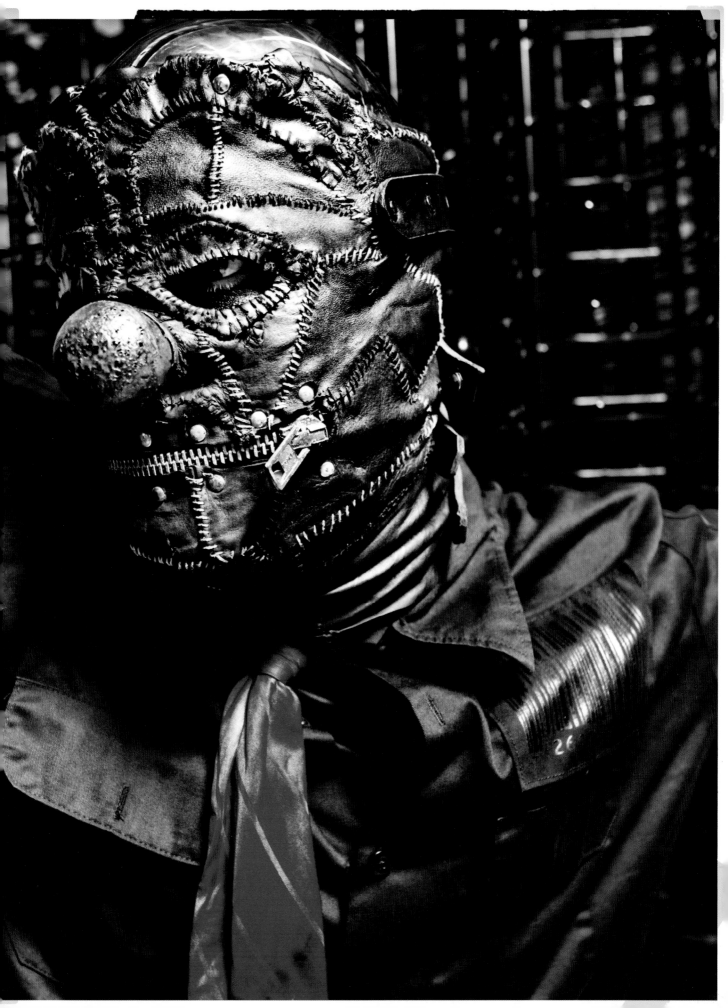

THE FIRST TIME I shot Slipknot I came away with just one thought: "Wait till the world sees this!"

The year was 1999, a different century and a different age; a time before social media could transmit the image and sound of a brand new band around the world at the click of a finger. Back then magazines were the first port of call when it came to alerting people to new groups, a notion that today seems antiquated. Then, as now, I was a photographer for the British rock publication *Kerrang!*, the world's best-selling music weekly. The order came down: I would fly to Des Moines in Iowa. Once there I would photograph a new band, the ferocity and the downright peculiarity of whom it was estimated would soon start making quite a splash in international waters.

I had shot bands who wore masks before and, to be honest, I'd often found the results to be disappointing or comical.

Slipknot were unsettling and creepy. Although the 'real' identity of each of the group's nine members was hidden, somehow each man projected his own individual personality. They were authentic. The uniformity of the red boiler suits gave the impression that this was a truly terrible union.

The masks were an exquisite touch, made all the more remarkable because of their perfect synergy with the band's sound. The disguises were crude and looked as if they had been made by ordinary people – perhaps not quite 'ordinary'.

They wore them well. Slipknot were pure theatre in the best sense of the word. Each man understood that their anonymity allowed them to become something that was different from their everyday selves. Rock photography is often about capturing someone's personality through the expressions on their faces. But with Slipknot the game changed. The group played their part so brilliantly that at times they did half of my work for me. The Clown – Shawn Crahan, very much the visual director – appeared genuinely macabre whenever a camera lens focused on his frame. Joey Jordison made use of his limited stature by portraying the runt of the litter that had somehow managed to murder his siblings.

Slipknot looked unclean and dangerous; they looked like the kind of men who lived in a place that had too much heat and not enough air. They reminded me of slaughterhouses and waste silos. They looked like they smelled – and sometimes they did. Being downwind of a drum box full of well-worn masks in the middle of a hot American tour is not an experience I wish to repeat any time soon!

On the first occasion I photographed Slipknot, I also saw them play live (another first). The reaction they received from their hometown crowd made me think, "There's no doubt about it, the audiences in the UK are going to love this." In truth, I didn't know the half of it.

That same year they arrived in London for their first appearance on British soil. The venue was the Astoria, a now demolished 1,600 capacity hall bang in the centre of the city. I remember that night that there was no support band. This in itself is amazing, really, because at this time Slipknot had just one album to their name. It was quite the audacious start. But one of the things I remember most about that evening is the sense of anticipation that hung thick in the air. I've not known anything like it, before or since. The audience in the Astoria (many wearing homemade Slipknot masks) couldn't wait to see this band. It wasn't so much that no other band in the world mattered, more like other bands didn't even exist. The feeling inside the venue that night was feverish and unpredictable.

During the gig itself turntablist Sid Wilson clambered up one of the PA stacks at the side of the stage. I hadn't been warned that he was going to do this – he probably didn't even know himself – but once he got to the top he just threw himself off into the audience below. As this happened, I managed to get a shot of him in mid-air flight. Even 15 years later, just looking at this picture reminds me of the lost-in-the-moment insanity of that evening.

Since that first summer in their company, I have shot Slipknot countless times, in locations that stretch from New York to New South Wales. Many of the sessions have taken place in a state of utter chaos. Because

CONTINUES ▶

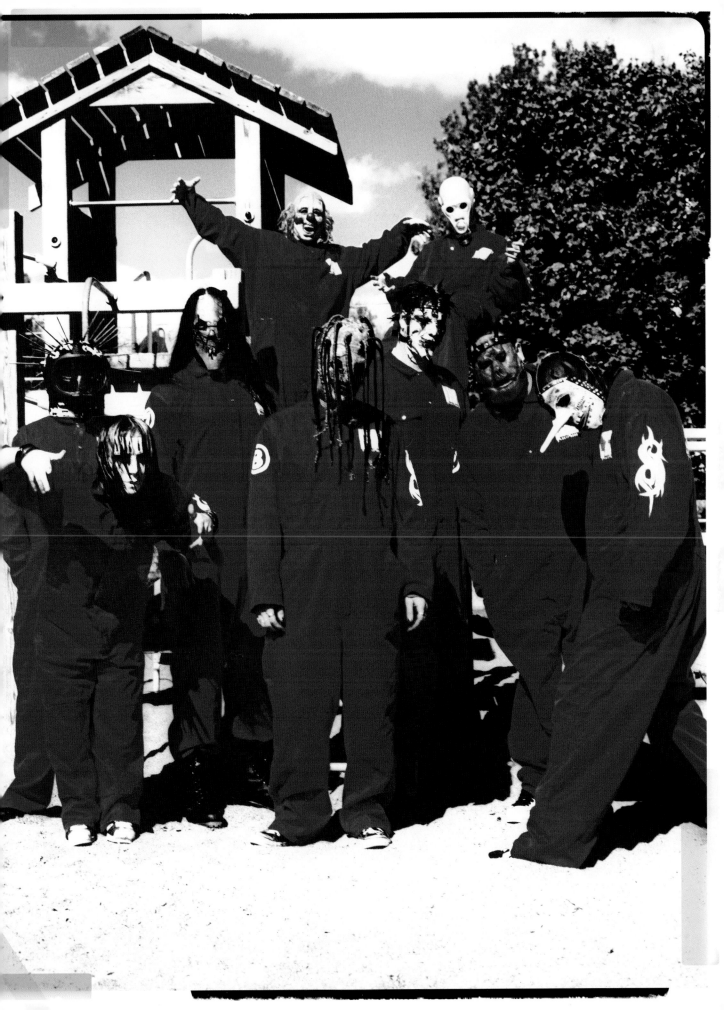

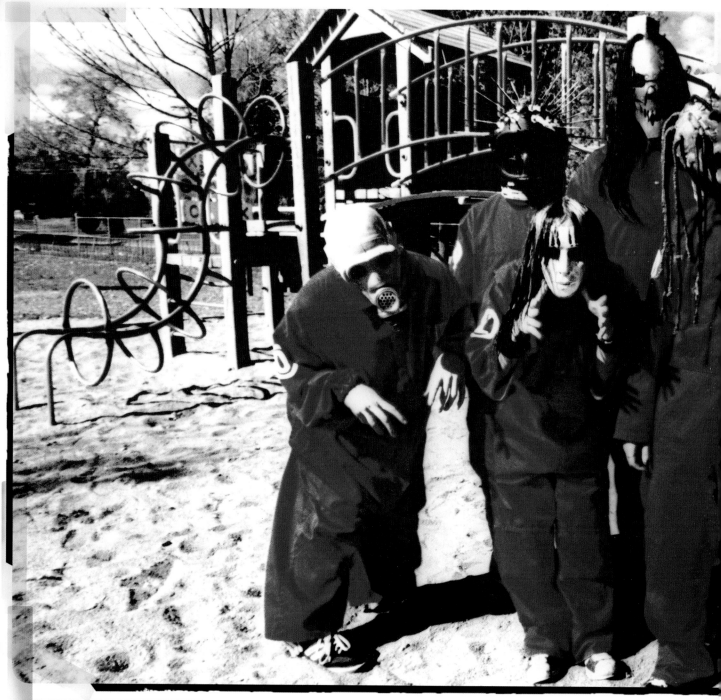

◀ CONTINUED FROM PREVIOUS PAGE

the band has so many members, getting them all together in one place is a lot like herding cats. I've learned from experience that if I'm promised an hour with Slipknot, what I'm going to get will probably be no more than 10 minutes. I remember on one occasion shooting the band at an outdoor show in New York. Time was so tight that only a few minutes after I'd started taking pictures, the band's intro tape began playing and immediately the air was filled with the sound of thousands of people front of house bellowing in anticipation.

Obviously my work for the day was done. I got the shot – it ended up as yet another *Kerrang!* Slipknot cover – but I do remember thinking, "I've come all this bloody way for 10 minutes with the band!"

By 2011 Slipknot had become the band that I had shot more than any other. In fact, I realised that I had enough photographs of the group – and a sufficient variety of shots, at that – to stage an exhibition dedicated solely to the masked men I'd first encountered some 12 years previously. I spoke to the staff of the Proud Gallery in central London

about the possibility of staging a Slipknot exhibition. From the point of view of the gallery itself – who had never before staged anything dedicated to a metal band, let alone one as noisy as this – the event was a gamble. But much to their delight it was a gamble that paid off. I was deeply honoured when on opening night Corey, Shawn and Sid came along to lend their support. Or something close to it, at least. I remember Corey Taylor looking at the shot of him in the farmer's field, giving me a wink and saying to everyone in the gallery, "What hack took this?"

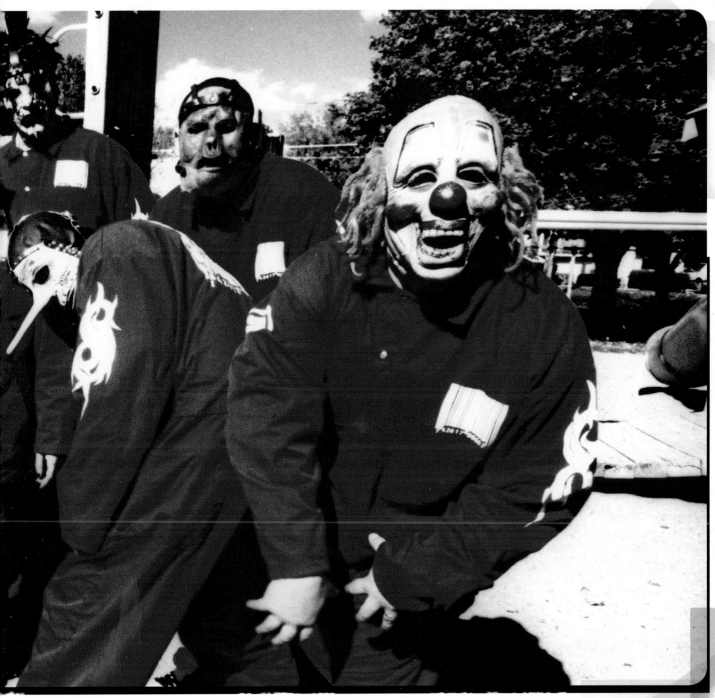

This book is the result of over 15 years shooting a band that are like no other. In the course of pursuing Slipknot literally all over the world I have been jet-lagged, delayed, rushed, stressed and placed under the kind of pressure that gives deep-sea divers the bends. What I have never been, however, is bored. But even amid the madness that is the inevitable result of putting nine grown men in masks and then throwing them out on tour, the band themselves are never less than gracious company and have always made me feel most welcome.

Looking today at the photographs that make up this book, I'm struck by the ongoing freshness of what is in essence a simple idea. Because the band subtly change their look with each album they release, their visual image never grows stale or old. And speaking of growing older, like all of us, the men beneath the masks are themselves accumulating their share of grey hairs. But the masks are not. So Slipknot are one of the few outfits in the world who can claim to look as good and as dynamic today as they did when people first clapped eyes on them back in the 20th century.

Over the course of my career I've been fortunate to photograph literally hundreds of bands, many that are famous and a greater number that are now long forgotten. But more than any other group, Slipknot are the union that push my buttons. What they do in a visual sense is exactly the kind of thing that I love. They are dark theatre, and like all good performers they are committed to what they do. They are the most berserk and entertaining band in the world, and for a photographer like myself they are the gift that keeps on giving

PAUL HARRIES.

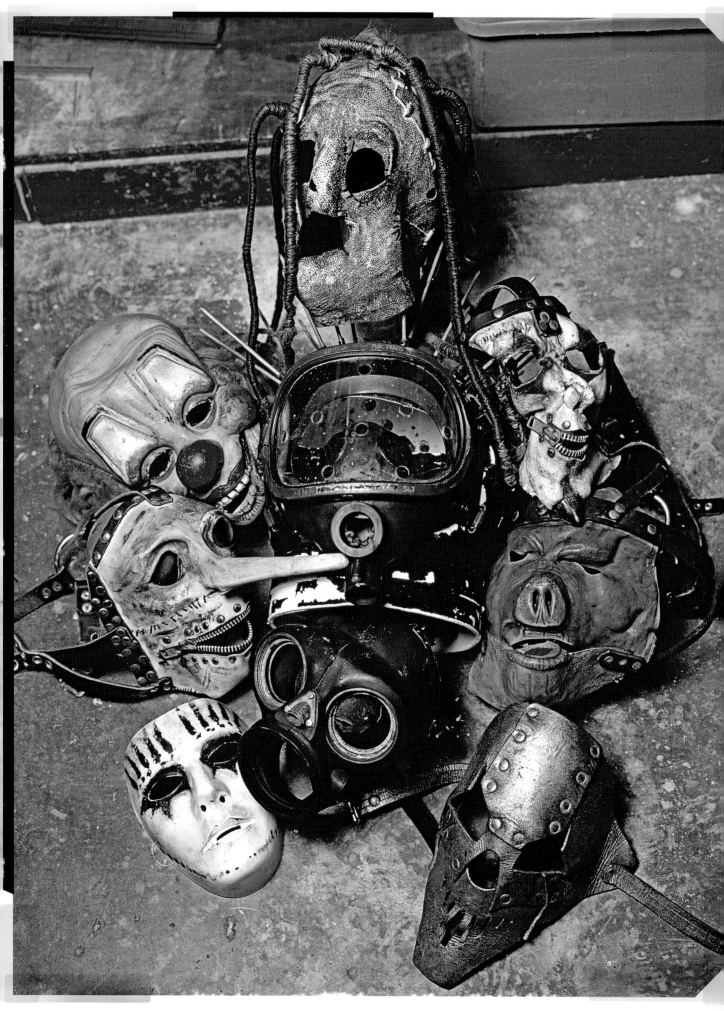

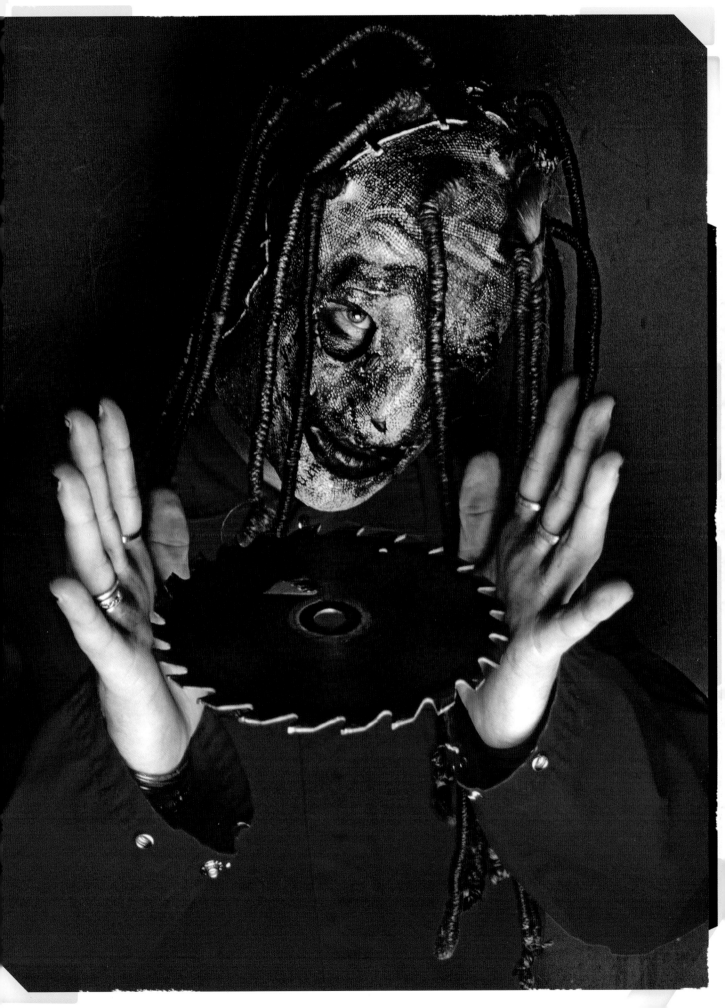

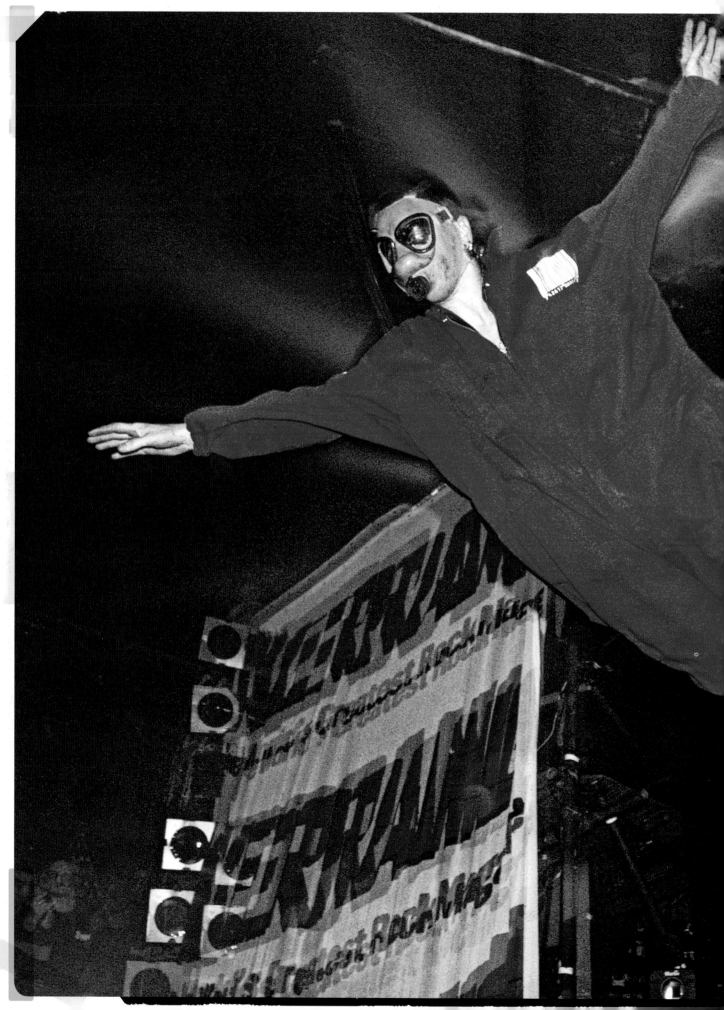

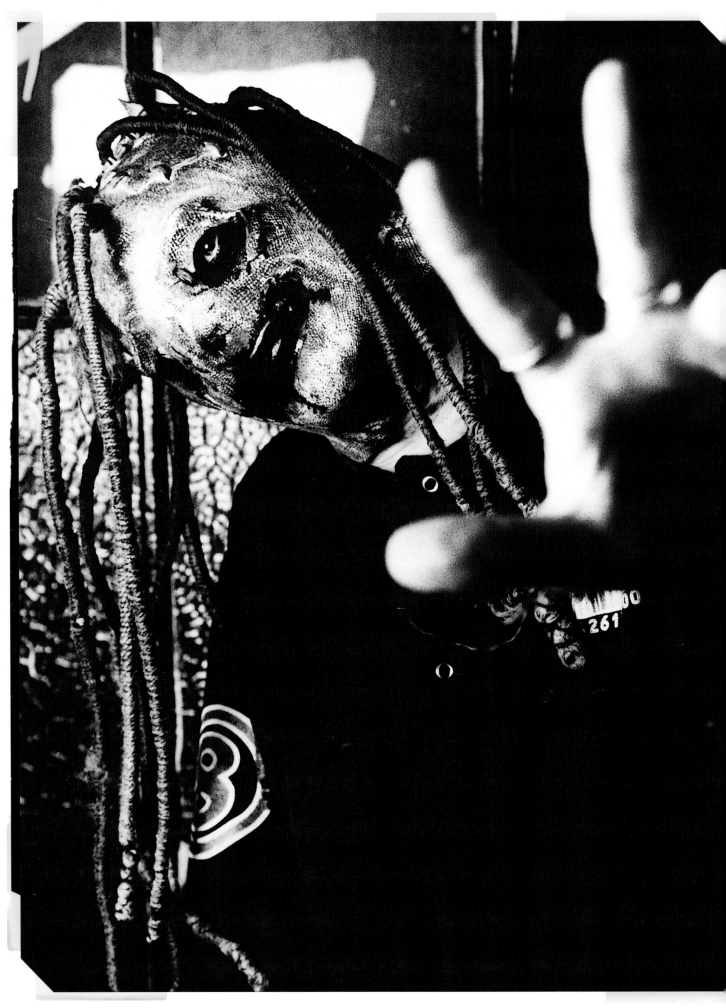

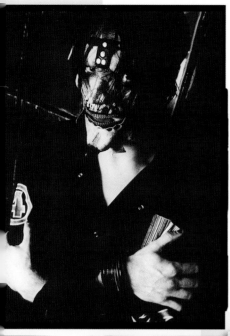

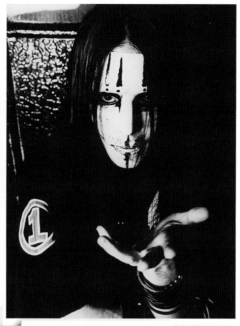

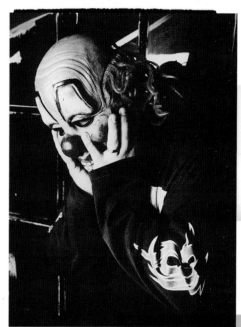

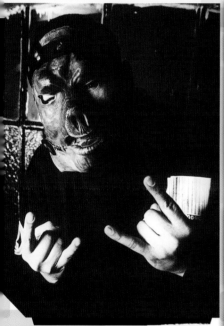

IN 2000, SLIPKNOT began its first UK tour. Standards were set and venues were demolished. When it was all done, I remember seeing incredible shots from the various shows in our wake. Later I found out many were taken by a man named Paul Harries.

Over the years, I've worked with Paul several times and each time has resulted in some of the best shoots I've ever been a part of. I've also come to consider him a friend. There's a trust that has to exist between the lens and the light, and thankfully with Paul I know that trust has not been misplaced, or taken for granted. He is exceptional, wonderful, and an all-round good bloke. I hope you enjoy his photos as much as I do.

#8 COREY.

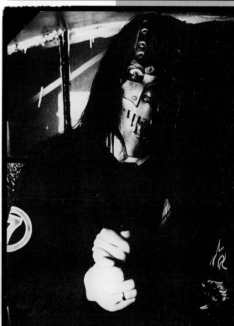

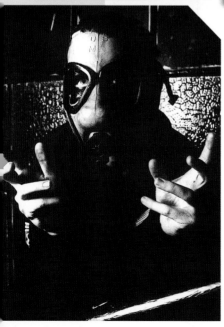

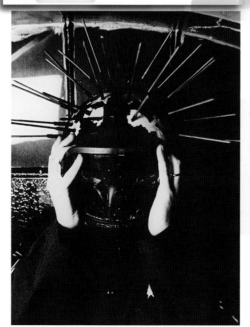

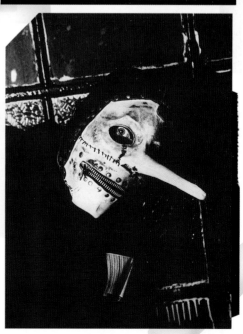

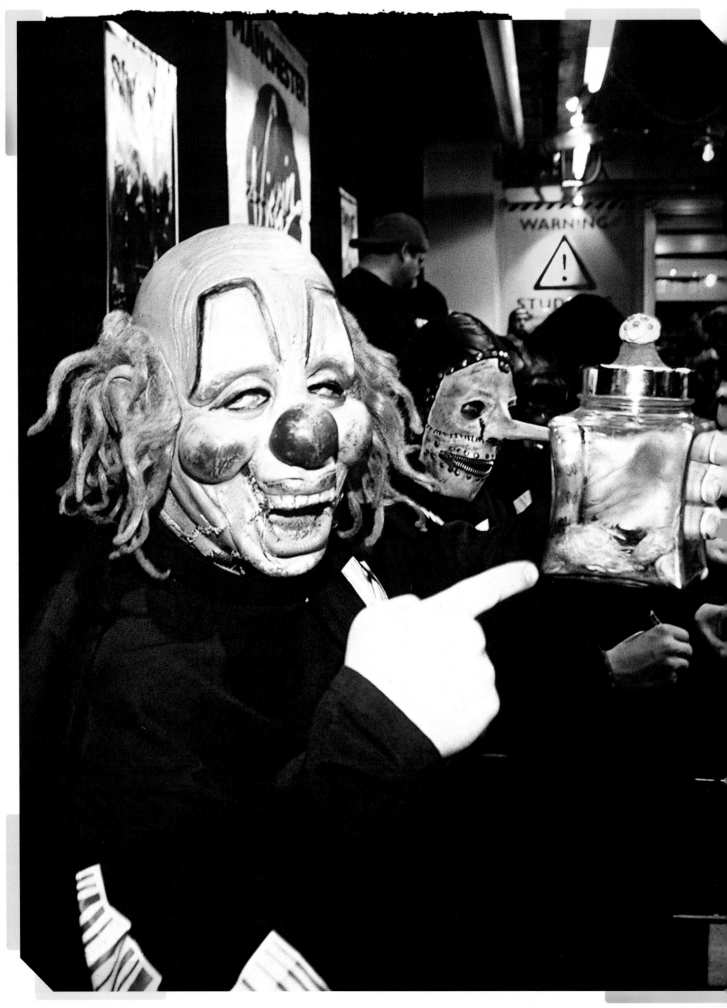

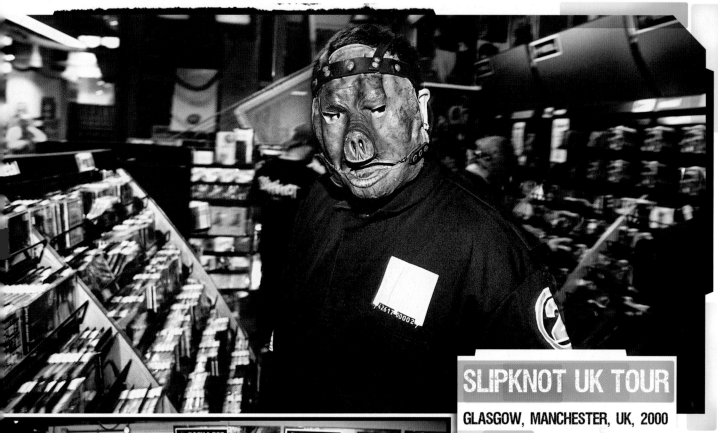

SLIPKNOT UK TOUR

GLASGOW, MANCHESTER, UK, 2000

AS PART OF an 'on the road' feature we joined Slipknot in Glasgow and followed them to Manchester. First stop was a record signing at the Virgin Megastore.

Some Slipknot fans were proving to be just as strange as the band themselves. One maggot even brought along a jar of dead chicks as a gift for Clown.

After the signing it was amusing to watch the guys flicking through the racks of CDs whilst still wearing their masks; it's very rare to see them doing anything resembling 'normal life' dressed in stage gear.

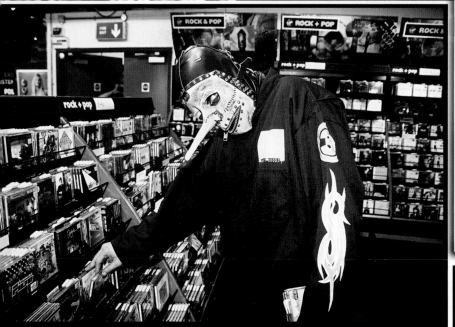

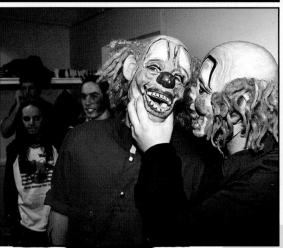

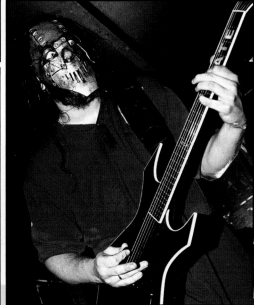

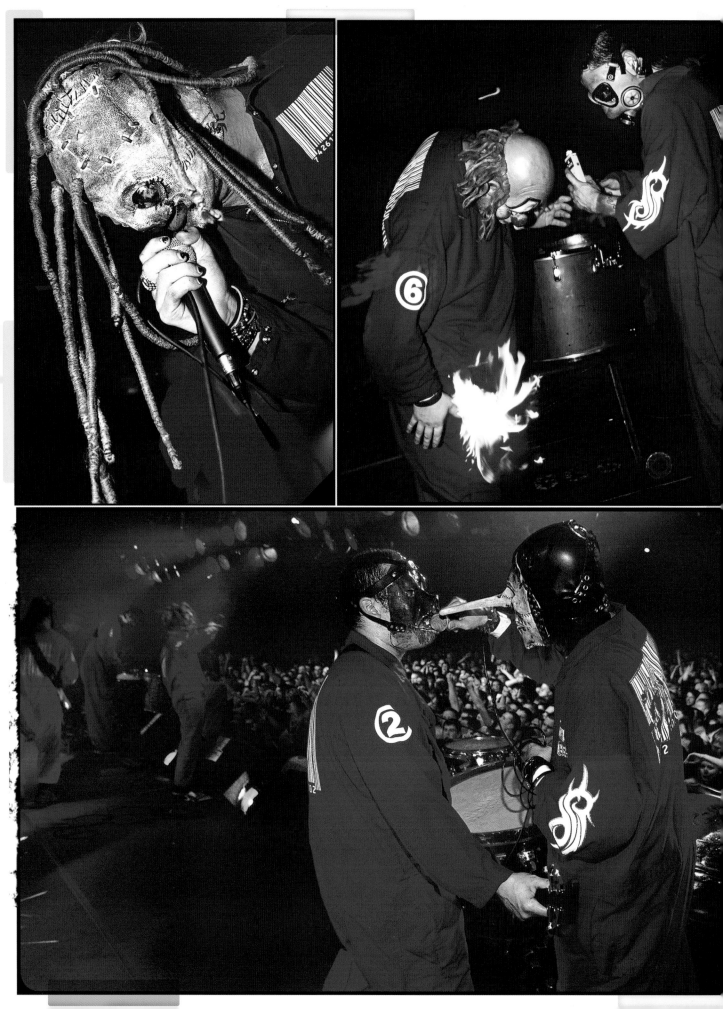

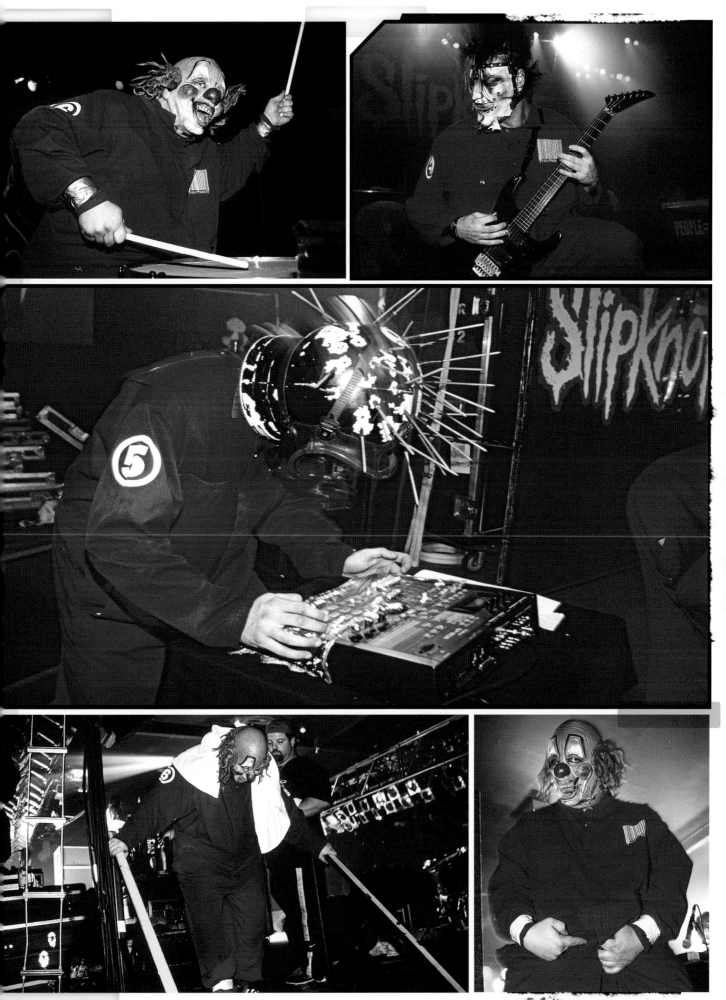

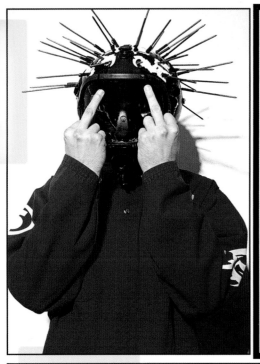
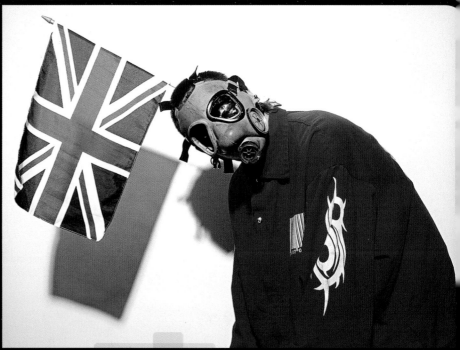
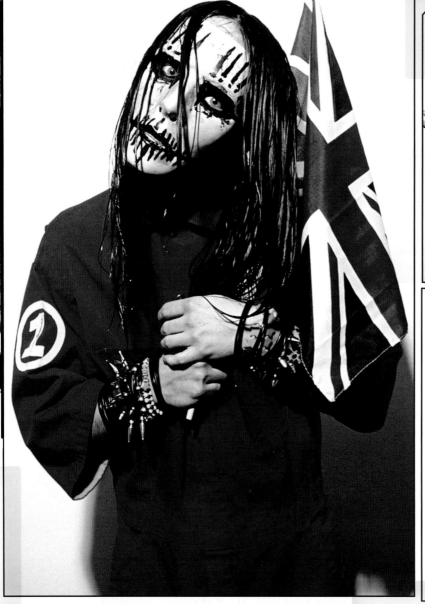
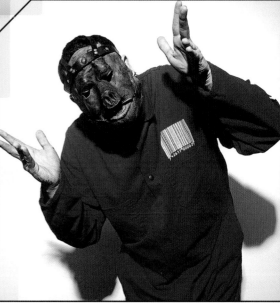
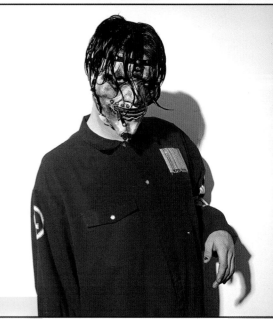

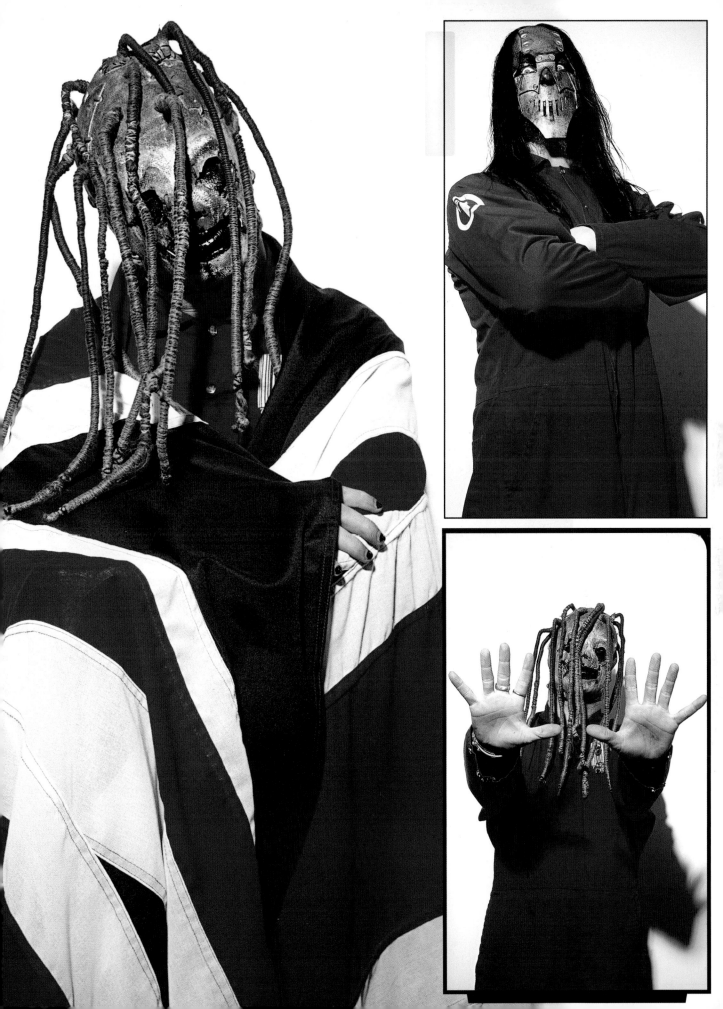

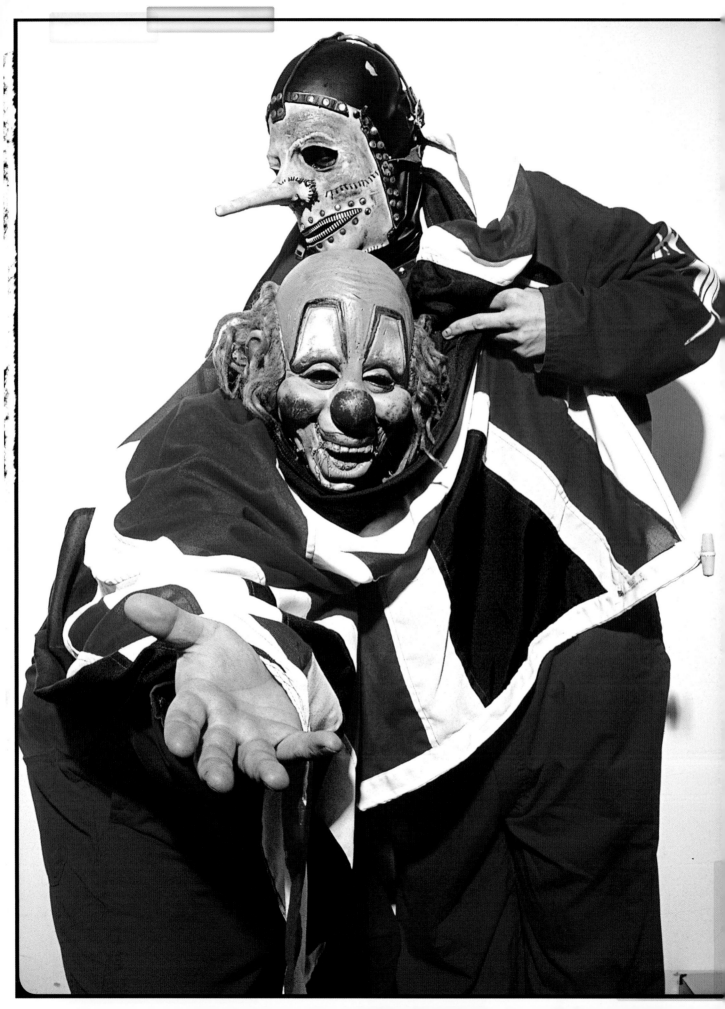

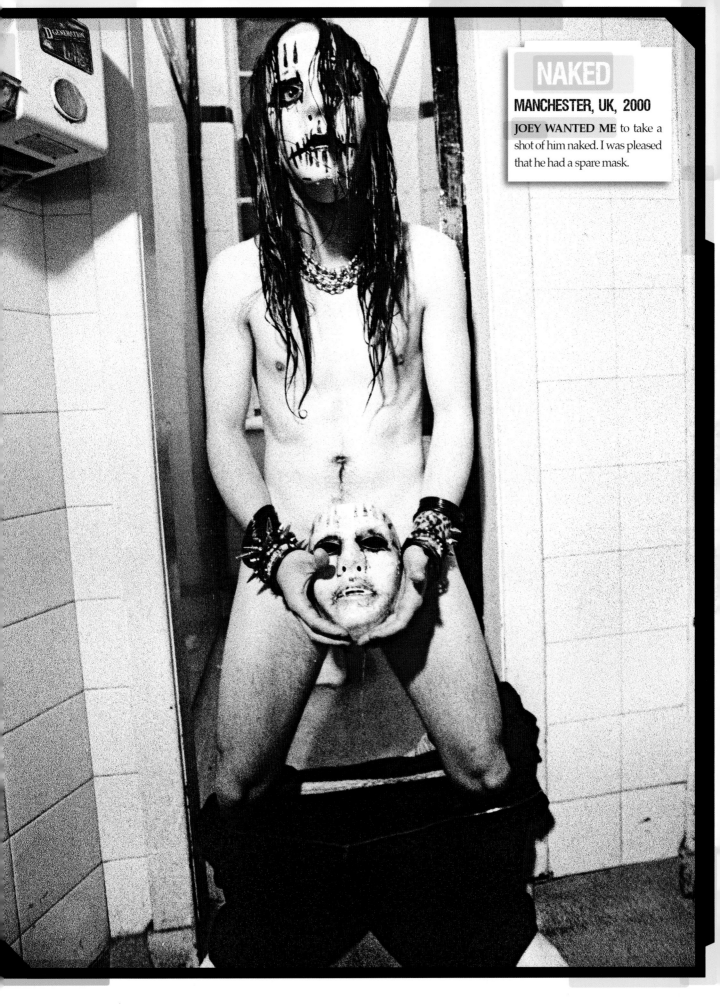

MANCHESTER, UK, 2000

JOEY WANTED ME to take a shot of him naked. I was pleased that he had a spare mask.

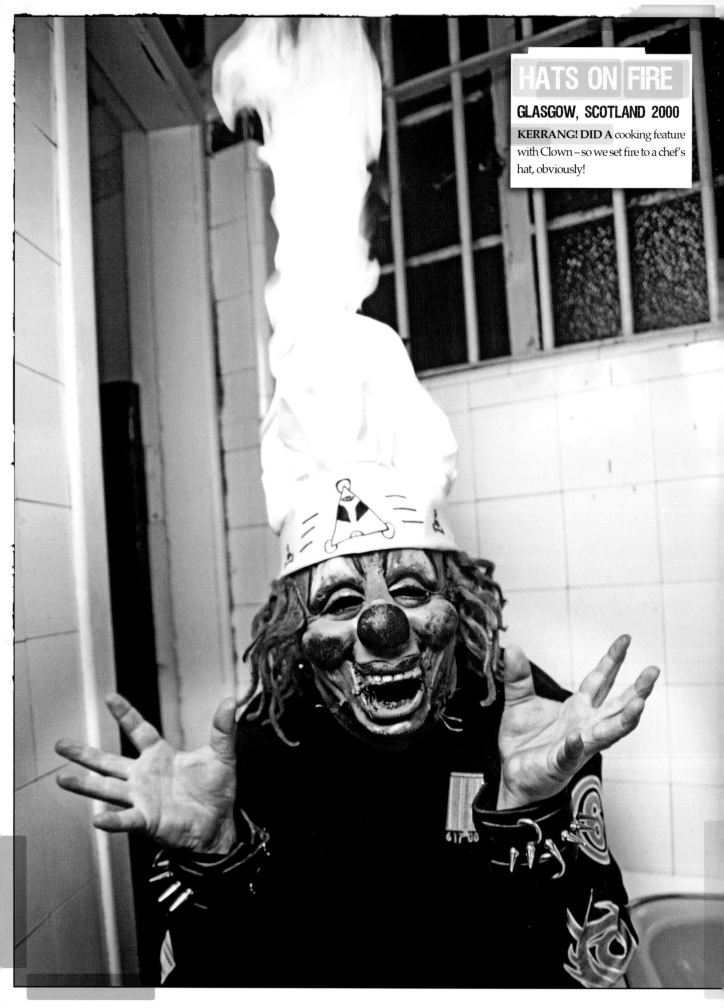

HATS ON FIRE

GLASGOW, SCOTLAND 2000

KERRANG! DID A cooking feature with Clown – so we set fire to a chef's hat, obviously!

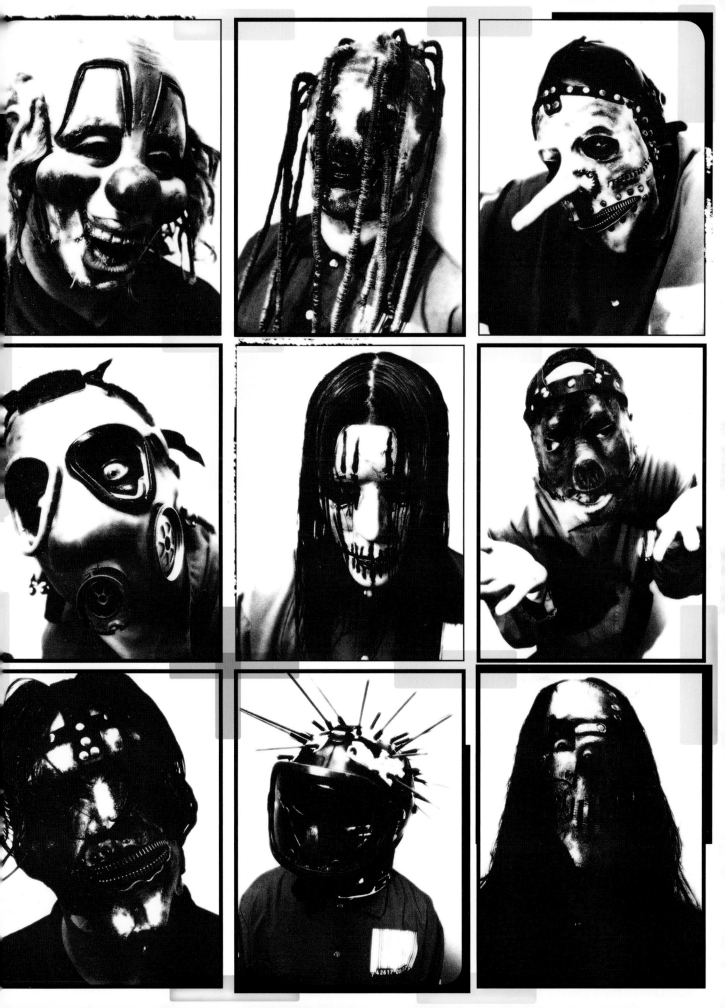

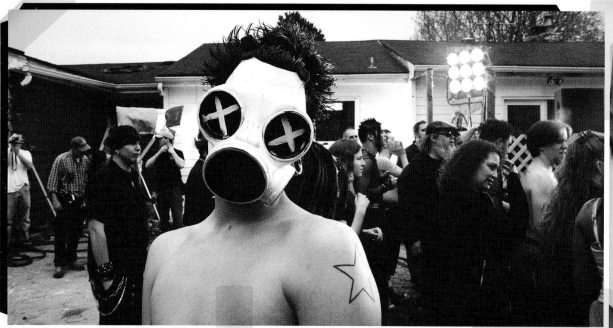

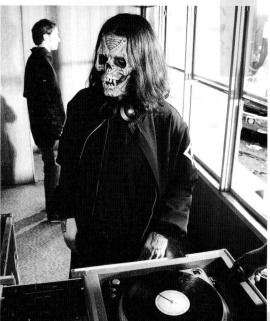

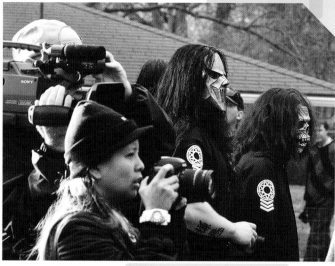

'DUALITY' VIDEO SHOOT

DES MOINES, IOWA, USA, MARCH 2004

NOT ALL OF the sessions I've done with the band have taken place backstage in anonymous American concert halls or in sour-smelling dressing rooms. Occasionally I've been lucky enough to be invited to photograph the group between takes at one of their own video shoots. Sometimes, video shoots are interminably tedious affairs but as with much else about the band, for Slipknot things are different.

It was in late spring of 2004 when I flew out to Iowa to see them film the video clip that accompanies the song 'Duality'. The production involved several hundred fans going berserk inside a condemned – or, let's say, a very soon-to-be-condemned – house in suburban Des Moines. It was all very far removed from the normal video fare, as became clear even before the director had

CONTINUES ▶

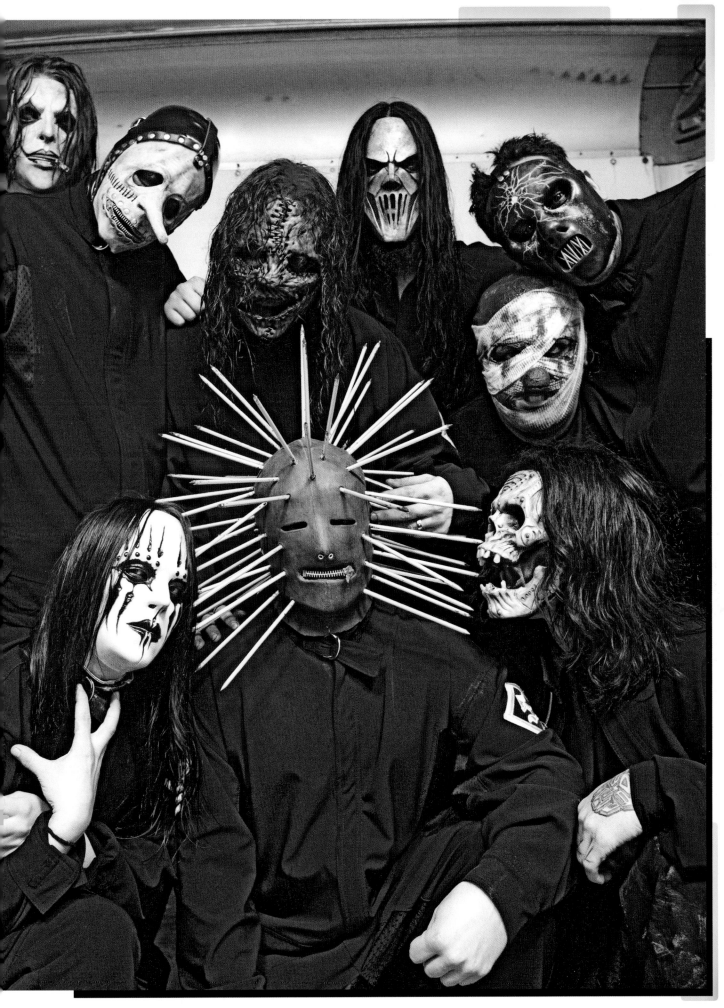

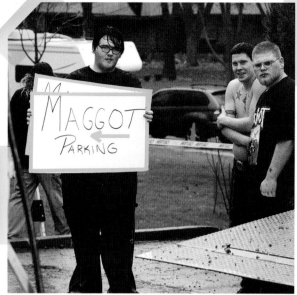

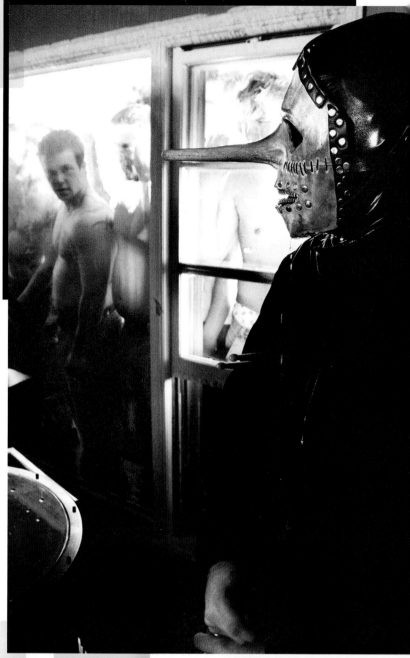

◀ CONTINUED FROM PREVIOUS PAGE

shouted 'action' for the first time that day. As my car approached the location of the shoot, I saw a young man standing by the side of the road. He was holding a sign on which were written the words: 'Maggot Parking'.

While the video was being shot upstairs, I was down in the basement setting up my lights and kit so I could photograph the band while the film crew above were preparing their next set-up. One storey up I heard the director instruct the cameramen to begin filming while I assembled my own set-up. Above my head, the ominous thump of 'Duality' walloped away. In sync with this beat, the band's fans began slam-dancing with a ferocity that can be clearly seen in the finished video. Immediately below, I couldn't help but notice that my ceiling – the fans' floor – was visibly shuddering under the force of this collective commotion. A member of the crew came down and told me that I "could be in danger" and suggested that I quickly move to the relative safety of a support column. I can just see the headlines now: 'Photographer killed by 250 plummeting teenagers and man dressed as clown'.

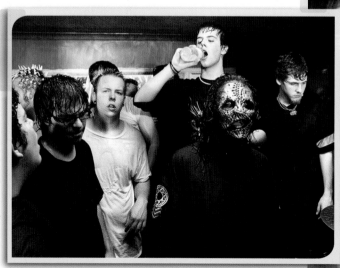

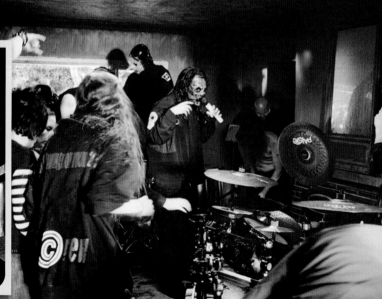

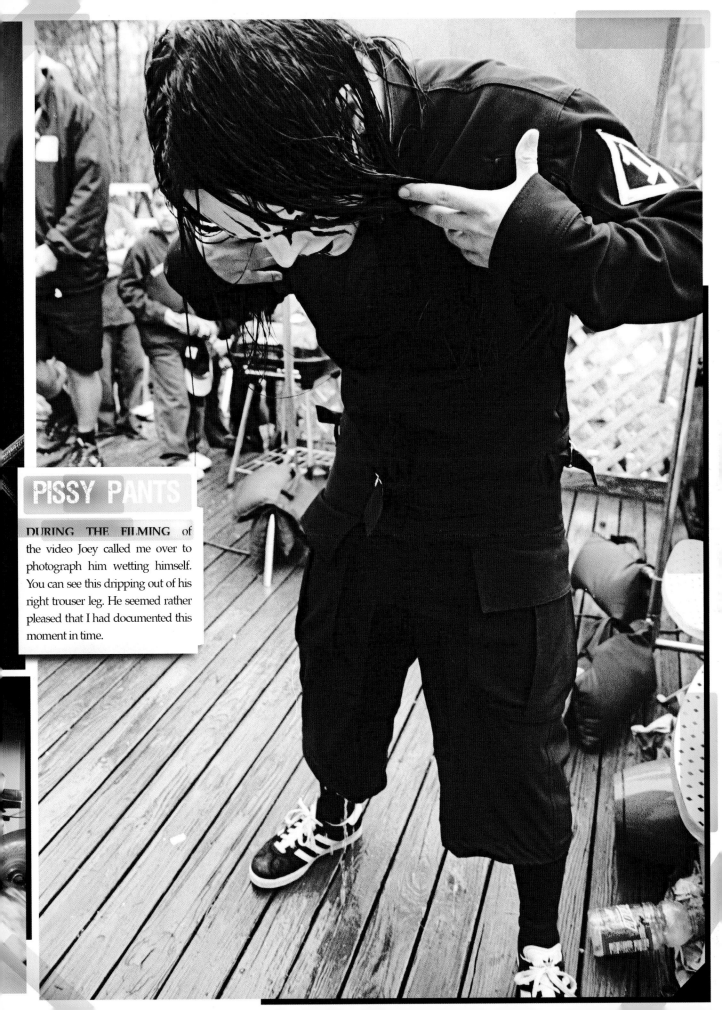

PISSY PANTS

DURING THE FILMING of the video Joey called me over to photograph him wetting himself. You can see this dripping out of his right trouser leg. He seemed rather pleased that I had documented this moment in time.

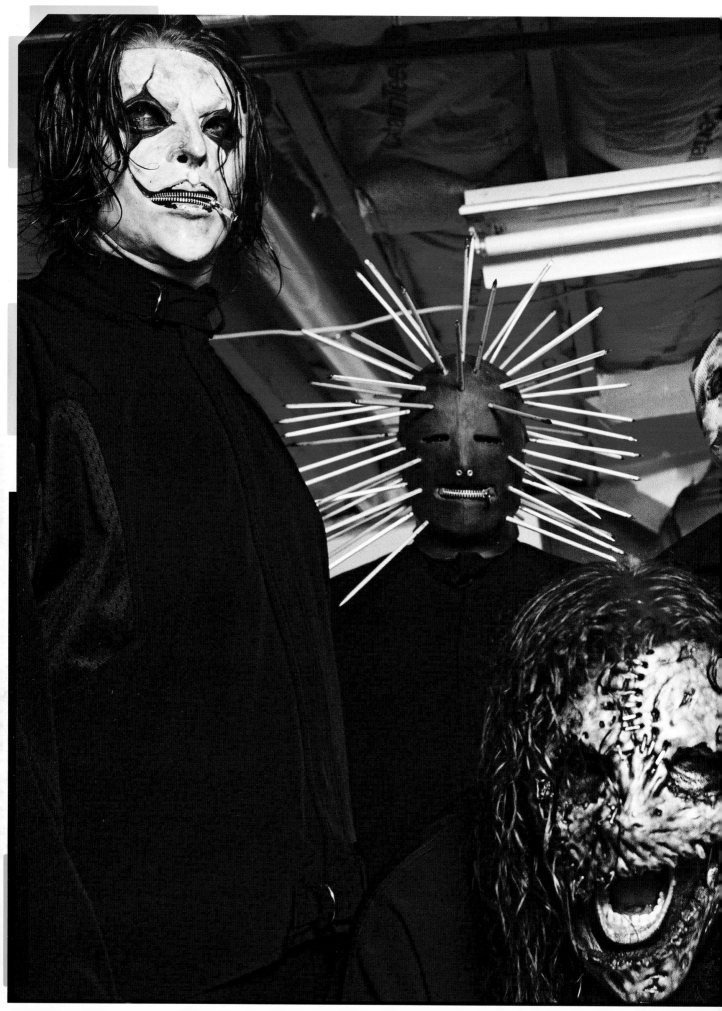

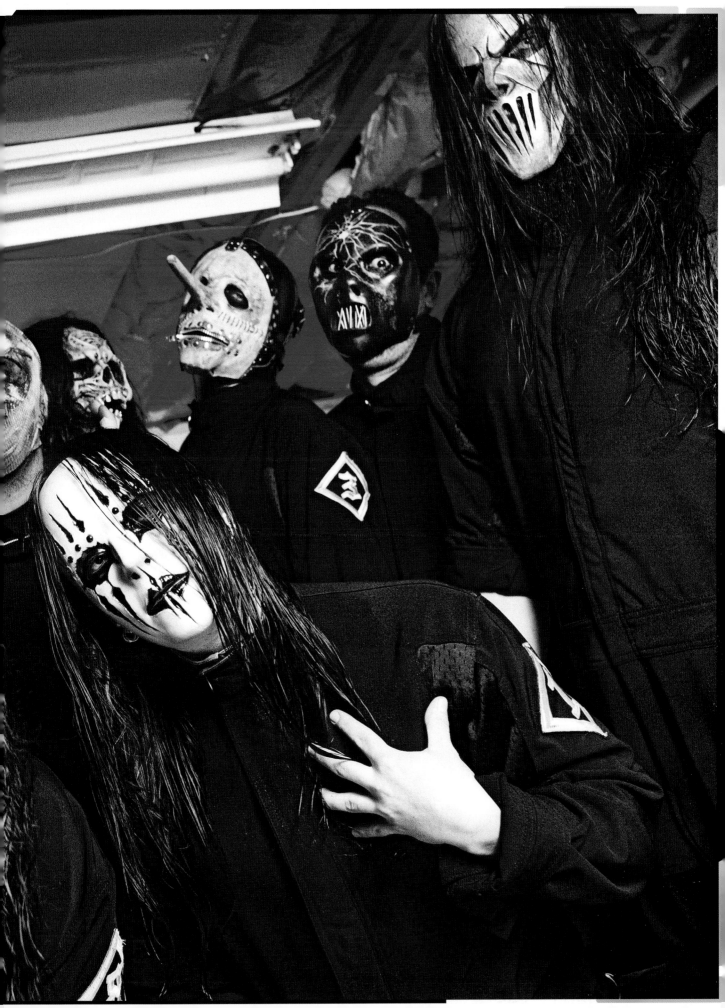

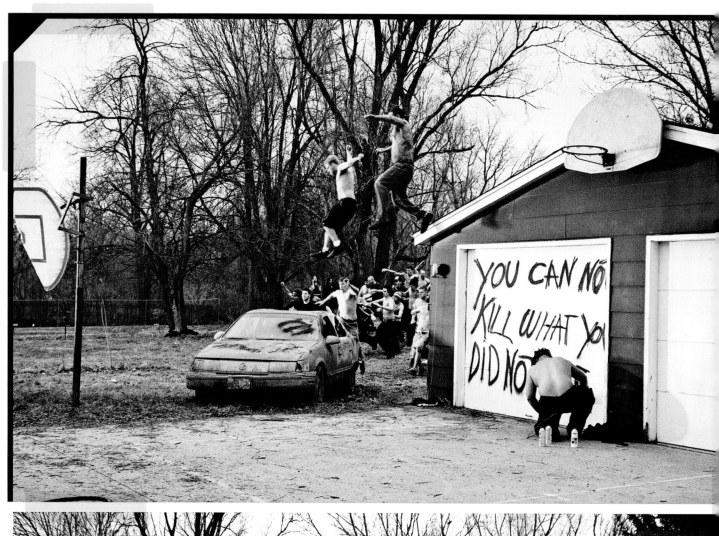
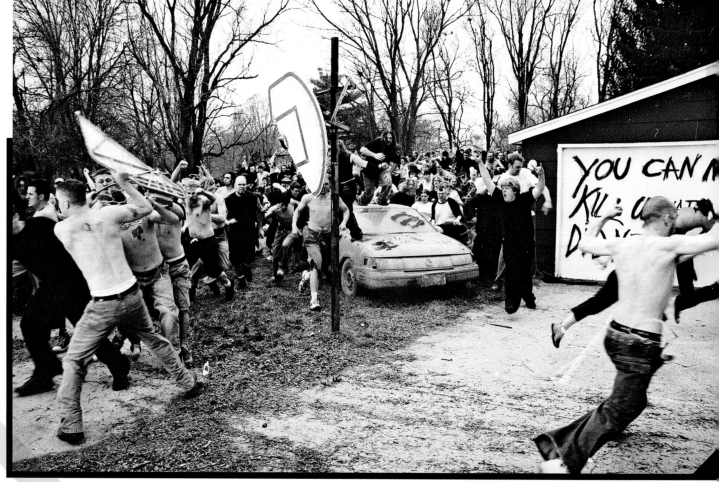

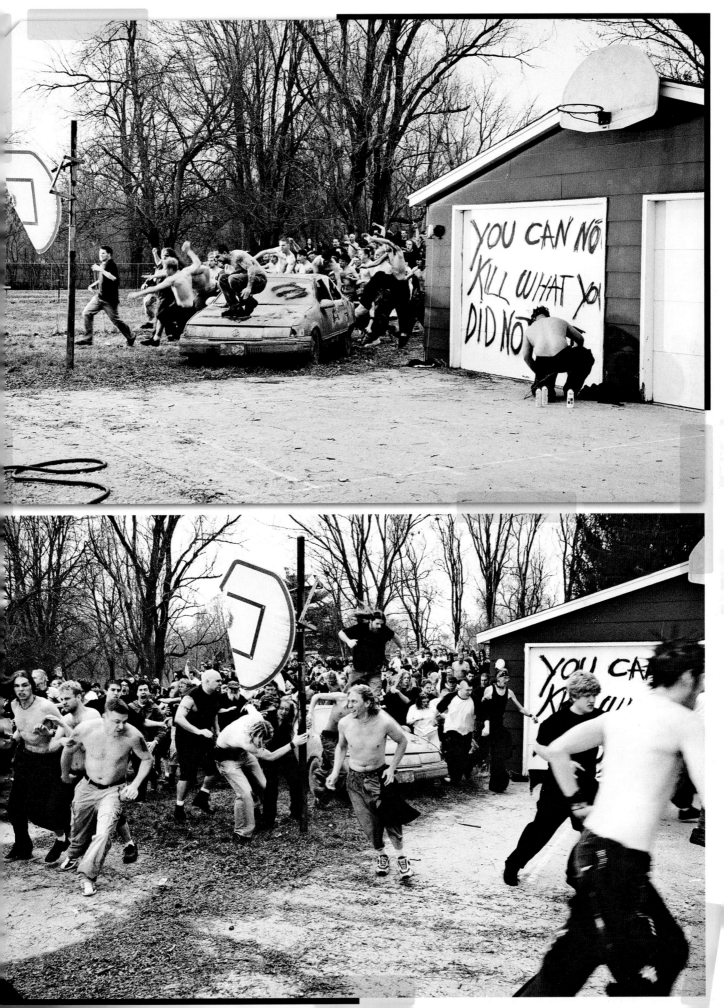

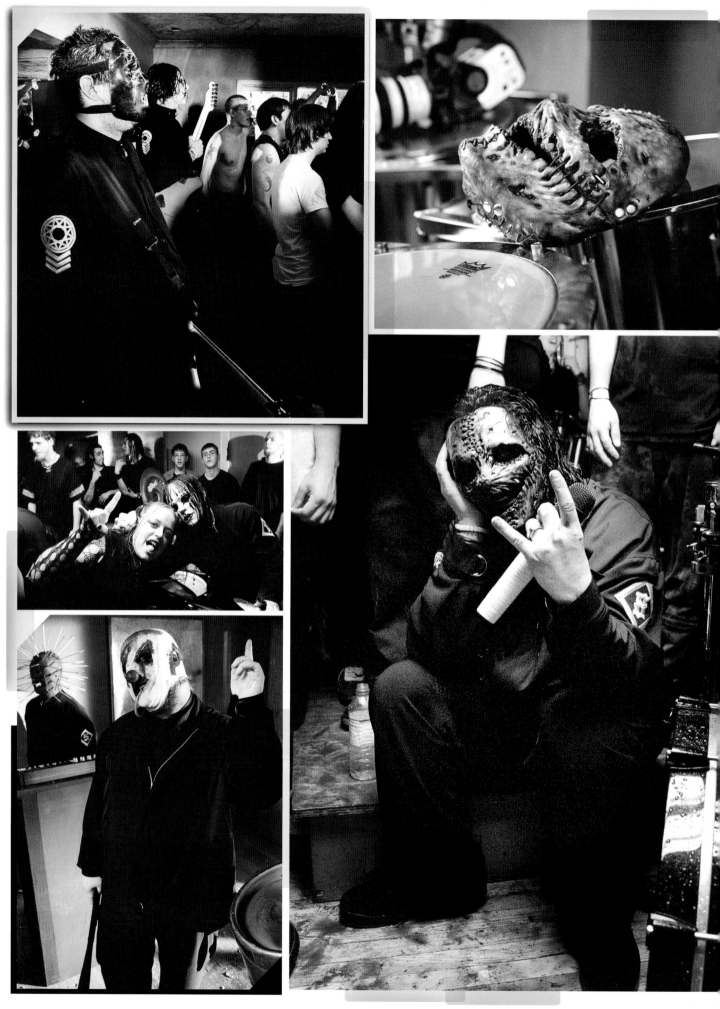

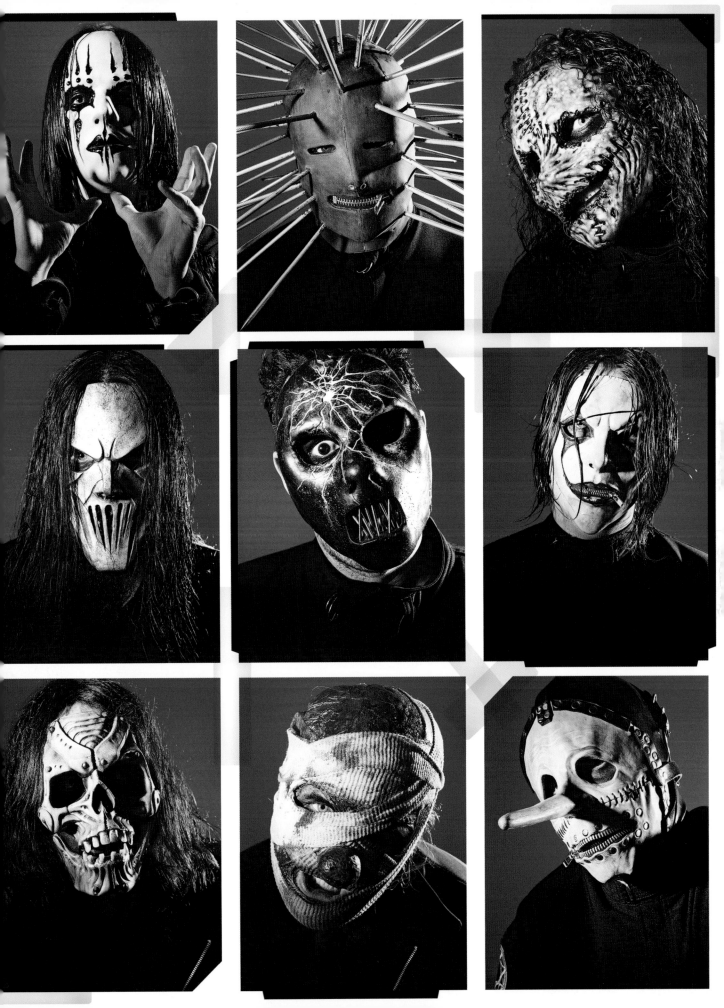

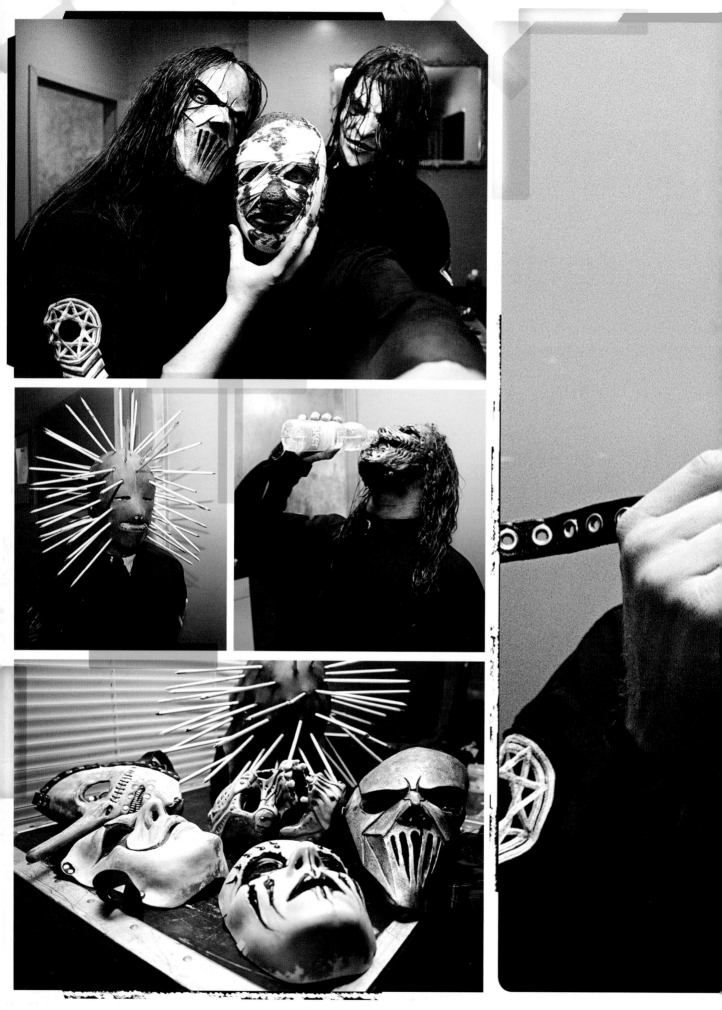

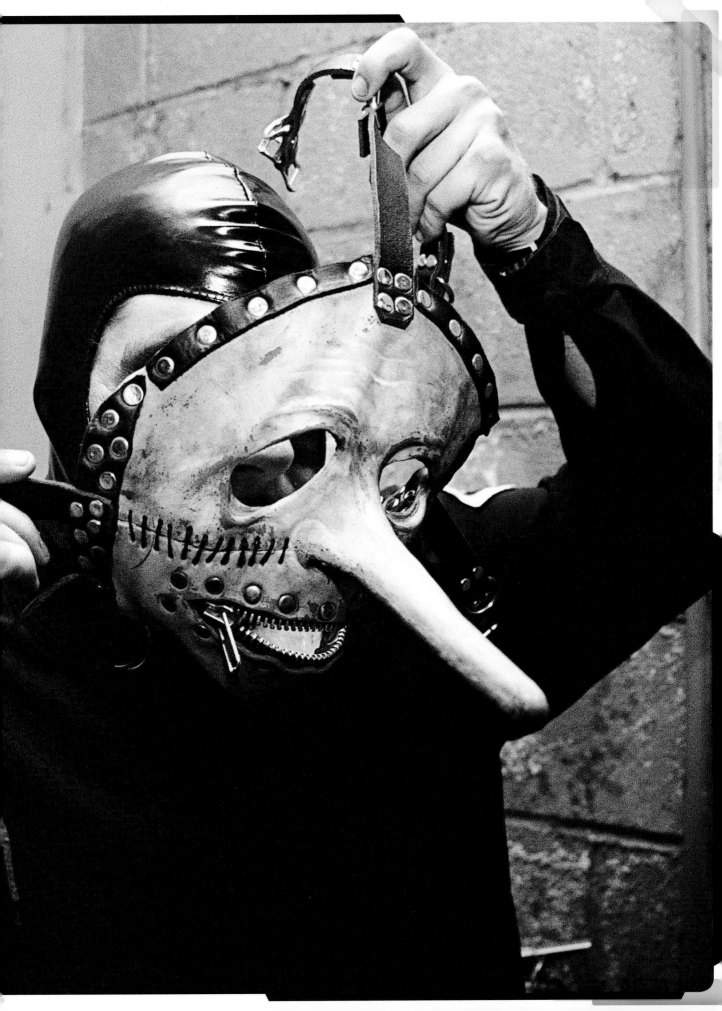

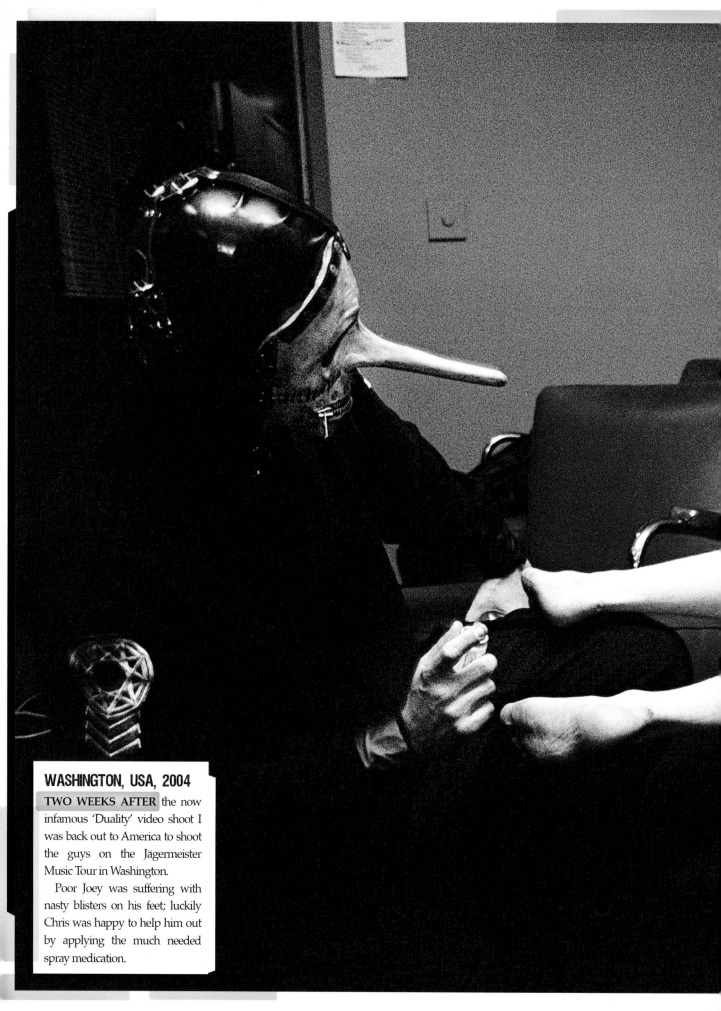

WASHINGTON, USA, 2004

TWO WEEKS AFTER the now infamous 'Duality' video shoot I was back out to America to shoot the guys on the Jägermeister Music Tour in Washington.

Poor Joey was suffering with nasty blisters on his feet; luckily Chris was happy to help him out by applying the much needed spray medication.

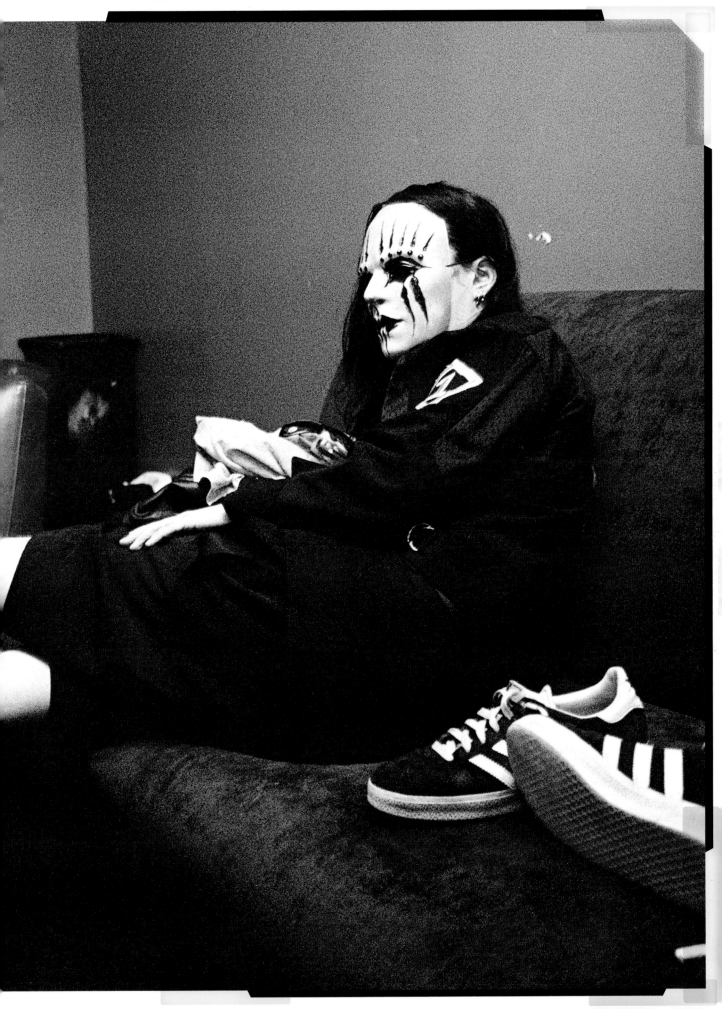

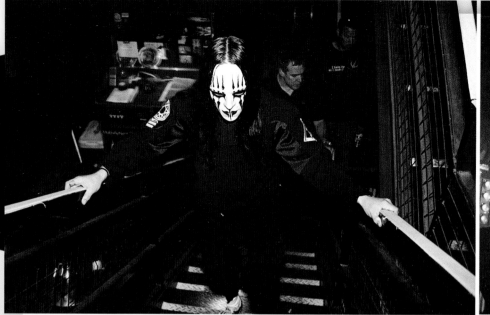
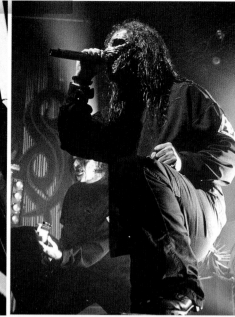

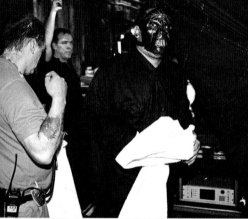

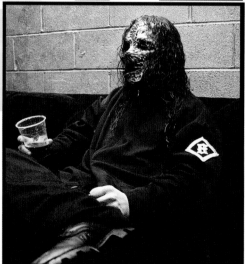

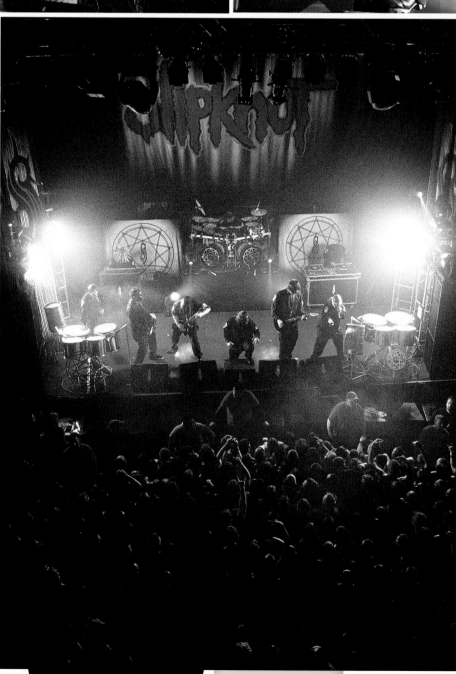

Bitch 742617000027
B
B (SIC) spit in bridge
B THE BLISTER EXISTS
B EYELESS Lead spit at end
B THREE NIL
B DUALITY Airline Case thing
B DISASTERPIECE Bass Balls
Gunmetal B PURITY
B PULSE OF THE MAGGOTS
Red A IOWA
A HERETIC ANTHEM
Black B SPIT IT OUT spit
B WAIT AND BLEED
B PEOPLE = SHIT Bass Balls
B SURFACING carve

Slipknot
NATION
WASHINGTON, DC
FRIDAY, APRIL 9, 2004

9:00AM LOAD IN
3:00PM SOUND CHECK
6:00PM DOORS
7:00-7:20PM SWORN ENEMY
7:40-8:10PM CHIMAIRA
8:30-9:15PM FEAR FACTORY
9:45-11:00PM SLIPKNOT
12:00AM CURFEW
2:00AM BUS CALL

DRIVE 460 MILES
WORCESTER, MA
SHOW AT THE PALLADIUM

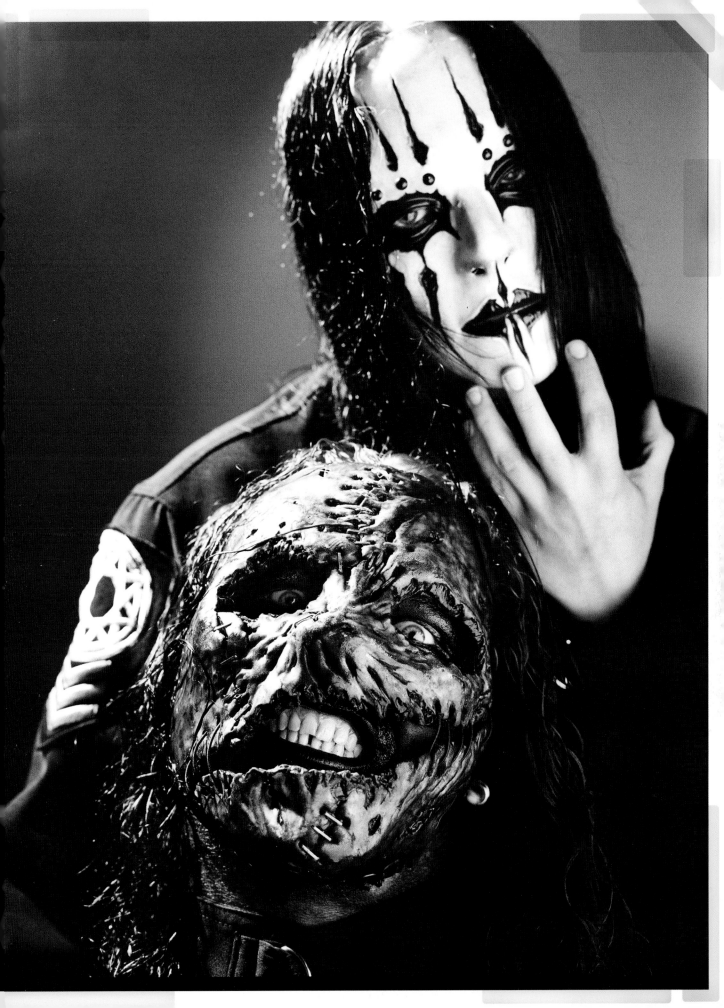

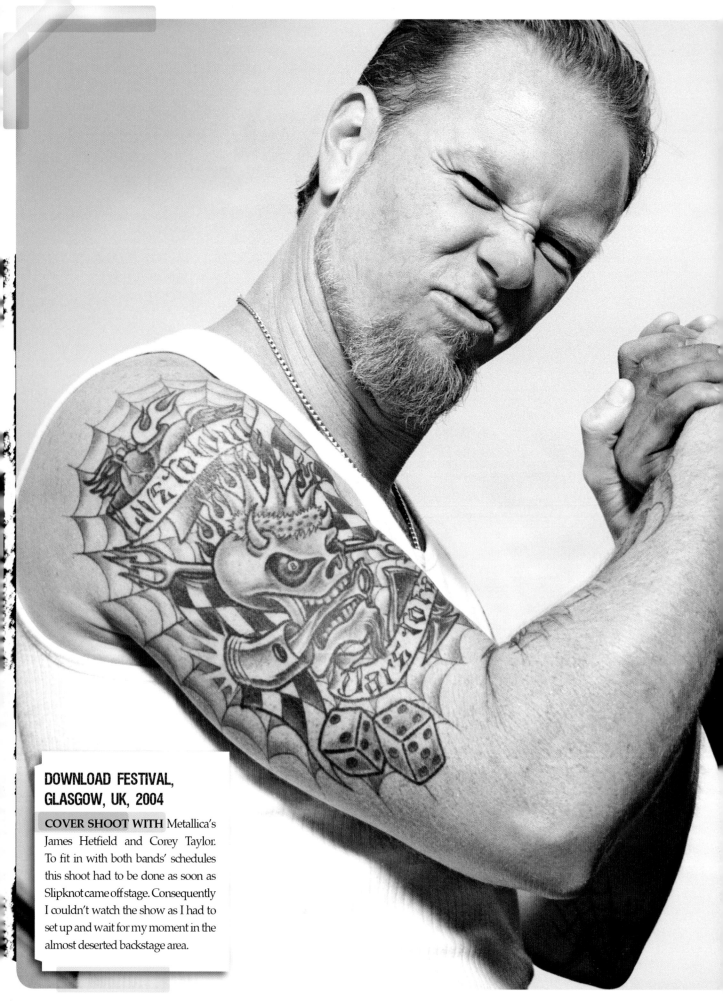

DOWNLOAD FESTIVAL, GLASGOW, UK, 2004

COVER SHOOT WITH Metallica's James Hetfield and Corey Taylor. To fit in with both bands' schedules this shoot had to be done as soon as Slipknot came off stage. Consequently I couldn't watch the show as I had to set up and wait for my moment in the almost deserted backstage area.

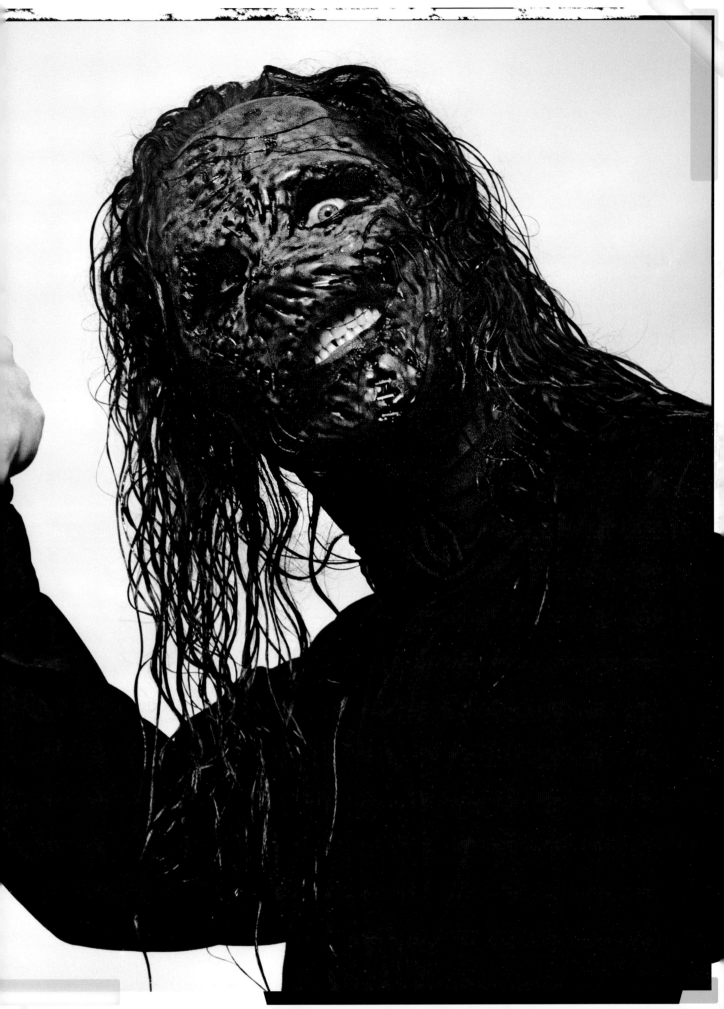

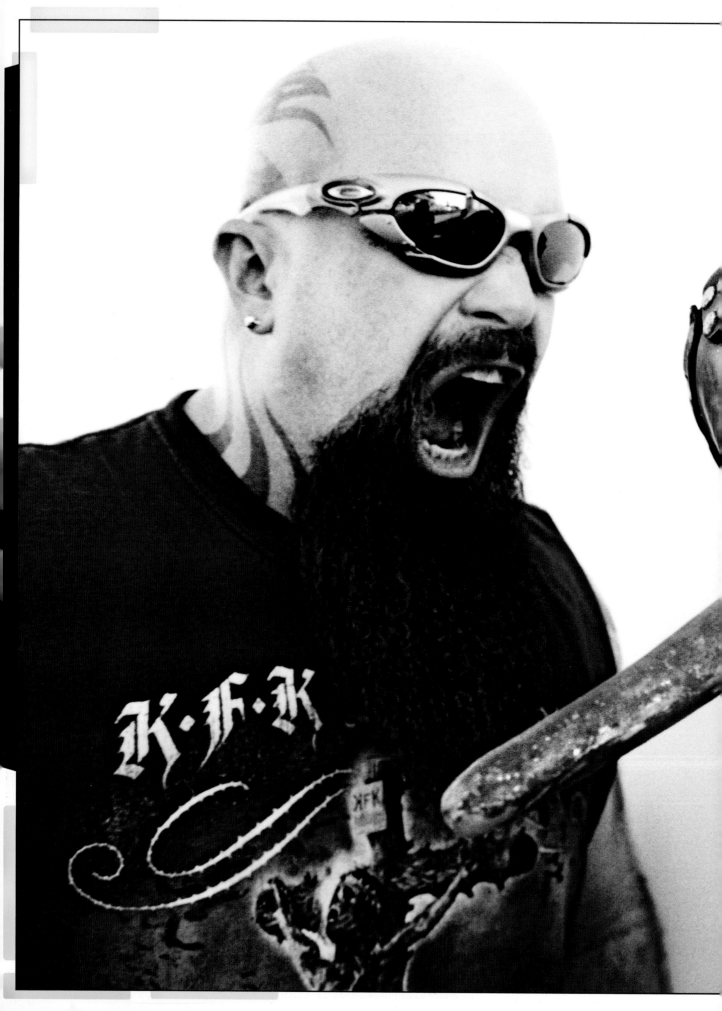

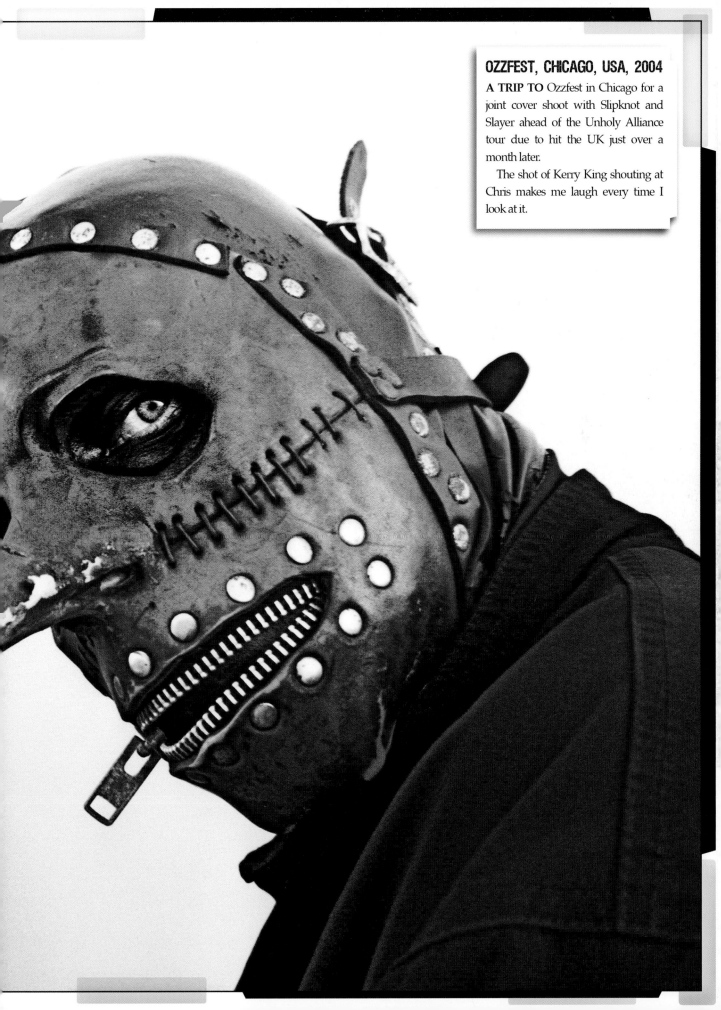

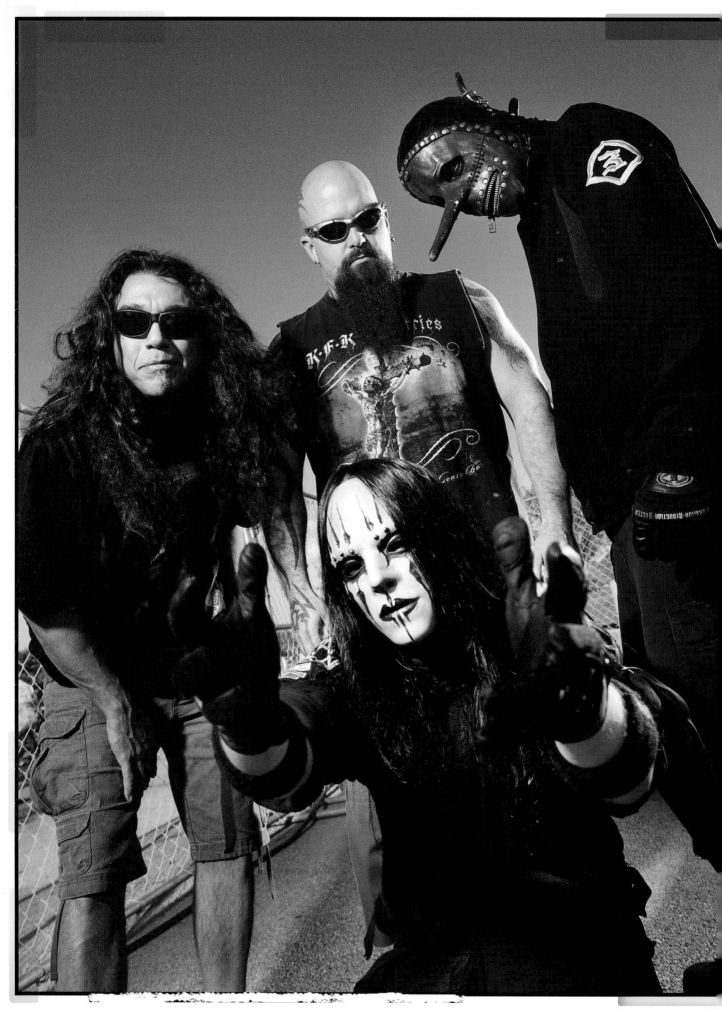

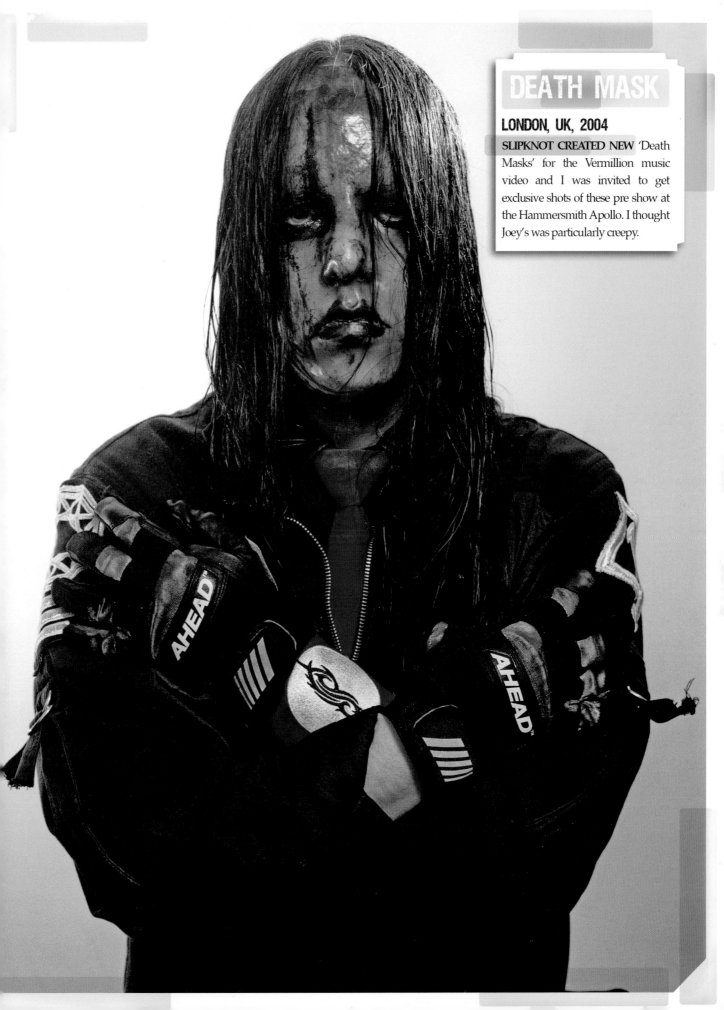

DEATH MASK

LONDON, UK, 2004

SLIPKNOT CREATED NEW 'Death Masks' for the Vermillion music video and I was invited to get exclusive shots of these pre show at the Hammersmith Apollo. I thought Joey's was particularly creepy.

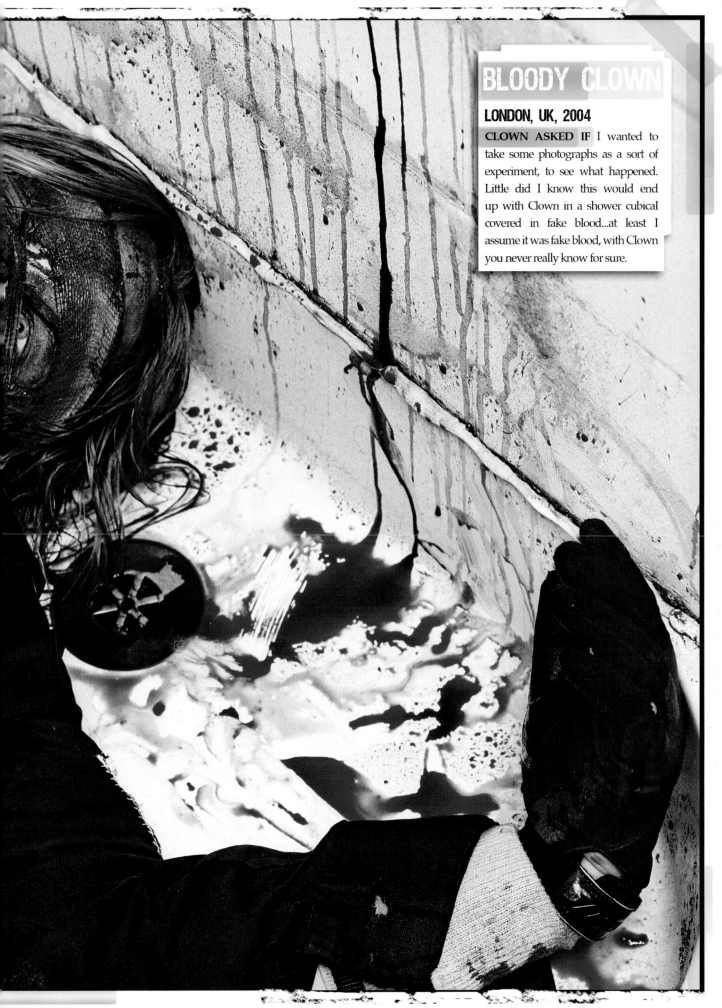

BLOODY CLOWN

LONDON, UK, 2004

CLOWN ASKED IF I wanted to take some photographs as a sort of experiment, to see what happened. Little did I know this would end up with Clown in a shower cubical covered in fake blood...at least I assume it was fake blood, with Clown you never really know for sure.

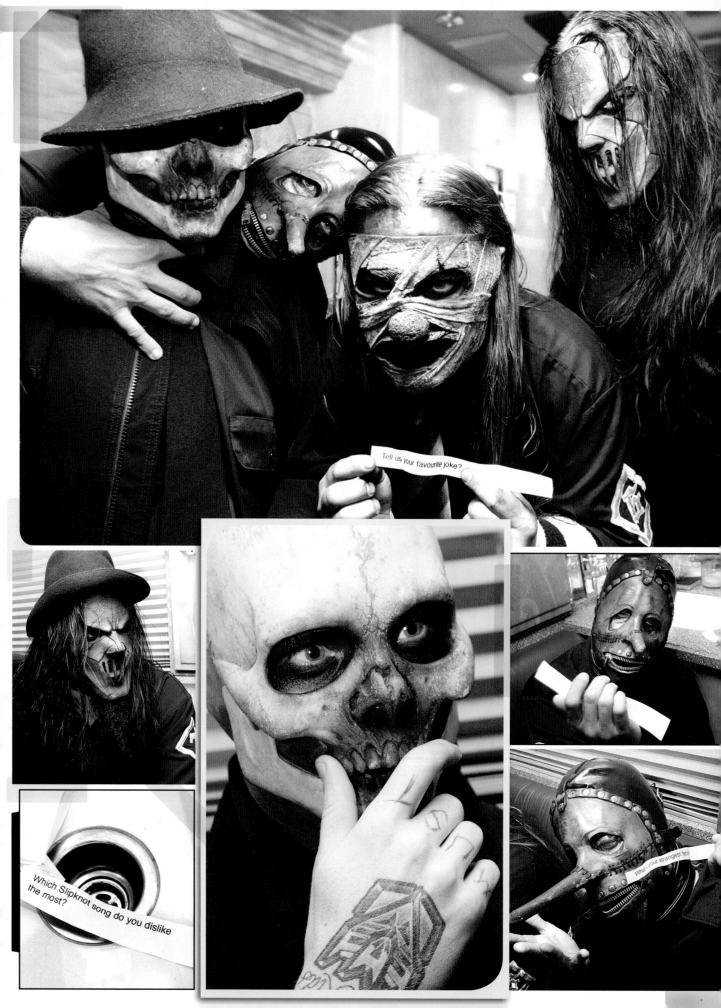

Tell us your favourite joke?

Which Slipknot song do you dislike the most?

What's your strangest fetish

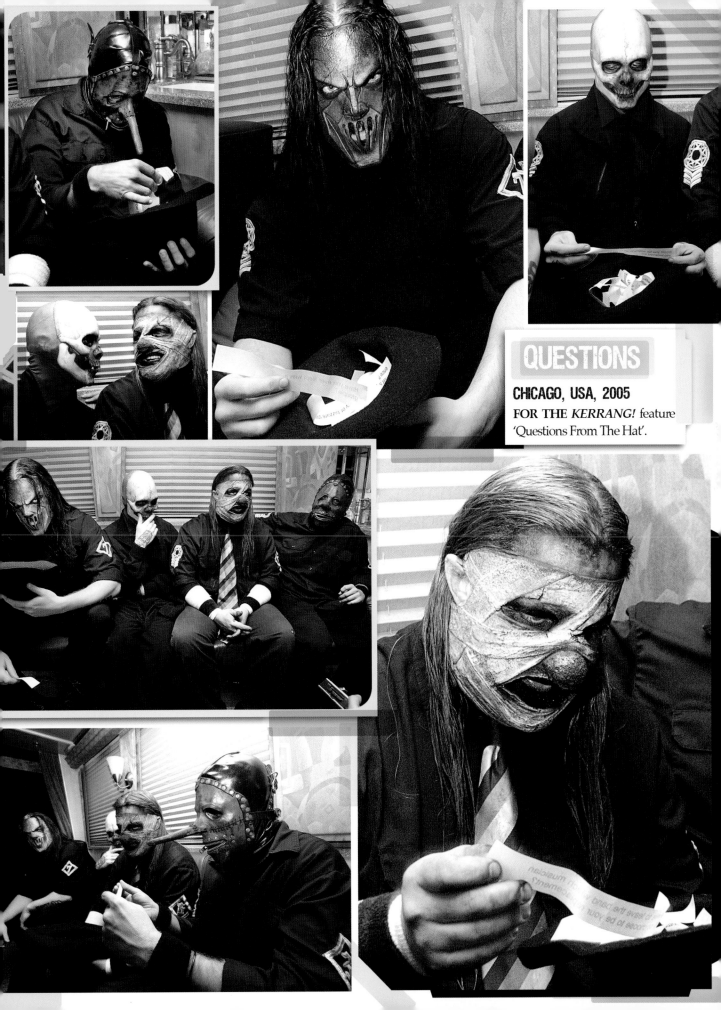

QUESTIONS

CHICAGO, USA, 2005
FOR THE *KERRANG!* feature
'Questions From The Hat'.

SPLIT PERSONALITY

BIRMINGHAM, UK, 2007

THIS SHOOT WAS commissioned to illustrate how Corey can switch his frontman duties between Slipknot and Stone Sour.

Stone Sour were on tour in the UK at the time so the Slipknot mask was shipped in especially. There was even talk of Clown flying in to oversee the project, as at this point they had never done a shoot like this.

As we couldn't actually split the mask for the main photo I had to shoot Corey with and without the mask under the same lighting conditions so that two shots could be combined later. Not as simple as it sounds because for the masked shots Corey had to black his face around his eyes and mouth first.

When the mask was unpacked, Corey looked at it and jokingly groaned, "Oh no, it's this guy again!"

I really like the shot of Corey holding his mask so they are face to face. It looks like a twisted version of the Yorick speech from *Hamlet*.

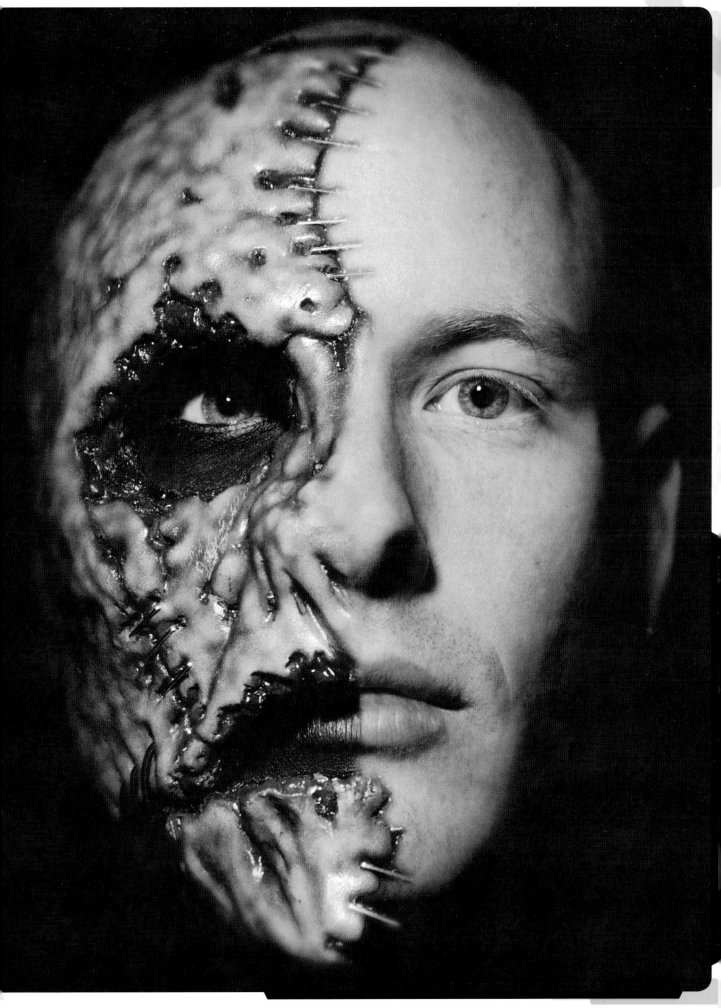

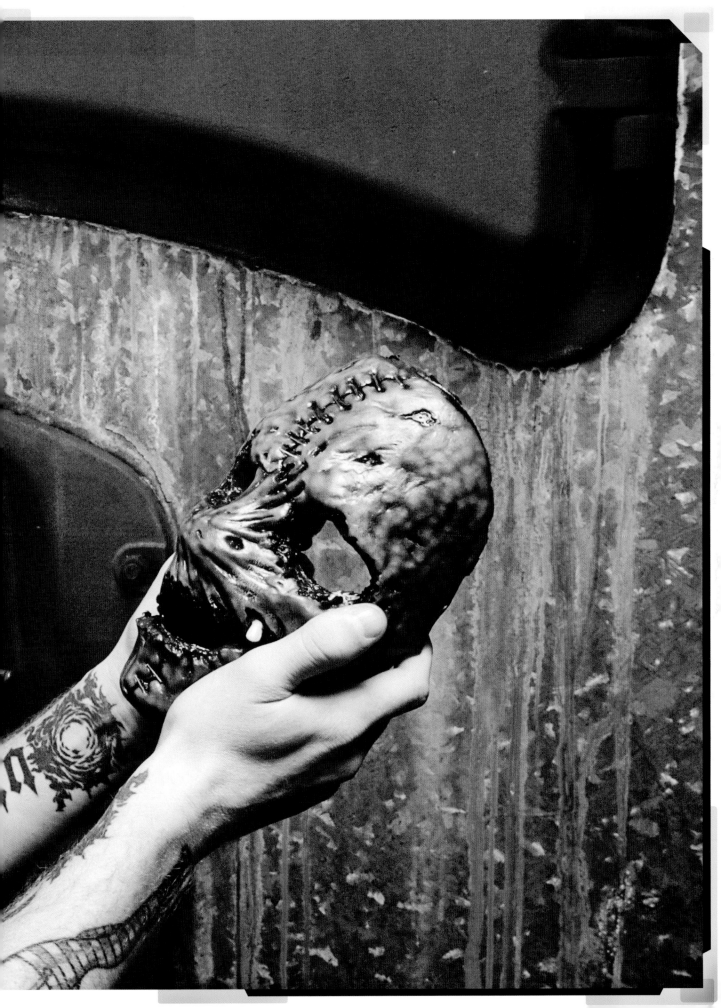

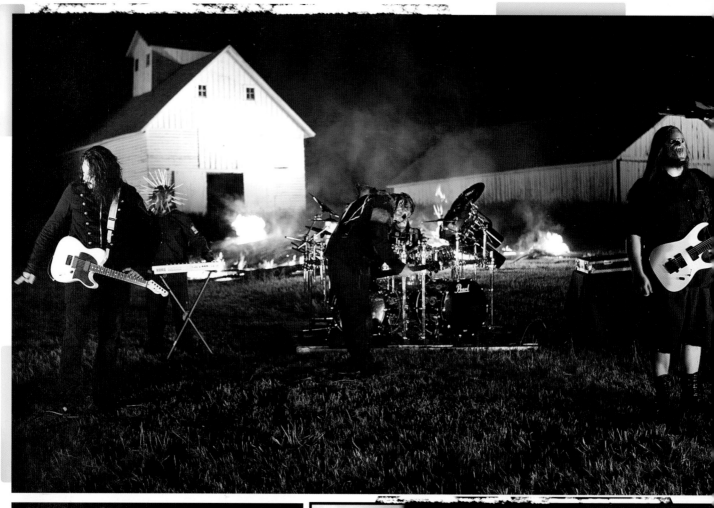

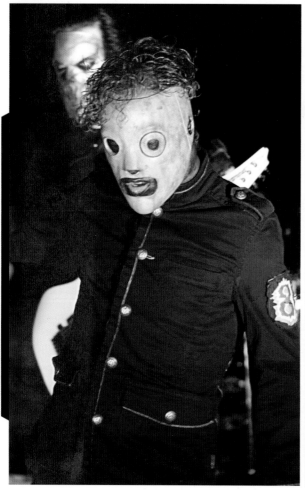

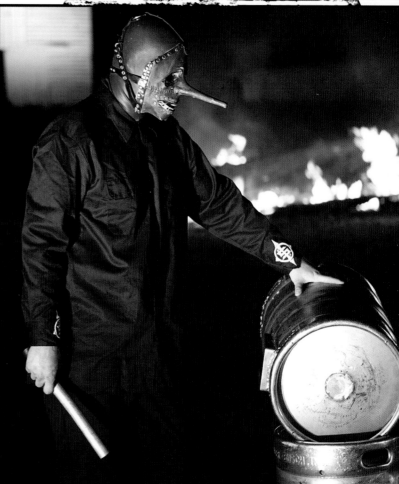

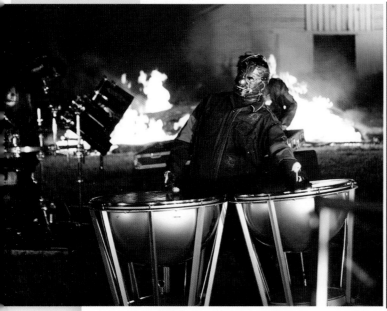

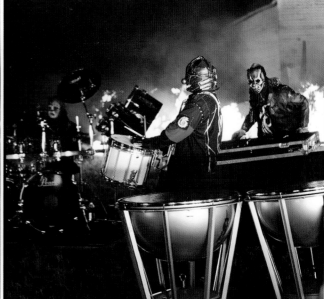

'PSYCHOSOCIAL' VIDEO SHOOT

JAMAICA, IOWA, USA, JUNE 2008

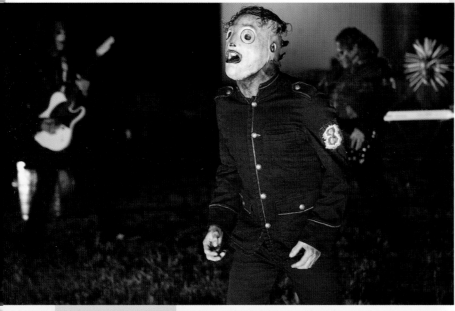

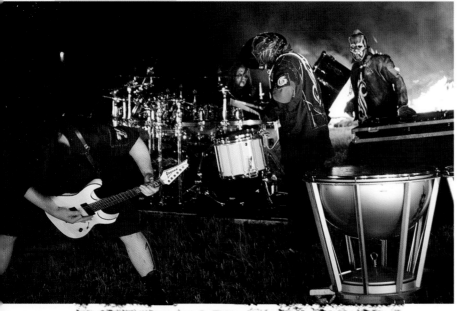

AS BEFITS A group with whom I am most closely associated, Slipknot have taught me a good deal about my trade. Perhaps more than anything, they have taught me how to think on my feet; they have taught me the bald truth that 'necessity is the mother of invention'. On one occasion I was again waiting to take pictures of the entire band; this, again, was in Iowa, this time for the video shoot for 'Psychosocial'. My task hadn't been made much easier by the fact that one of the group, Sid, was in hospital.

I remember looking outside and seeing the thing that every photographer dreads – fading light. Out of desperation, I said to Corey Taylor, "Any chance of the two of us going out and you posing for a few shots?" He agreed, and to this day I am grateful that he did. My picture of him standing alone in a farmer's field as the sun sets is my favourite of all the photographs I've taken of Slipknot.

The video itself was filmed through the night in the grounds of Sound Farm recording studio where the guys worked on *All Hope Is Gone*. It was a very warm night made even more intense by the fires burning on set and the constant insect bites endured by most of us.

I remember Clown telling me: "We are so remote here, if you ever saw a guy coming across a field towards you… chances are he is going to kill you." Is it any wonder that Iowa gave birth to a band like Slipknot?

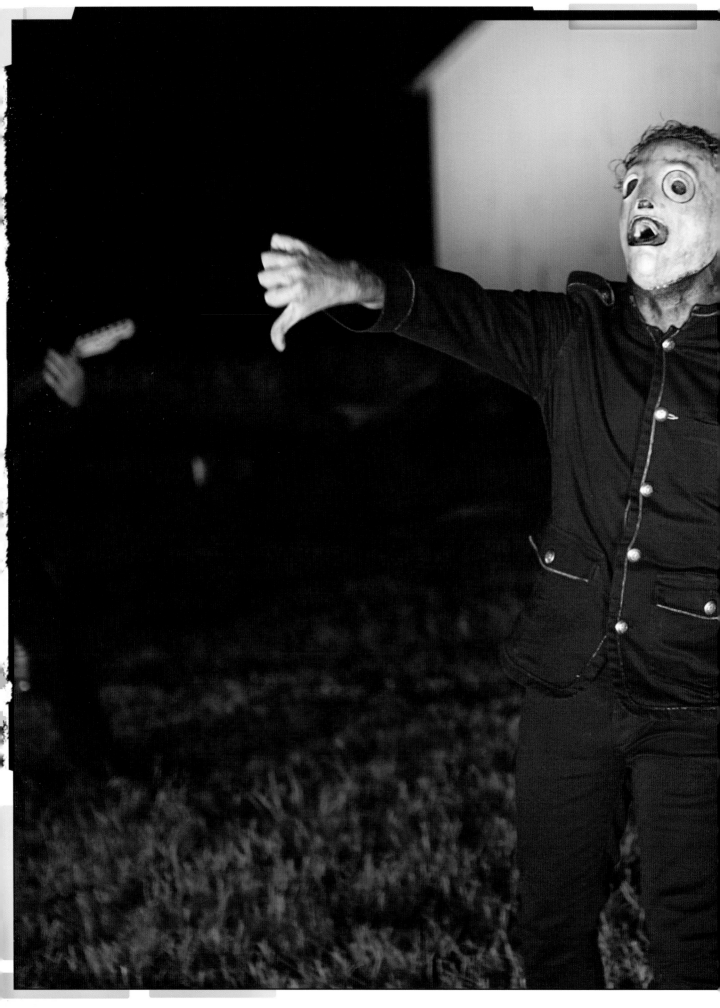

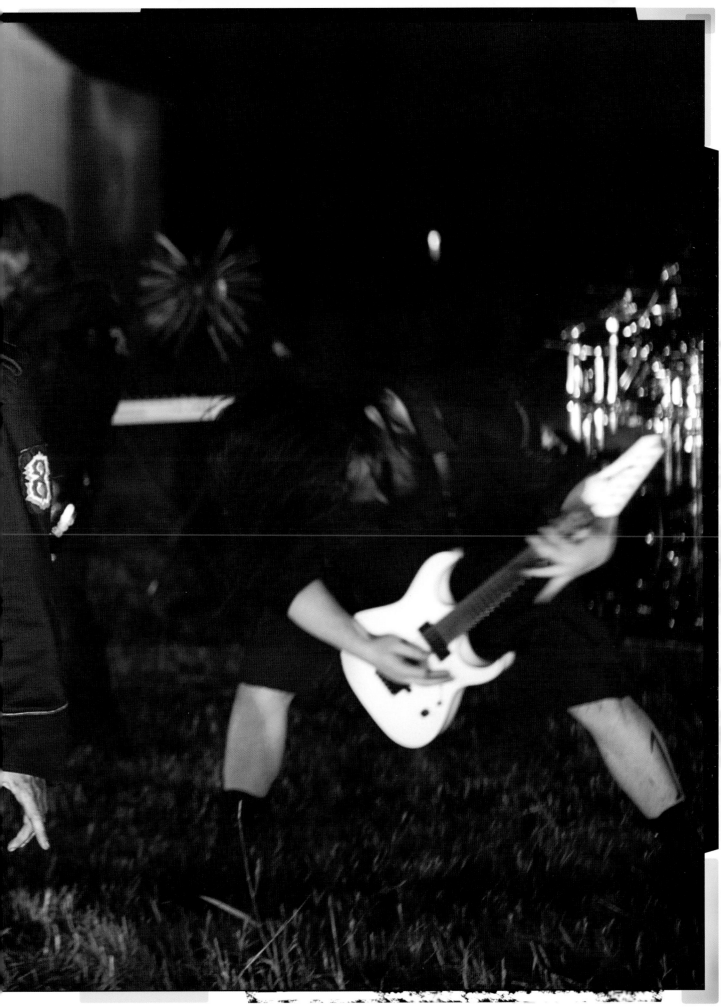

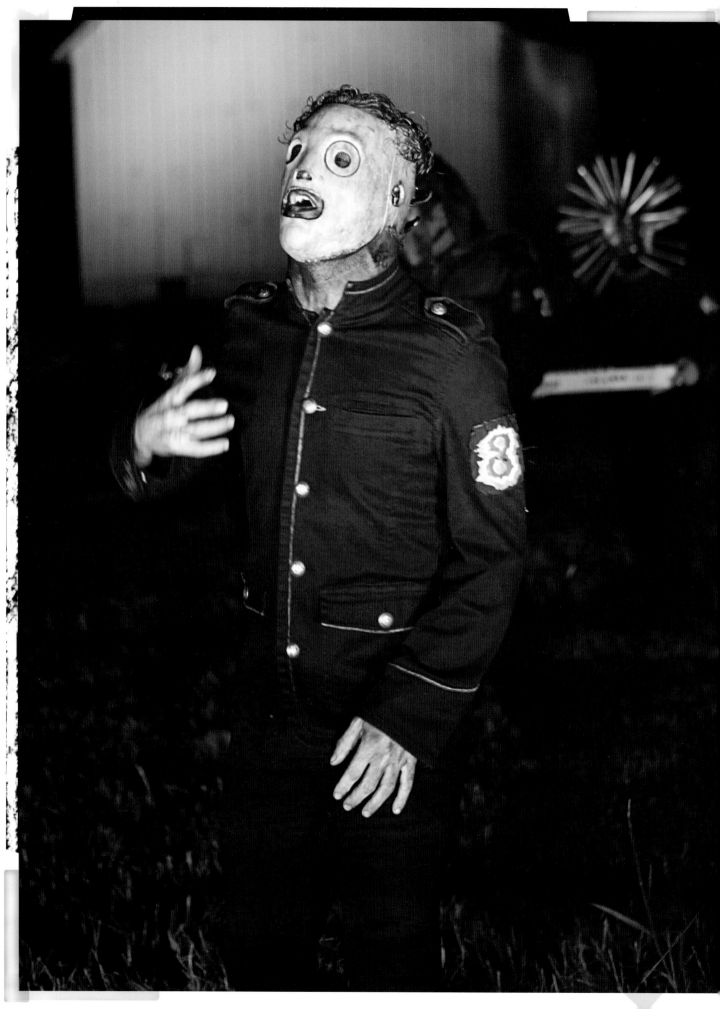

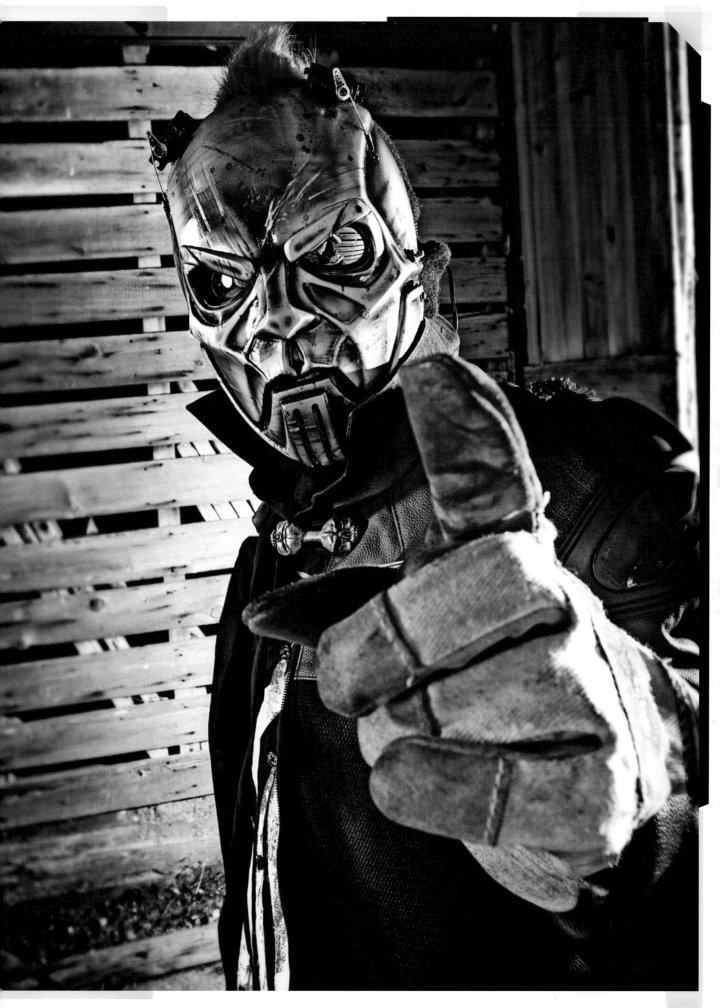

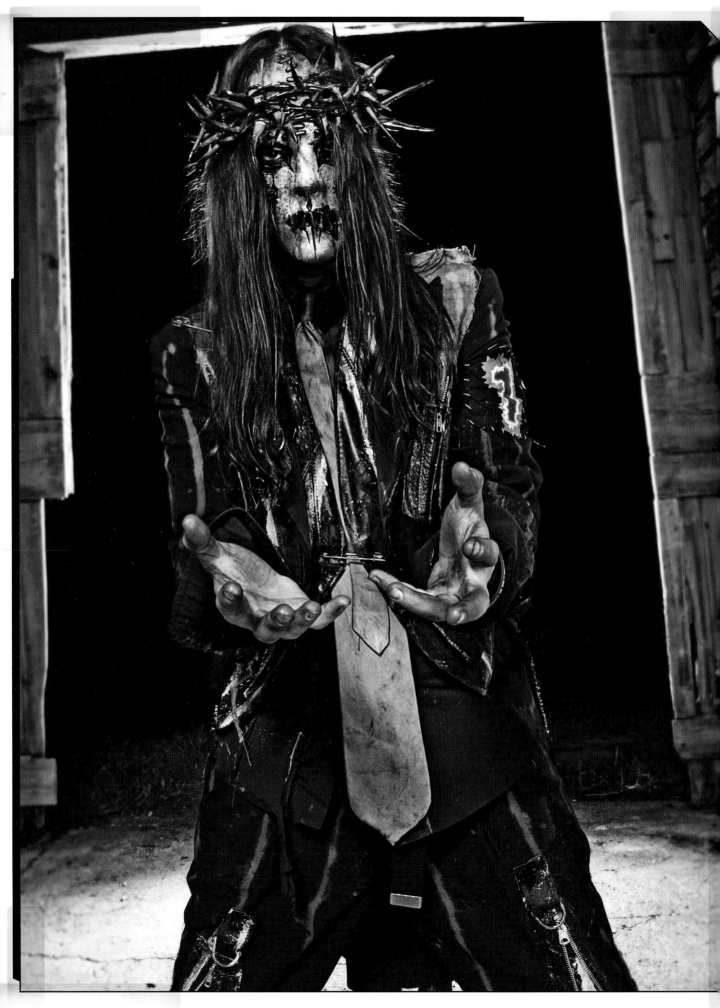

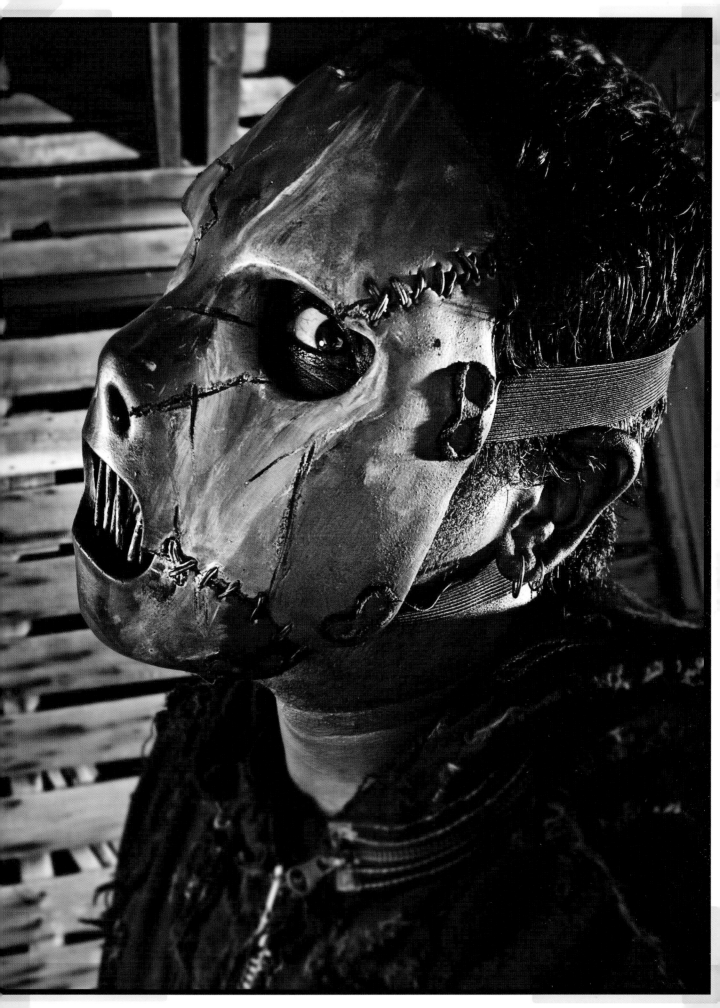

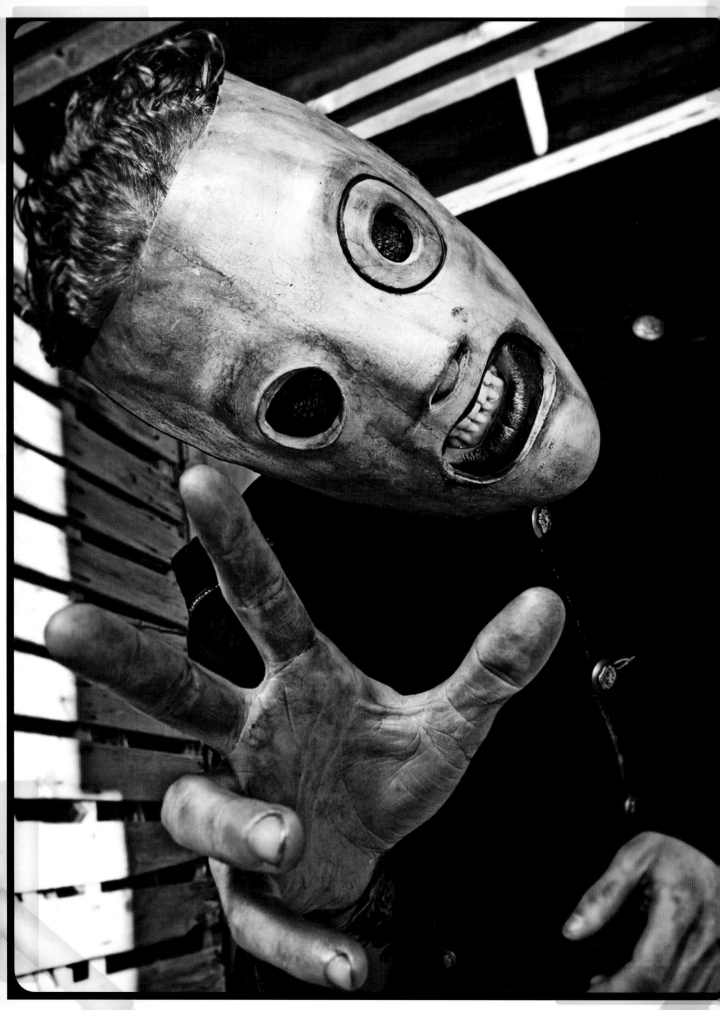

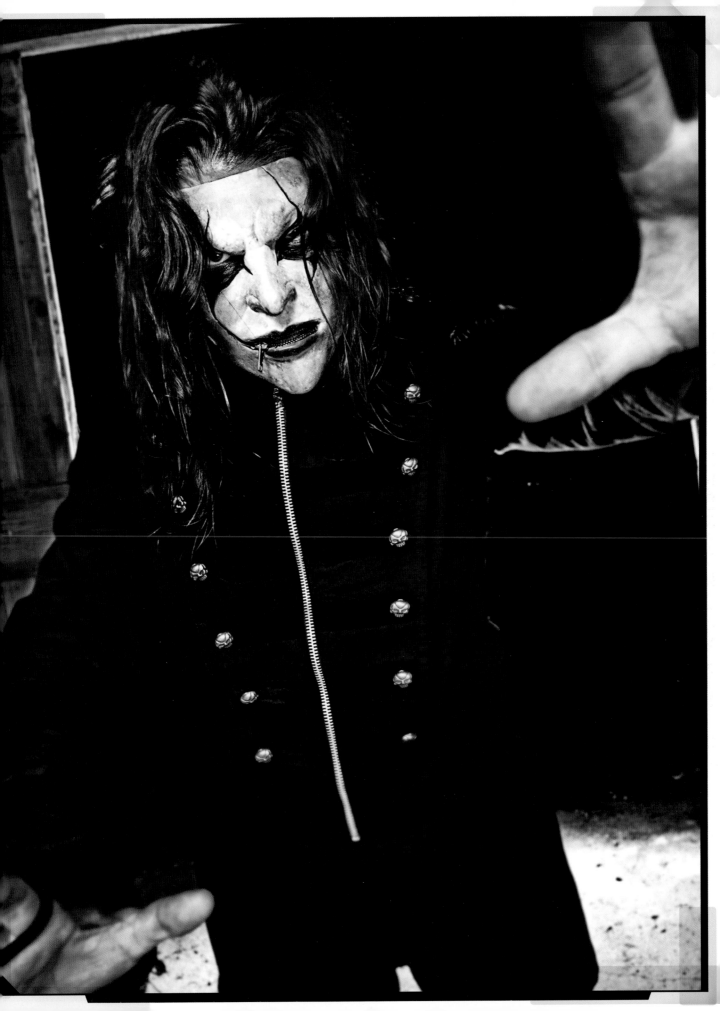

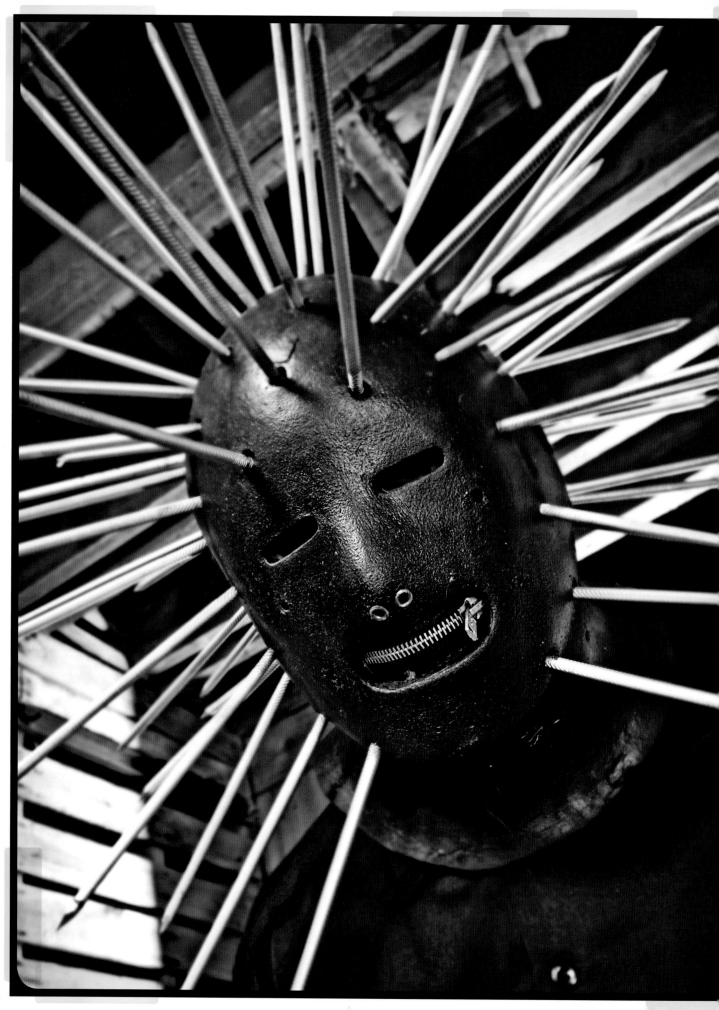

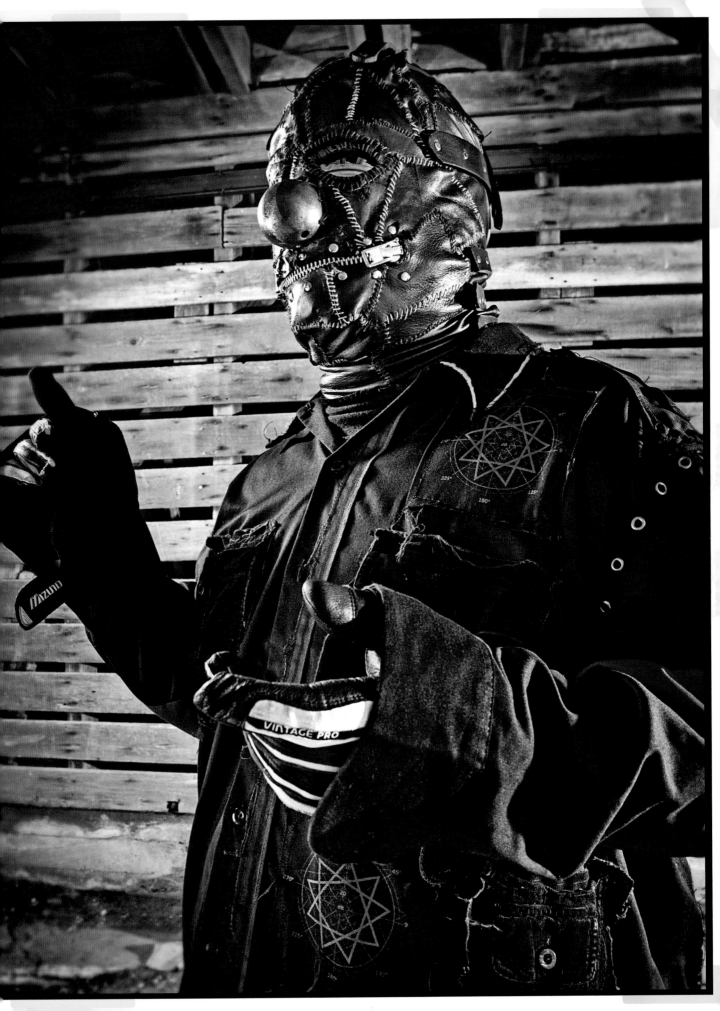

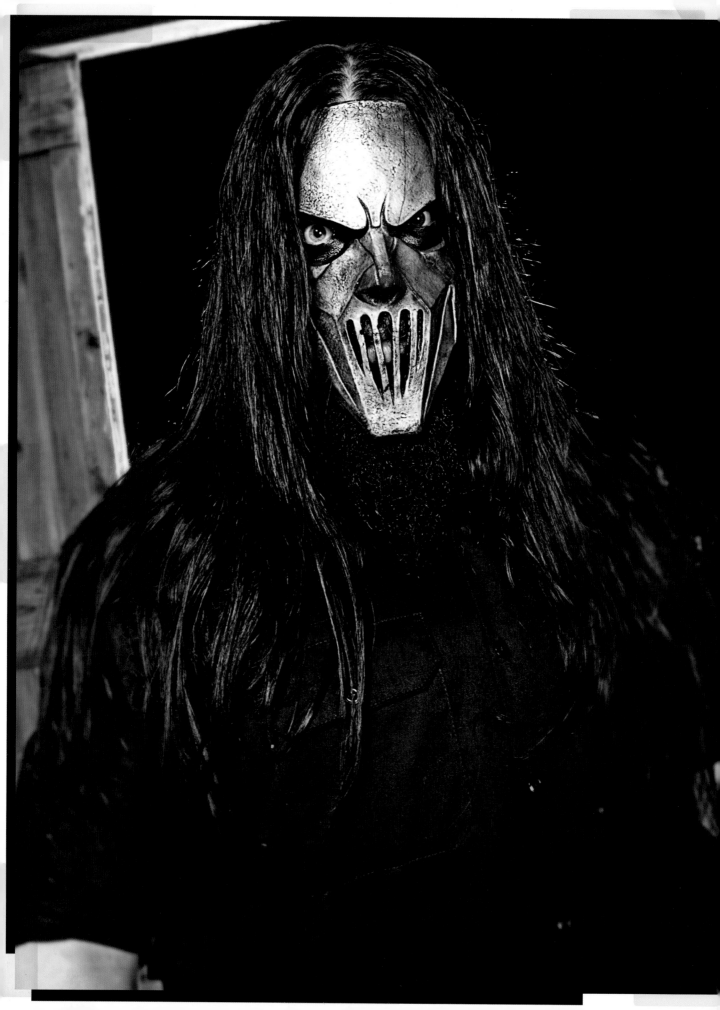

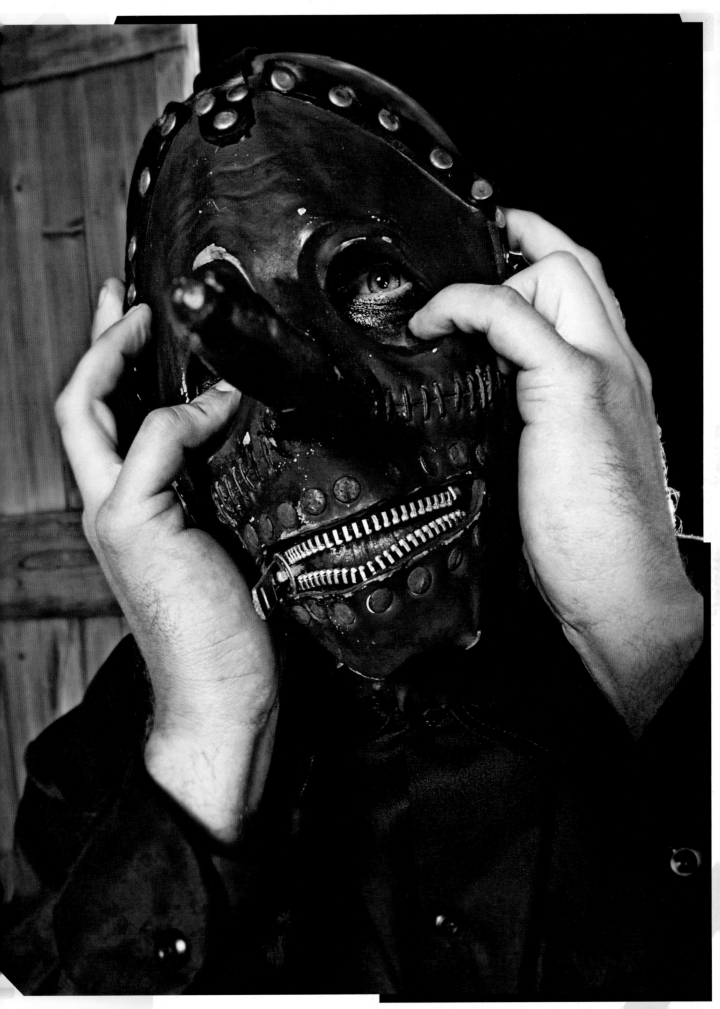

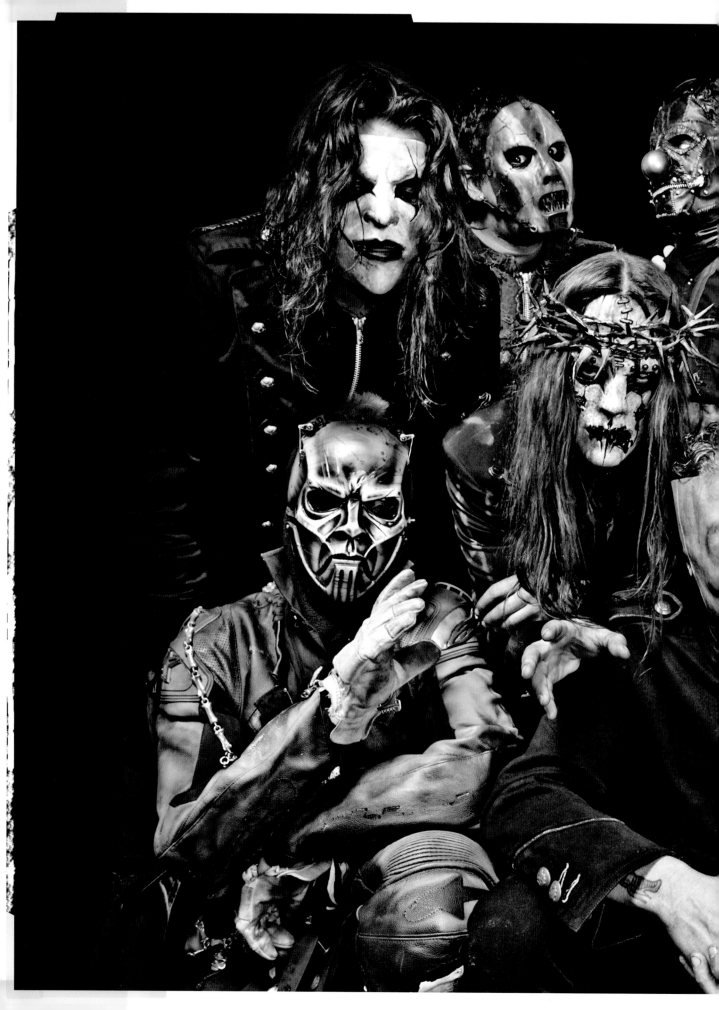

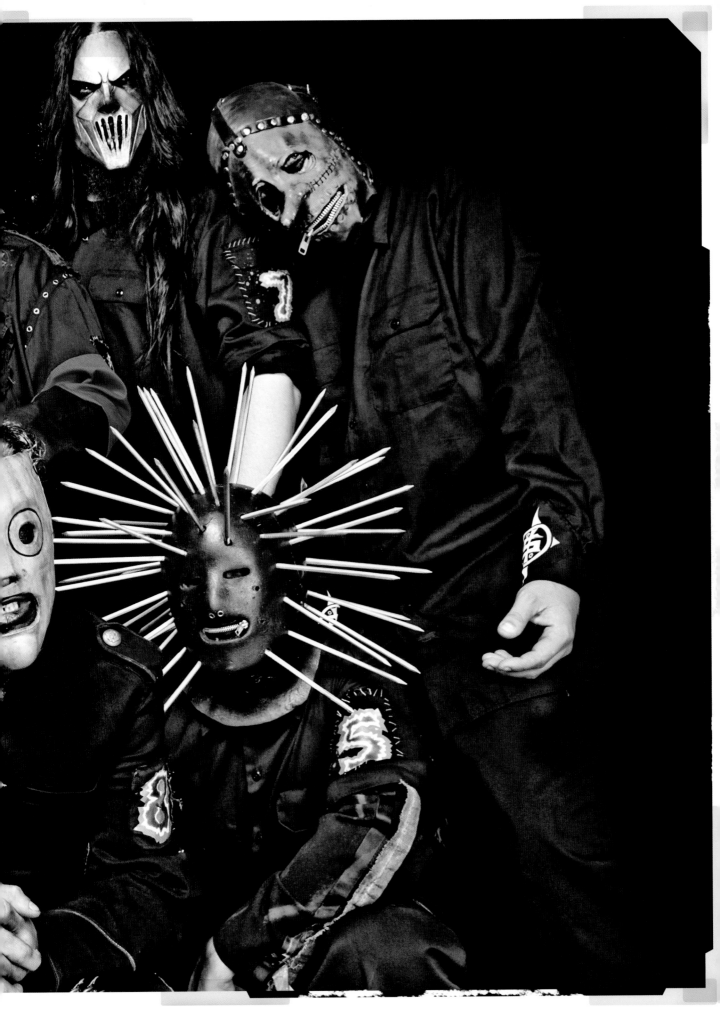

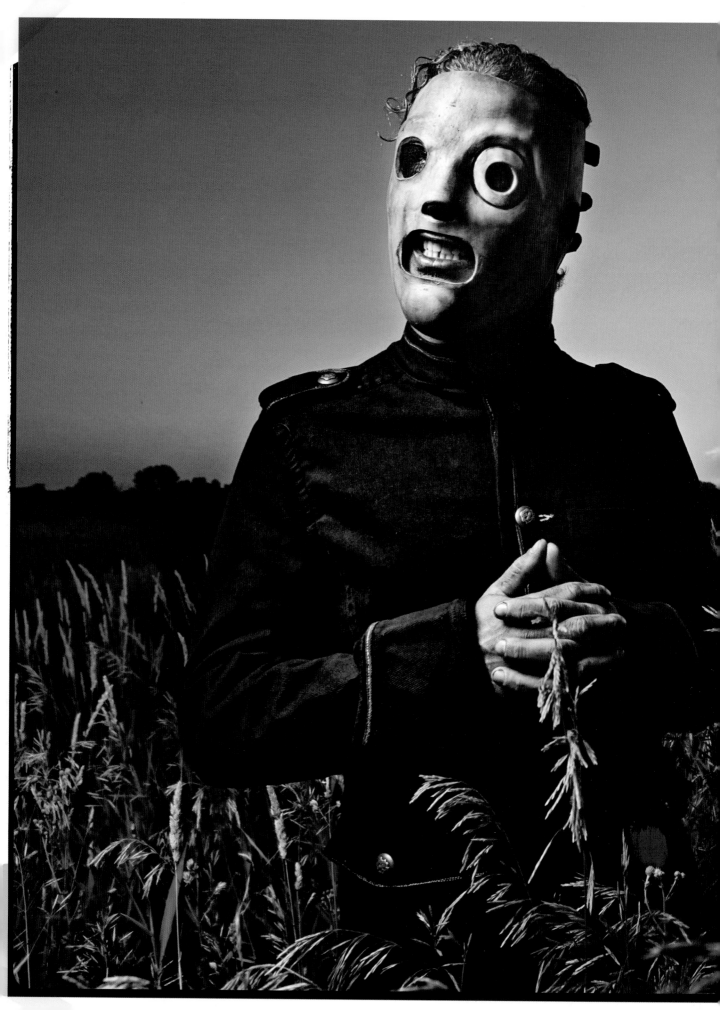

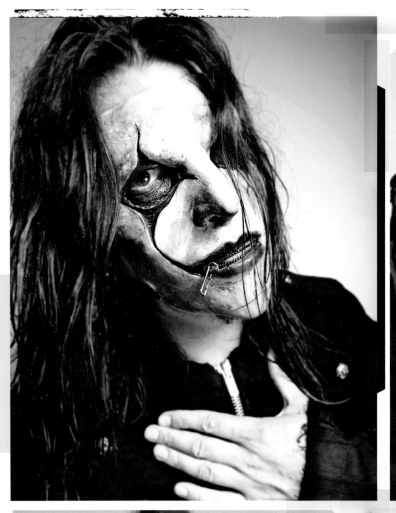
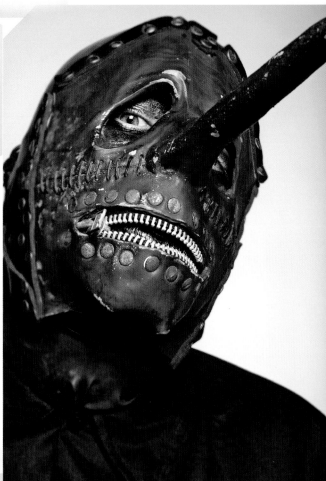
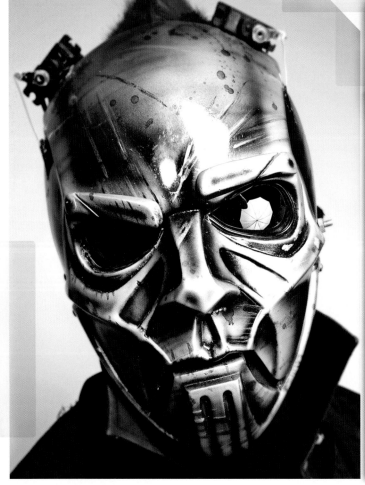
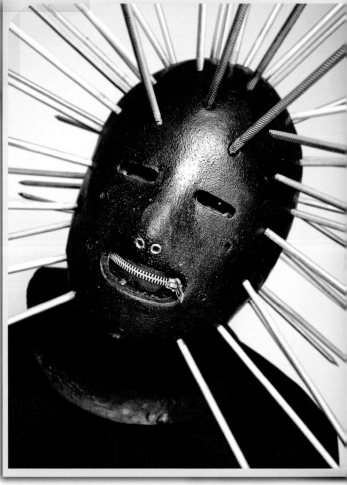

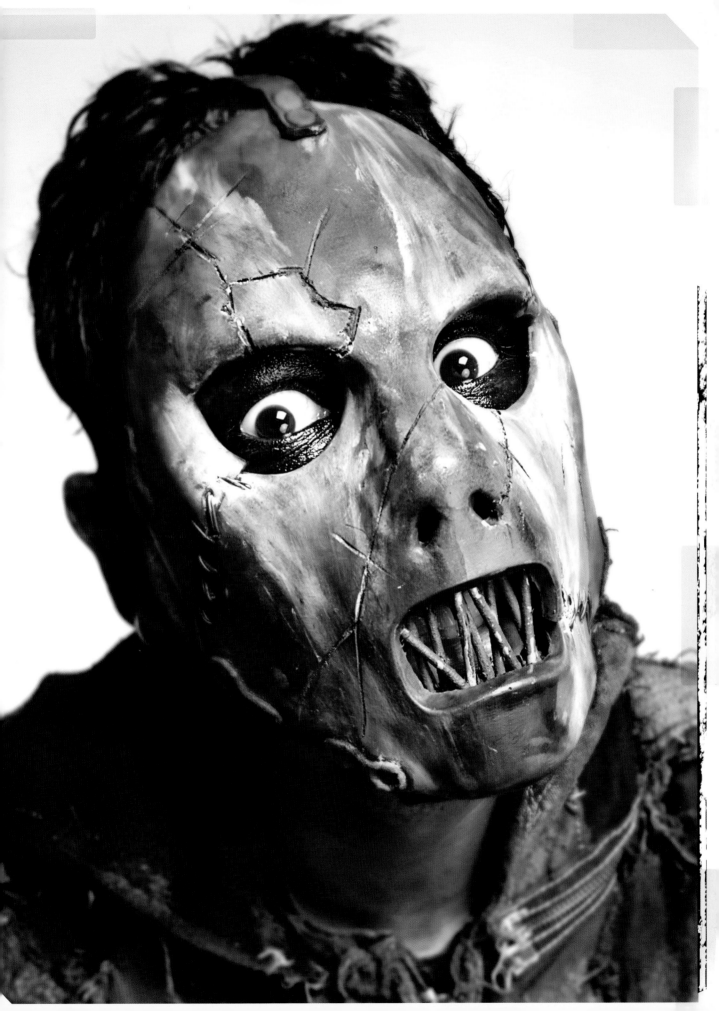

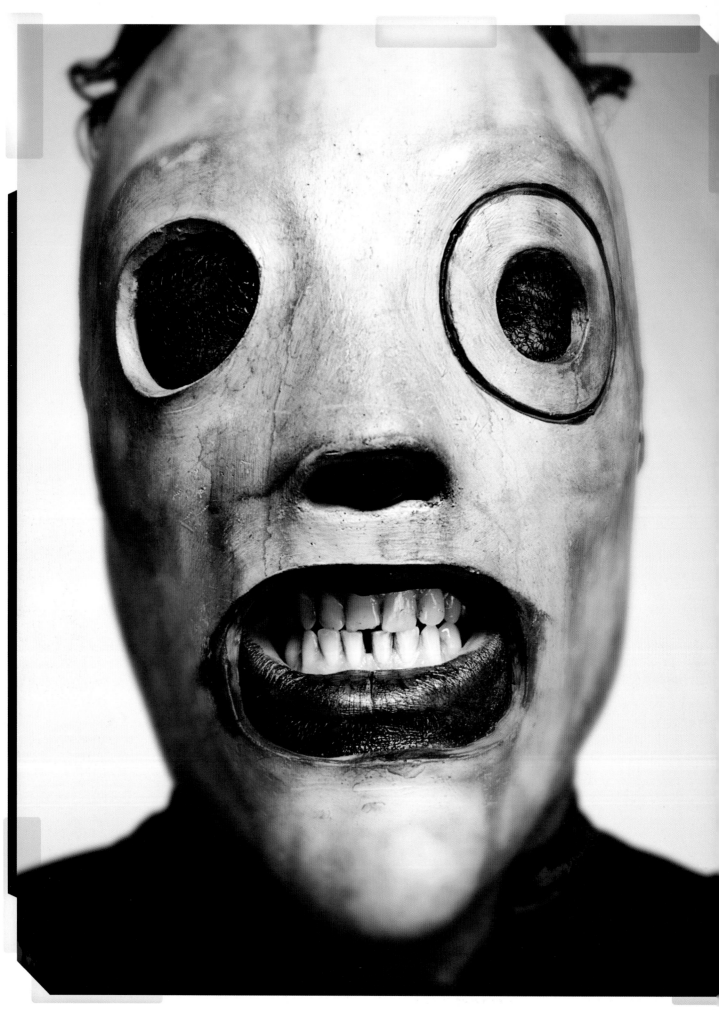

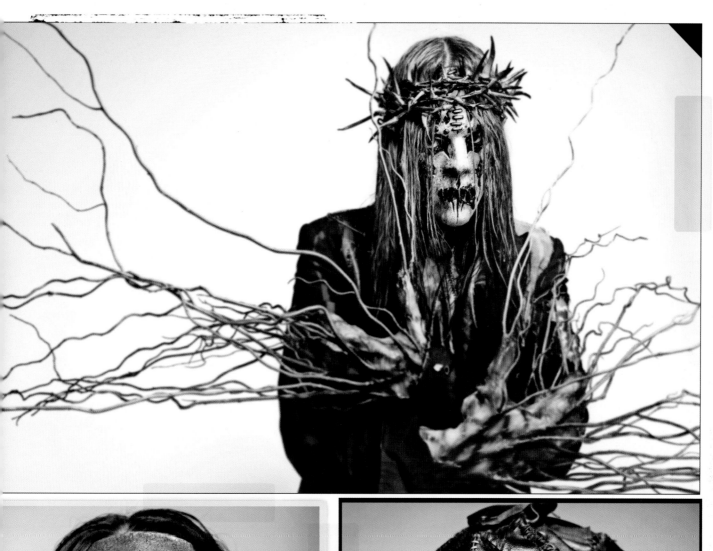

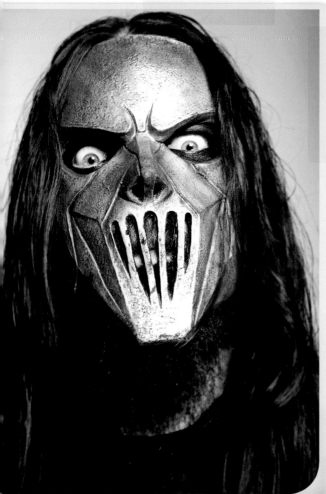

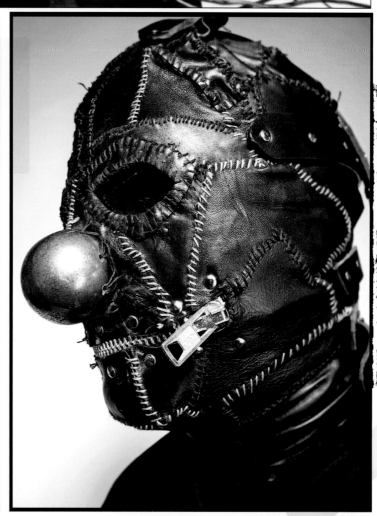

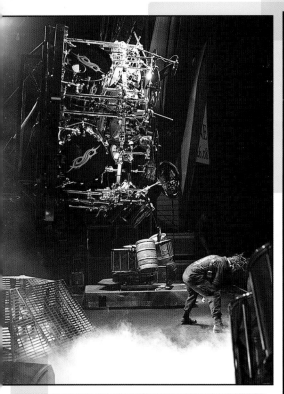

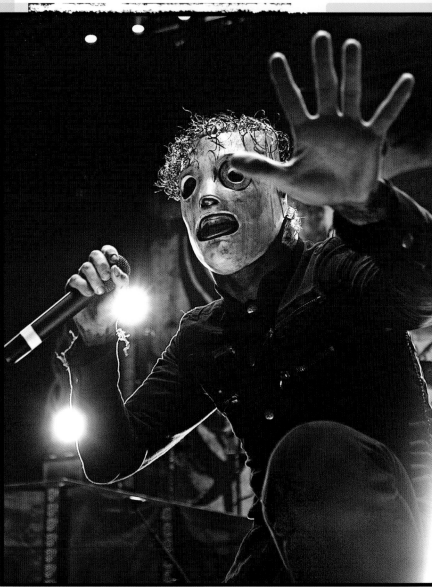

MAYHEM FESTIVAL

ALBUQUERQUE, NEW MEXICO, USA, 2008

SLIPKNOT STARTED TOURING *All Hope Is Gone* by headlining the Mayhem Festival in the USA. I joined them in Albuquerque, New Mexico. My taxi driver seemed confused as to why an Englishman would visit Albuquerque. He then went into great detail about how he only ended up there himself because he got a girl pregnant.

We discovered Sid was in a wheelchair. Being the crazy acrobat that he is, a misjudged jump earlier on the tour had left him with broken heels. I had never heard of such an injury before and he explained he had landed so badly his heels broke like eggshells (this actually made me feel sick).

But the show must go on and Sid performed in and out of the wheelchair.

Corey's new mask looked really good up on stage; the mismatch of his powerful vocals and the dead expressionless eyes made him disturbing yet compelling to watch.

Clown was also on good form. At one point he left the stage to go into the audience, then he found a seat and just sat down to watch the show for a bit.

After Albuquerque we followed on to Colorado to do it all again.

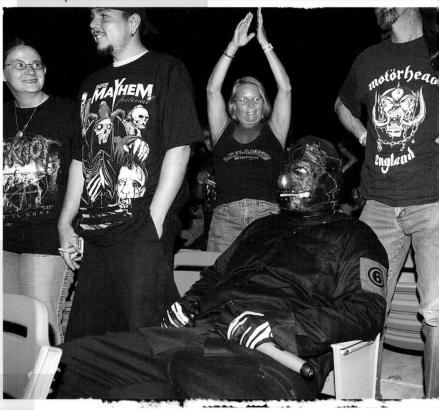

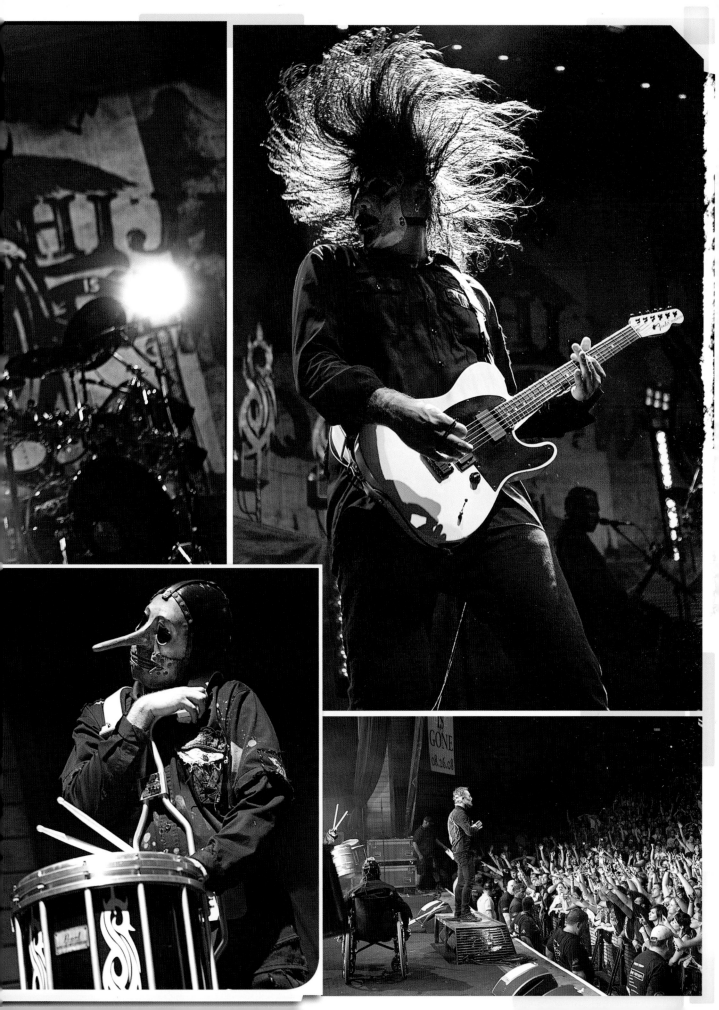

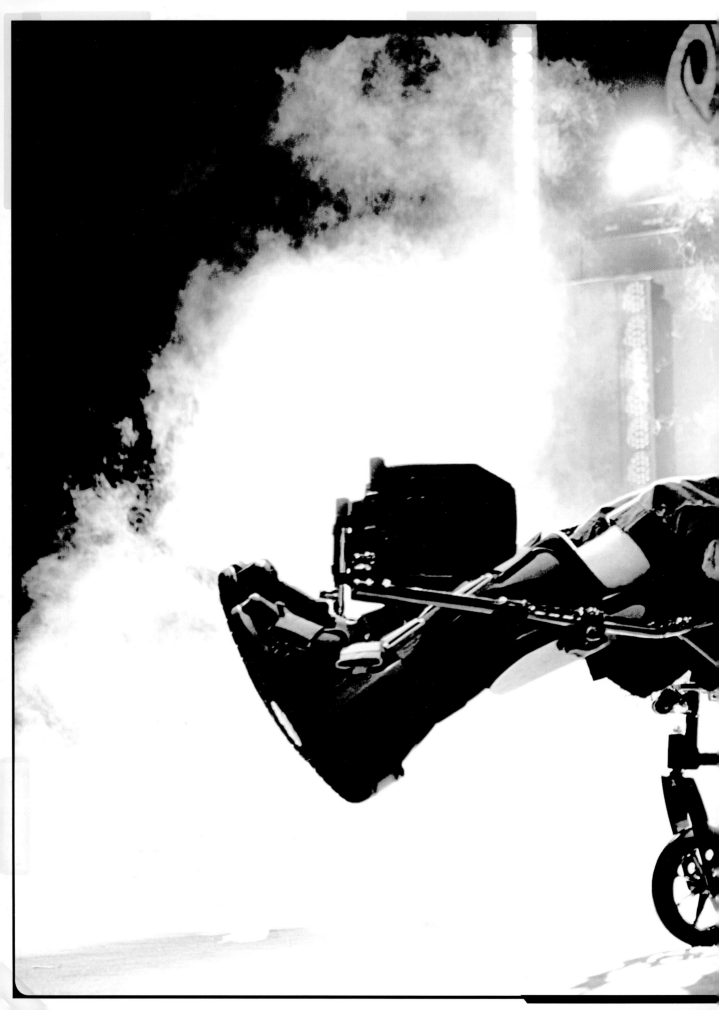

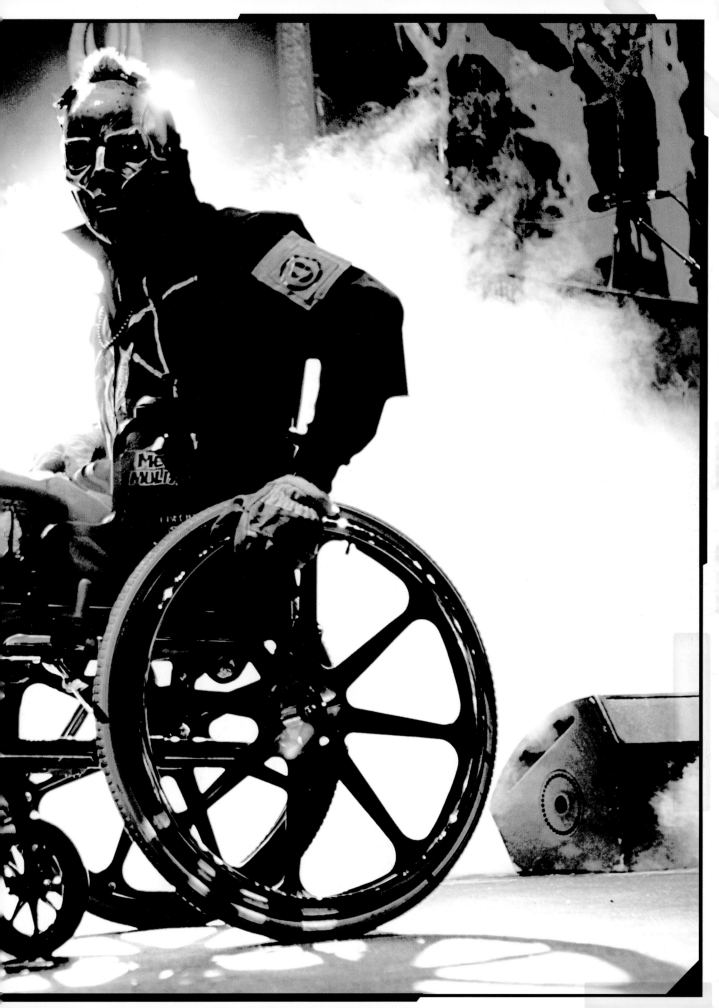

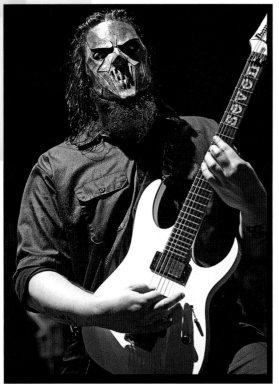
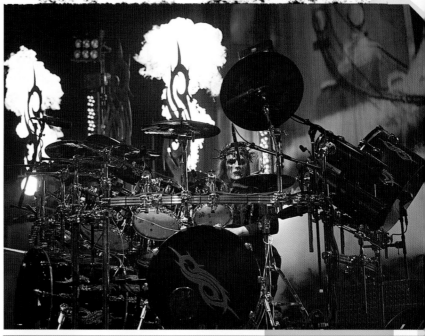
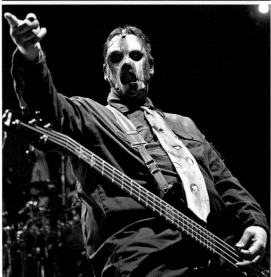
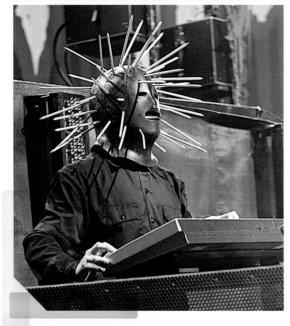
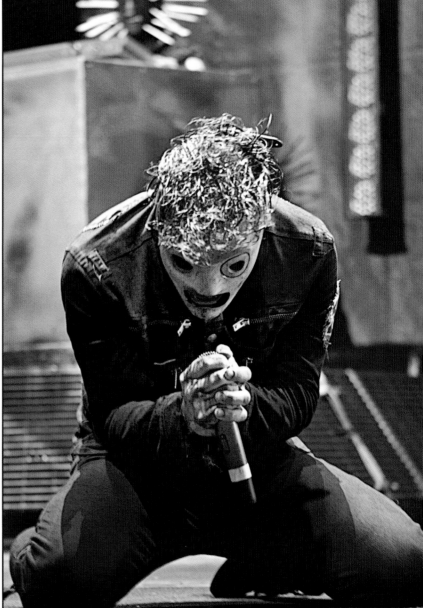

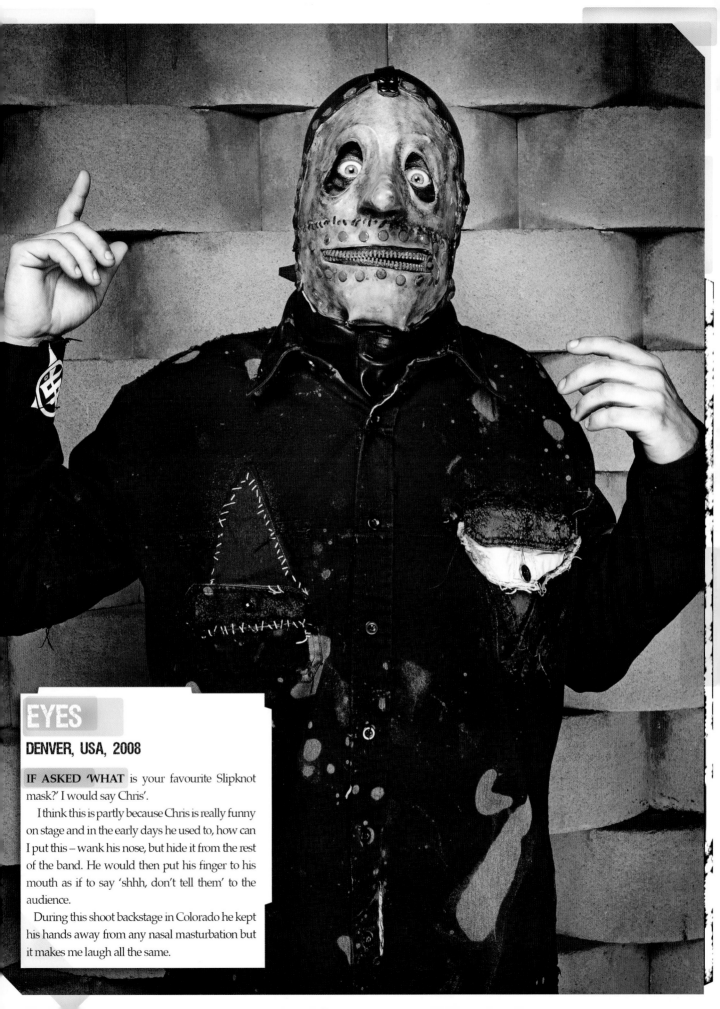

EYES

DENVER, USA, 2008

IF ASKED 'WHAT is your favourite Slipknot mask?' I would say Chris'.

I think this is partly because Chris is really funny on stage and in the early days he used to, how can I put this – wank his nose, but hide it from the rest of the band. He would then put his finger to his mouth as if to say 'shhh, don't tell them' to the audience.

During this shoot backstage in Colorado he kept his hands away from any nasal masturbation but it makes me laugh all the same.

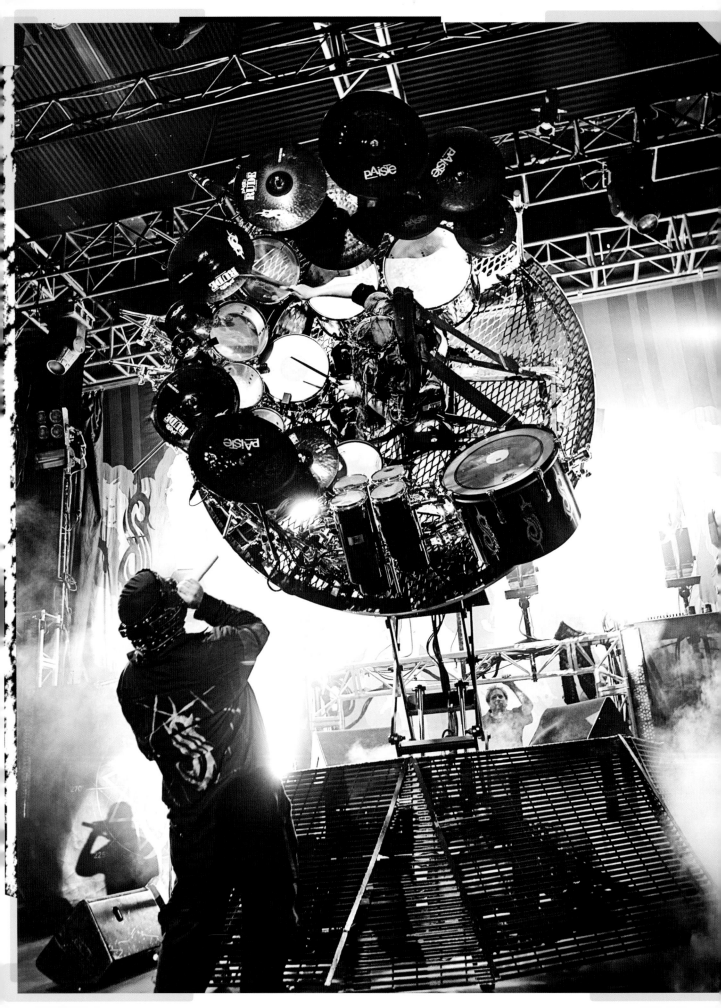

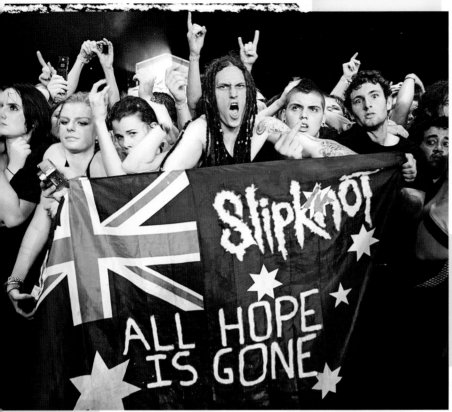
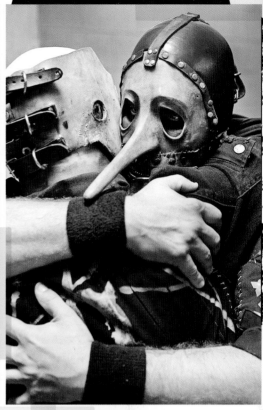
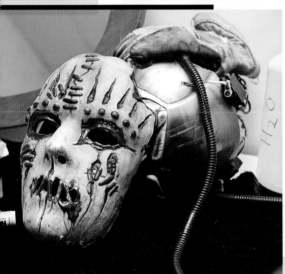
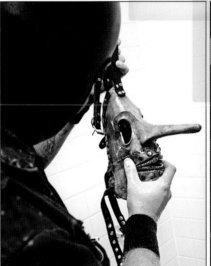
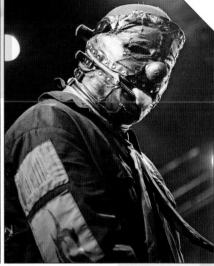

AUSTRALIA

BRISBANE AND SYDNEY, OCTOBER 2008

I THINK I must have travelled abroad with Slipknot more than I have with my own family but in the autumn of 2008 I was offered the chance to visit Brisbane and Sydney in Australia with them. It is pretty rare that trips this far afield come along, so I didn't hesitate in accepting.

My only worry was that I had no idea what *Kerrang!* were expecting from this; I really couldn't imagine that the nine masked men would want to be photographed with koala bears or kangaroos.

I needn't have worried as they gave me fantastic access to the shows and backstage. Shooting Joey from behind his kit was a real privilege; watching him work at close quarters is really a sight to behold, and my photographs of this are especially popular with other drummers.

At every gig the guys go through a ritual of individually wishing each other luck with a fist bump or hug before they all come together in a huddle. Corey will shout a few words usually ending with "Fuck Brisbane" or whatever city they may be in. One ritual shot I took in Sydney became especially meaningful when we learned of the death of Paul Gray less than two years later – Corey and Paul in a pre-gig hug really shows how much these guys mean to each other.

Mick Thomson had recently taken up photography so we ended up in a camera geek conversation during a post-gig drinking session. I finally got back to my hotel as the sun was coming up, which happened to be the day I was flying home – Sydney to London with a raging hangover is no fun at all.

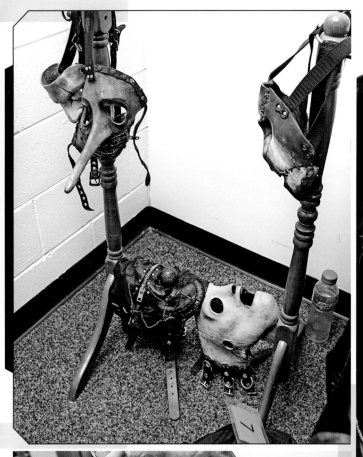
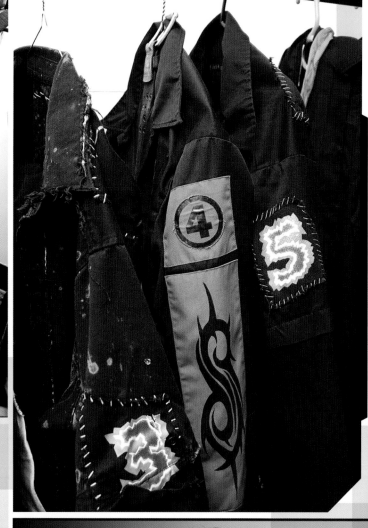

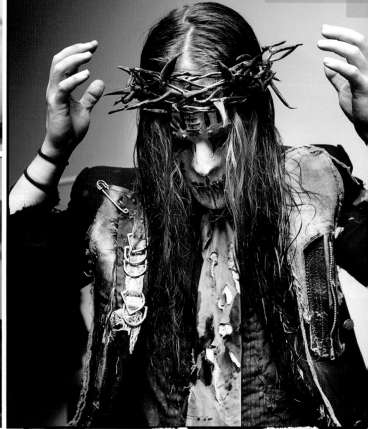

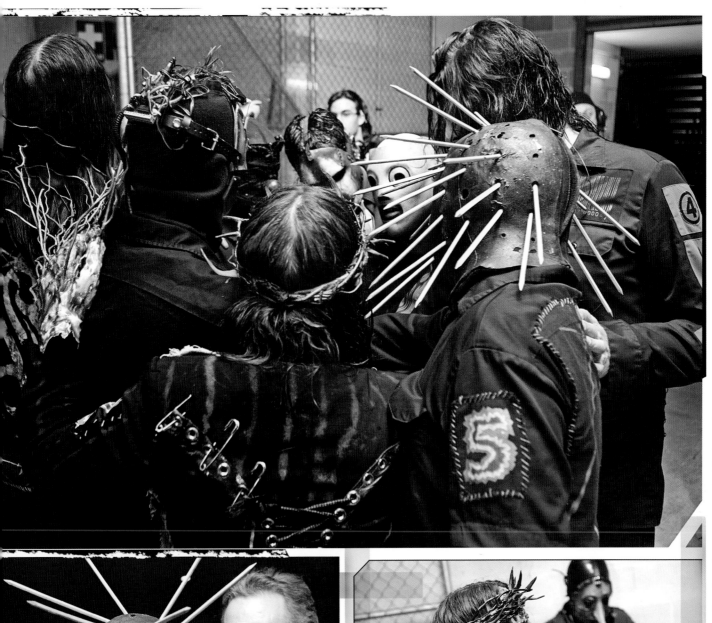
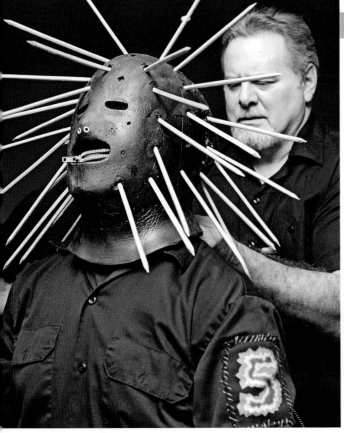
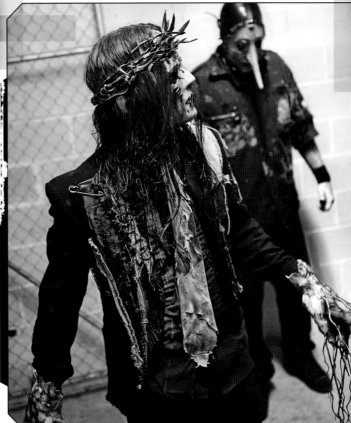

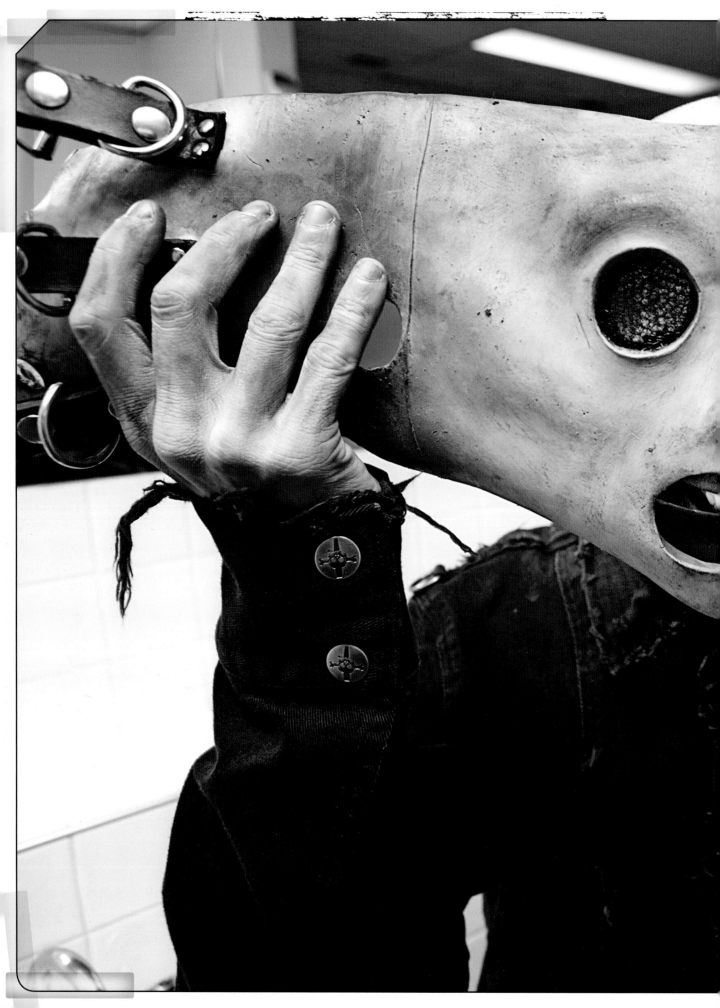

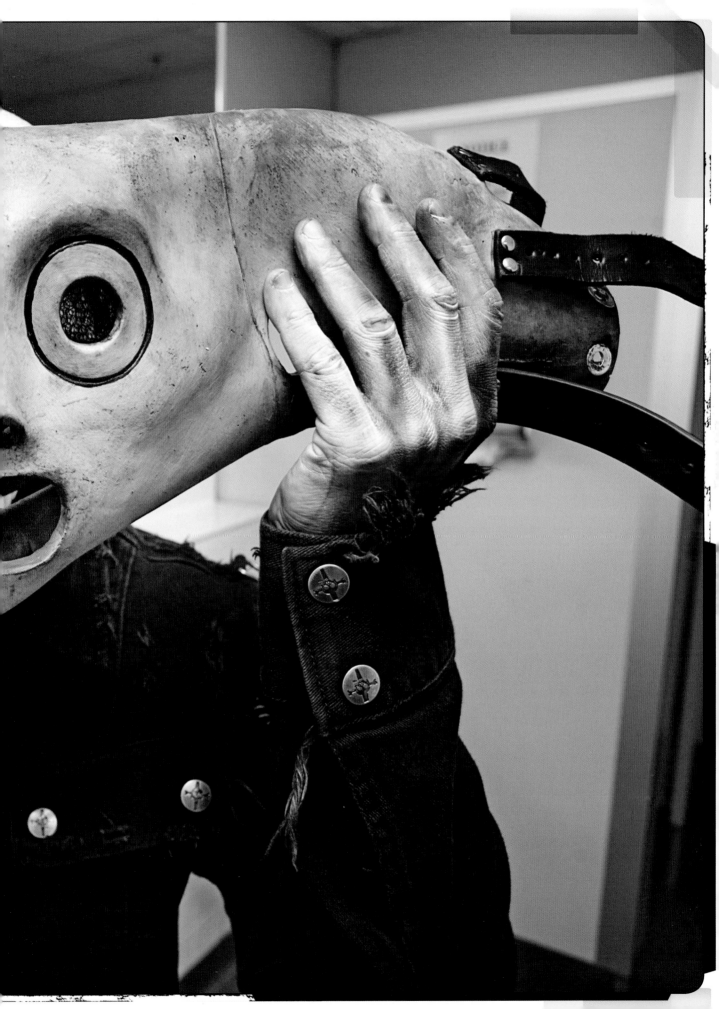

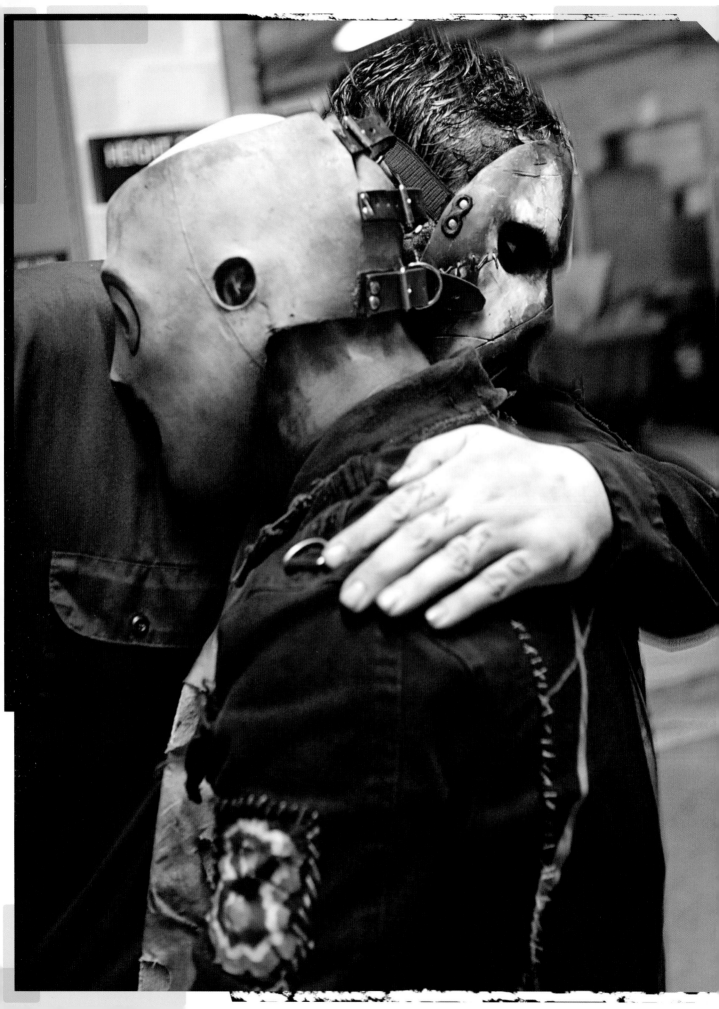

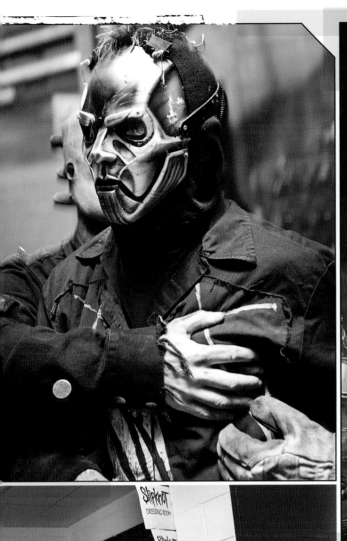
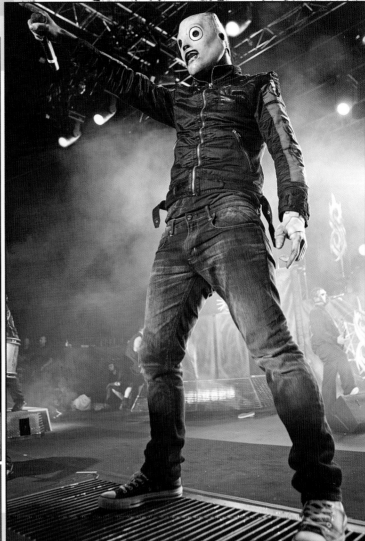
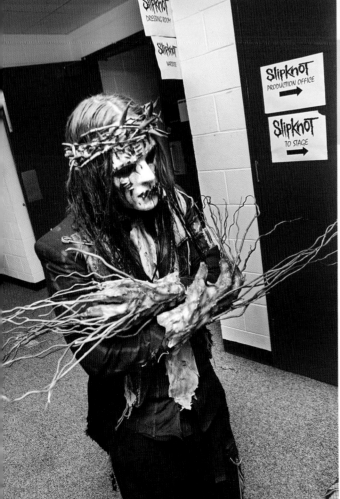
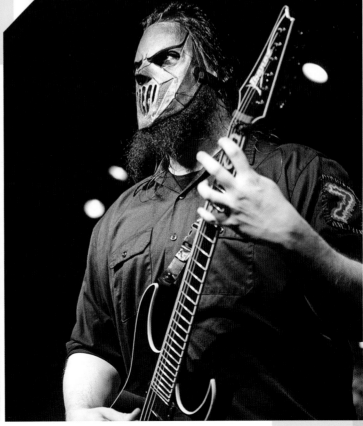

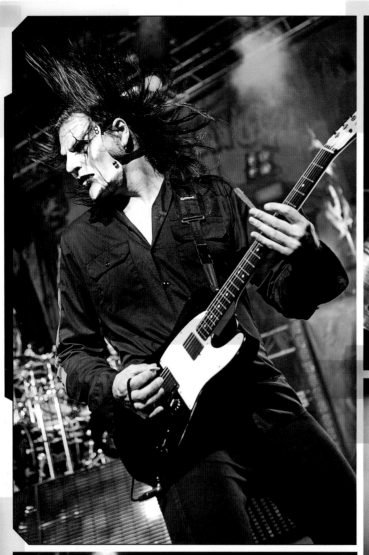
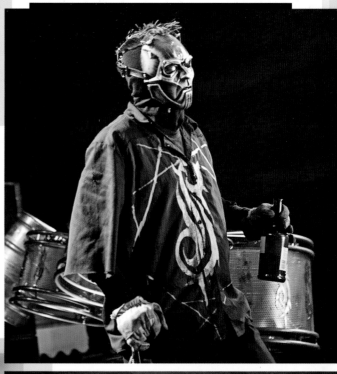
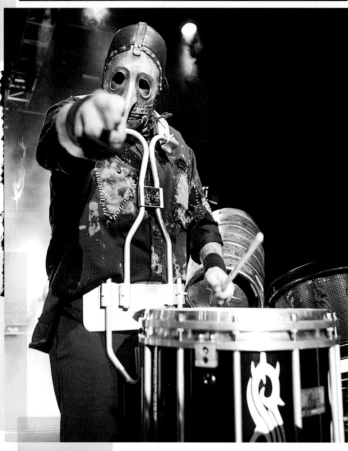
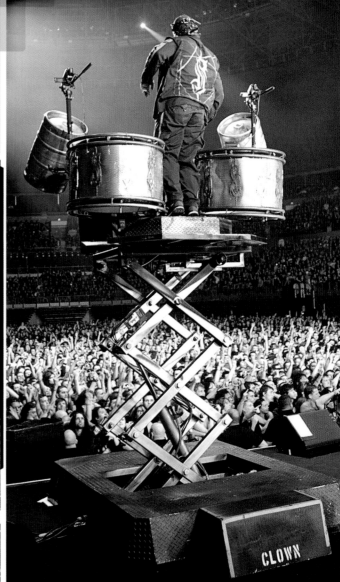

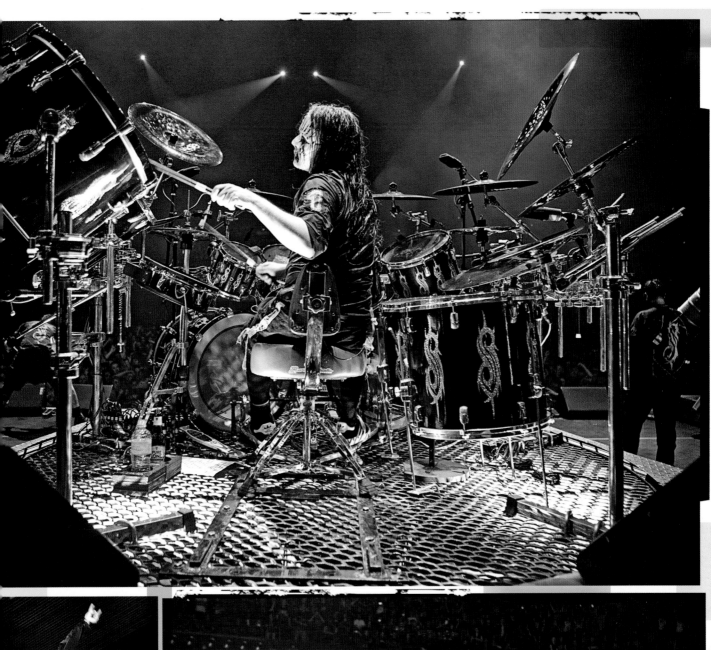

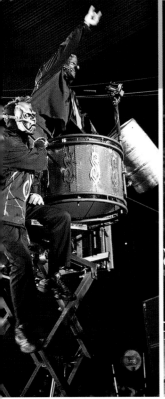

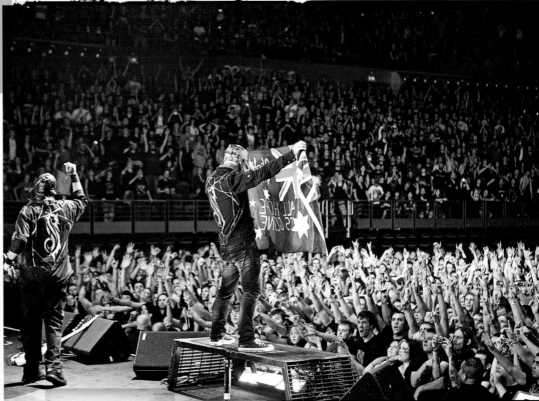

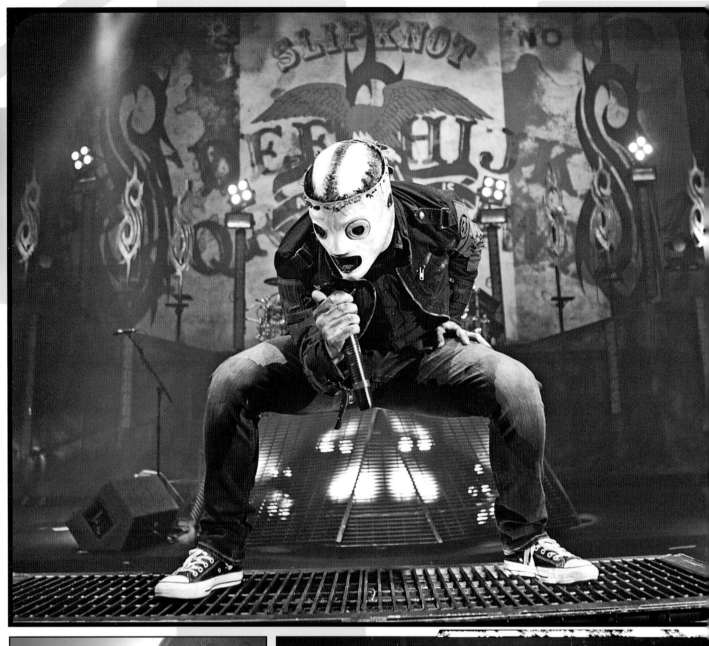

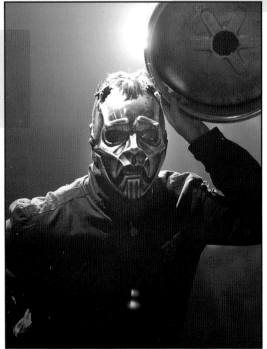

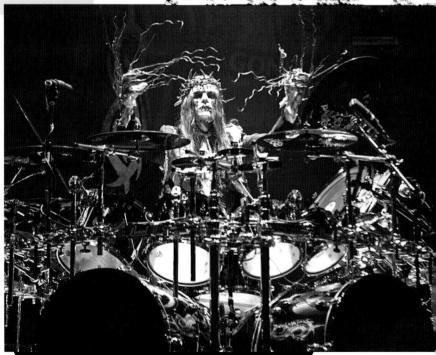

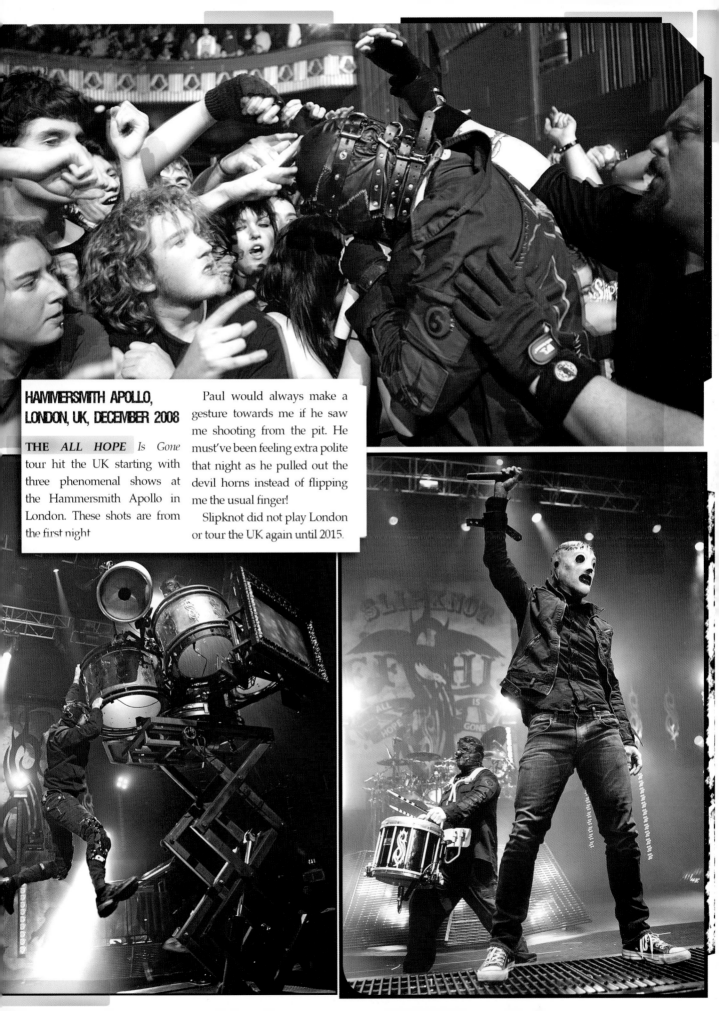

HAMMERSMITH APOLLO, LONDON, UK, DECEMBER 2008

THE *ALL HOPE* Is *Gone* tour hit the UK starting with three phenomenal shows at the Hammersmith Apollo in London. These shots are from the first night

Paul would always make a gesture towards me if he saw me shooting from the pit. He must've been feeling extra polite that night as he pulled out the devil horns instead of flipping me the usual finger!

Slipknot did not play London or tour the UK again until 2015.

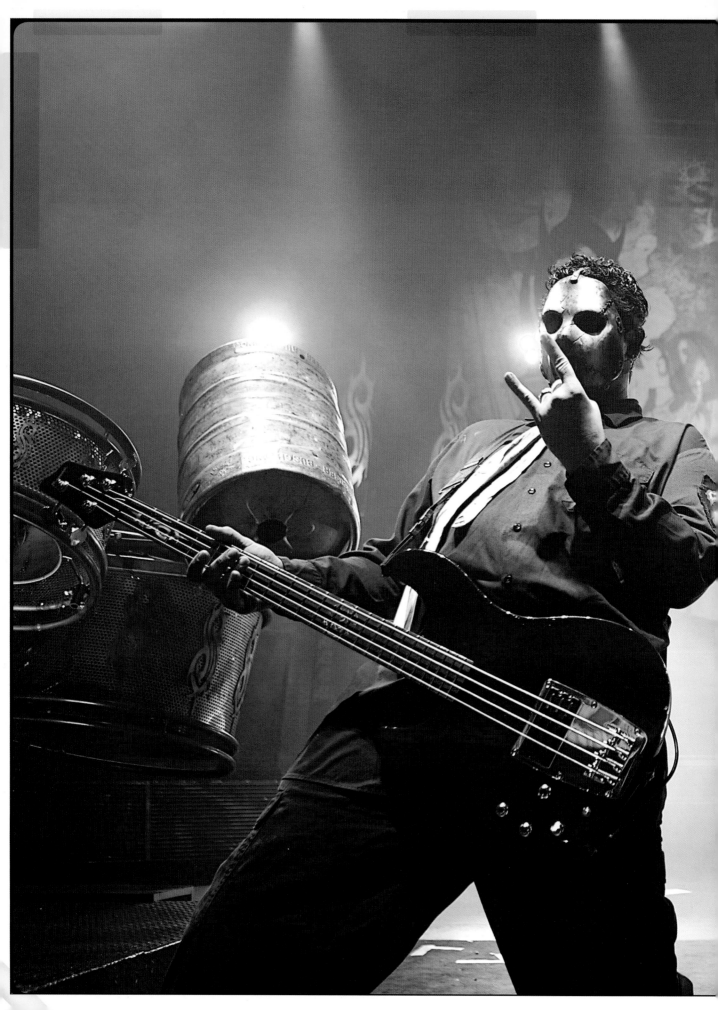

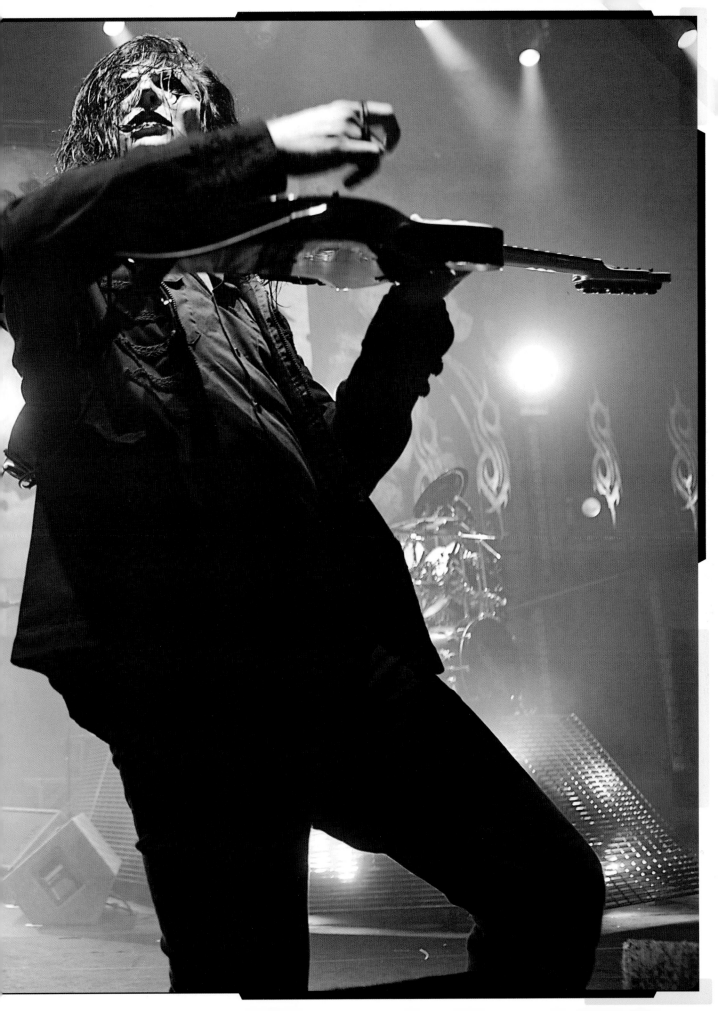

CIRQUE DE SLIPKNOT

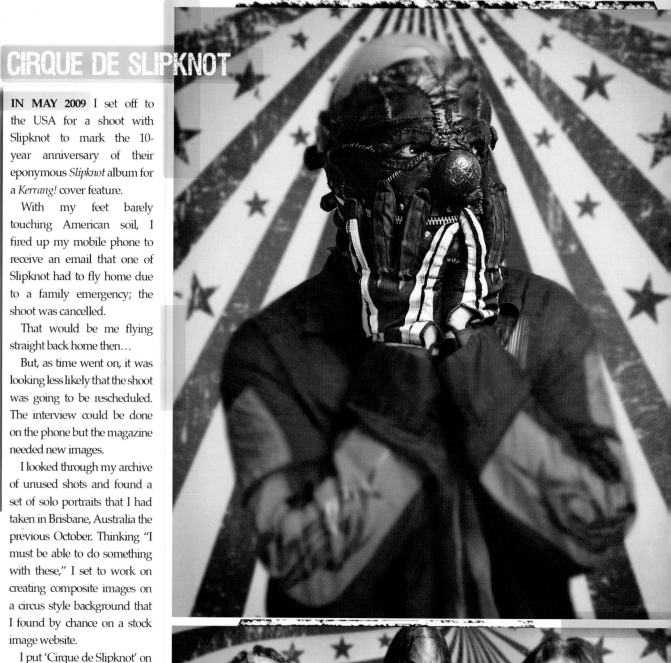

IN MAY 2009 I set off to the USA for a shoot with Slipknot to mark the 10-year anniversary of their eponymous *Slipknot* album for a *Kerrang!* cover feature.

With my feet barely touching American soil, I fired up my mobile phone to receive an email that one of Slipknot had to fly home due to a family emergency; the shoot was cancelled.

That would be me flying straight back home then…

But, as time went on, it was looking less likely that the shoot was going to be rescheduled. The interview could be done on the phone but the magazine needed new images.

I looked through my archive of unused shots and found a set of solo portraits that I had taken in Brisbane, Australia the previous October. Thinking "I must be able to do something with these," I set to work on creating composite images on a circus style background that I found by chance on a stock image website.

I put 'Cirque de Slipknot' on the main image to make former *Kerrang!* editor Paul Brannigan laugh. We are big fans of the *Knowing Me Knowing You with Alan Partridge* TV episode with 'Cirque De Clunes'.

The circus concept worked really well for the cover feature and after many long hours manipulating the images (although not as many spent on the wasted flight to America and back) it was great I was able to save the day.

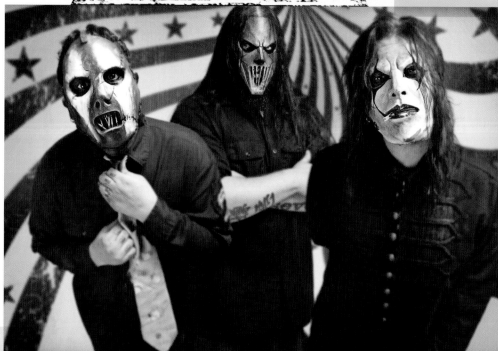

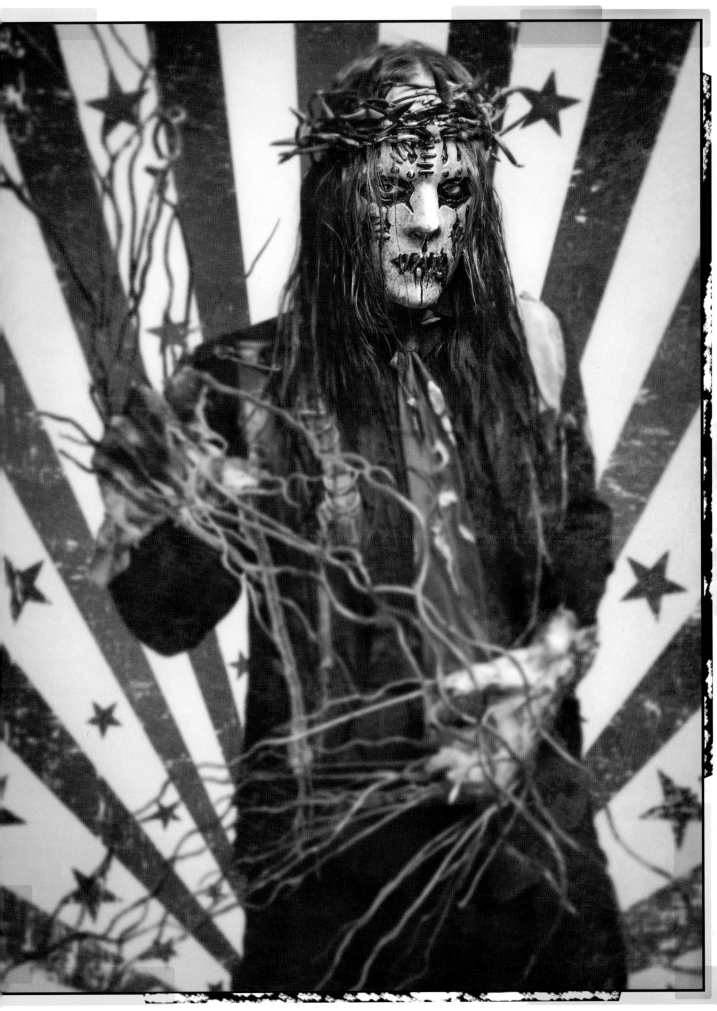

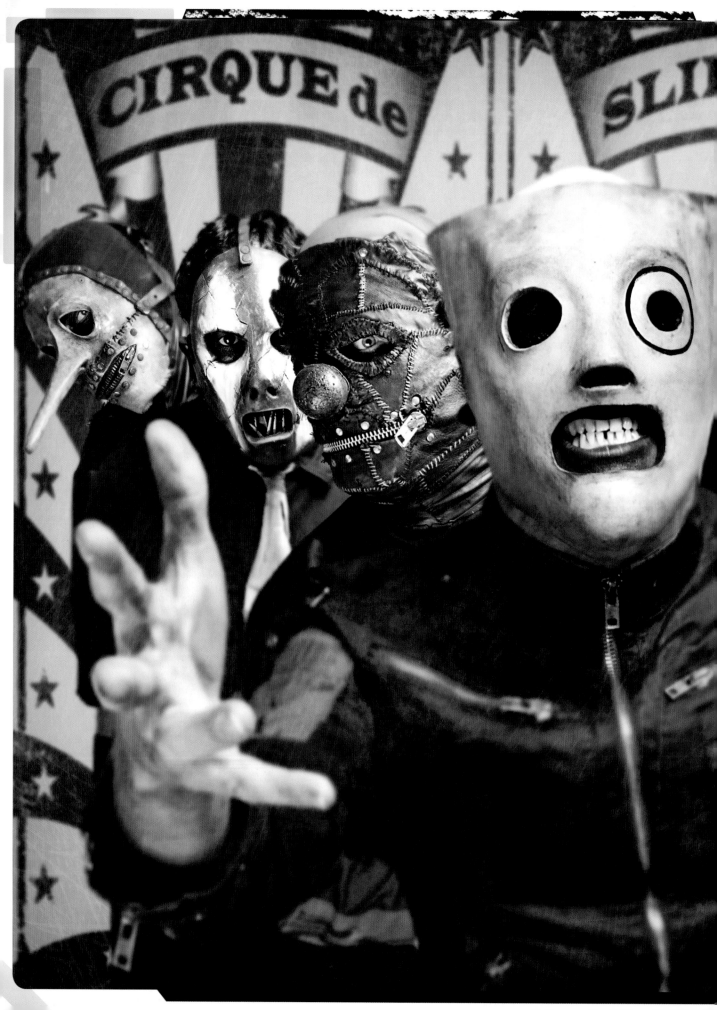

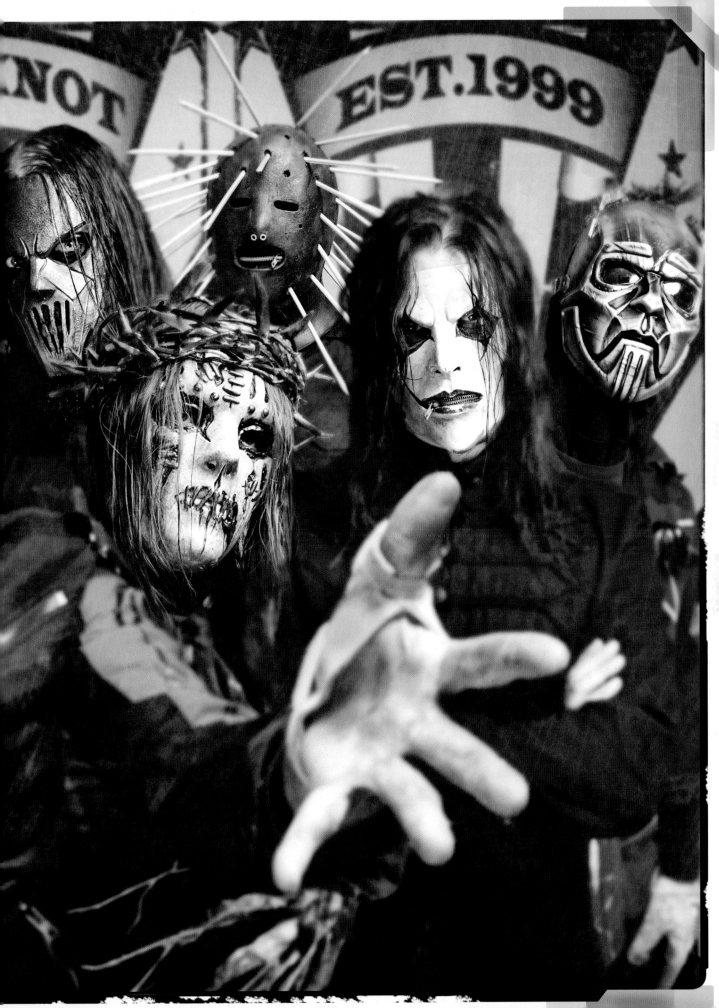

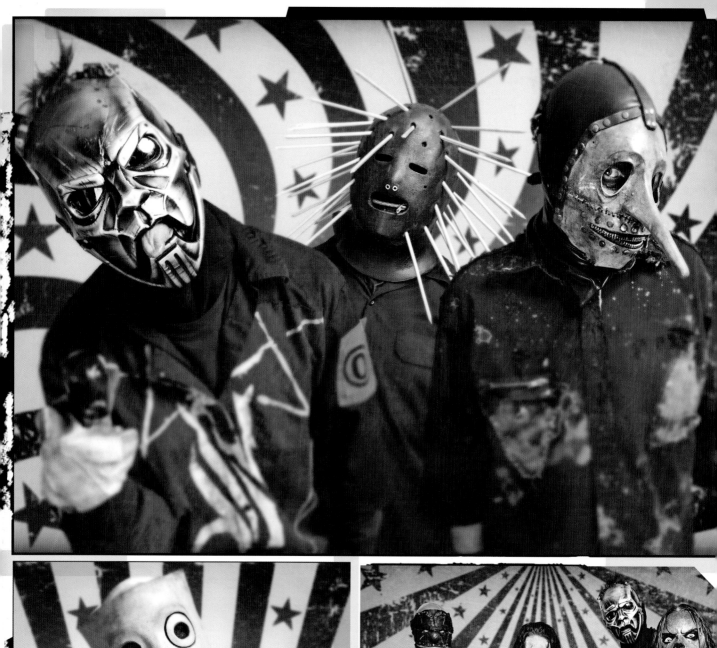
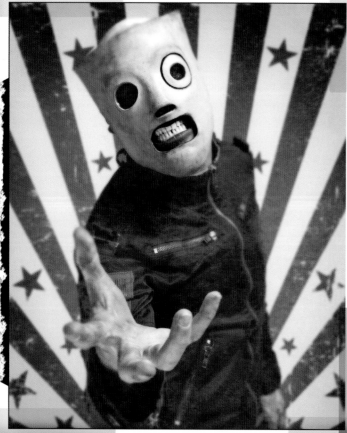
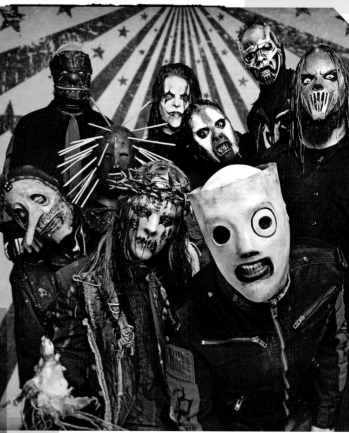

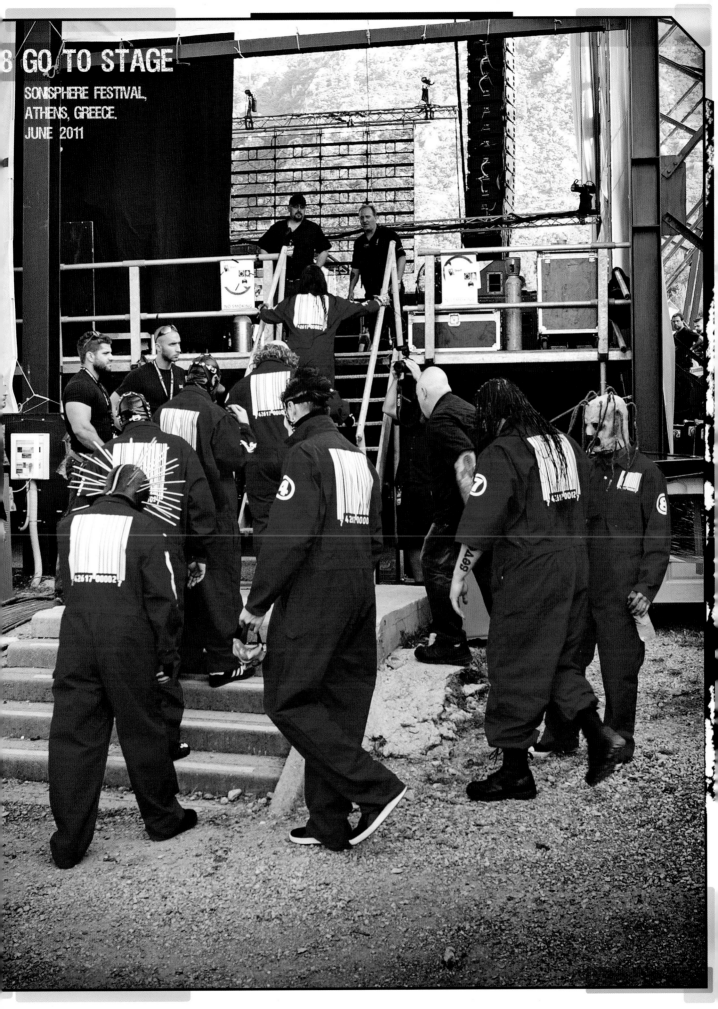

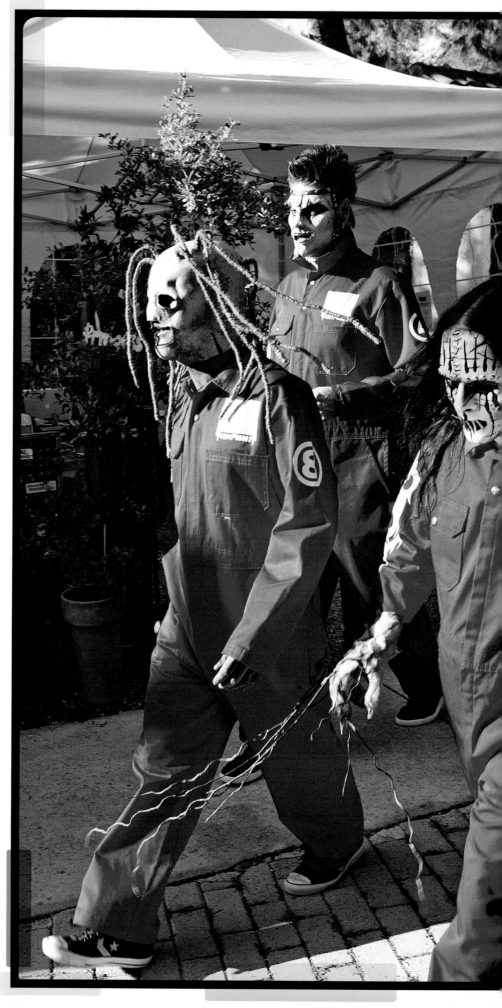

SLIPKNOT WERE IN a park just outside of Athens and were scheduled to play as part of the Greek leg of the Sonisphere Festival. Of the hundreds of gigs the group had performed, this one was different: it was the first since the death of bassist Paul Gray the previous year.

Like everyone who took any kind of interest in the band, I had wondered if Gray's passing – who along with Joey Jordison (now himself a former member) wrote much of the music – might signal the end of Slipknot. I remember shooting the band as they gathered behind the stage in the moments before their day's work began. I recall feeling uneasy and torn about shooting this very poignant moment as they prepared to go onstage. Of course, I was there to do a job but these guys that I had known for more than a decade were in obvious pain. I made the decision to shoot from a respectful distance; the image of eight red men mounting the stage speaks more than any words I could ever write.

But even in the face of such a tragedy, Slipknot were in some ways still their old irregular selves. Paul Gray's red overalls were hanging on the stage that day. At certain points during the set, Sid would sidle over to the garment and fondle the groin area, like some kind of pervert in mourning.

This was also the day that they stopped me from becoming an unwitting part of the show. I remember being on a platform in front of the stage next to what I didn't know was a new pyrotechnic, a flamethrower that shot jets of fire 20ft into the air. It was only the intervention of the Clown, steering me to safety, which prevented me from being burnt to a crisp in front of 25,000 people.

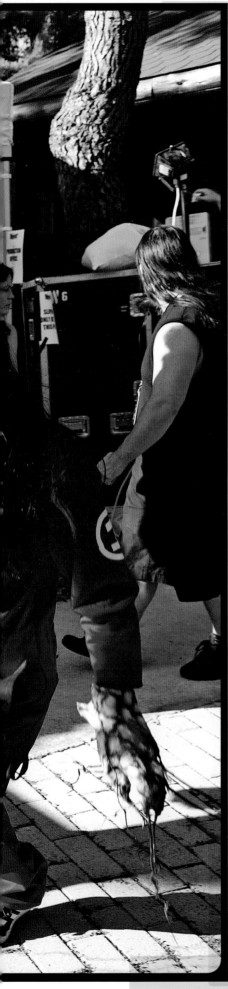
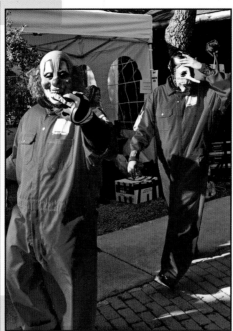
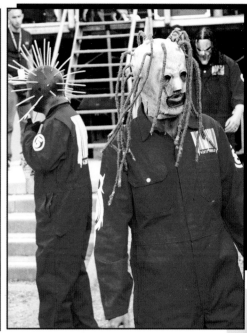
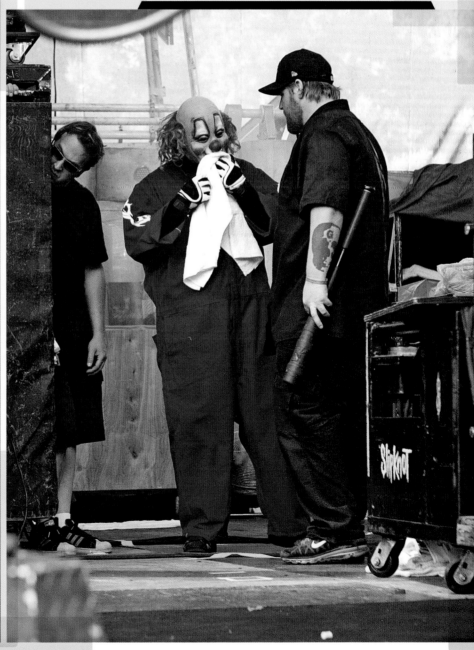

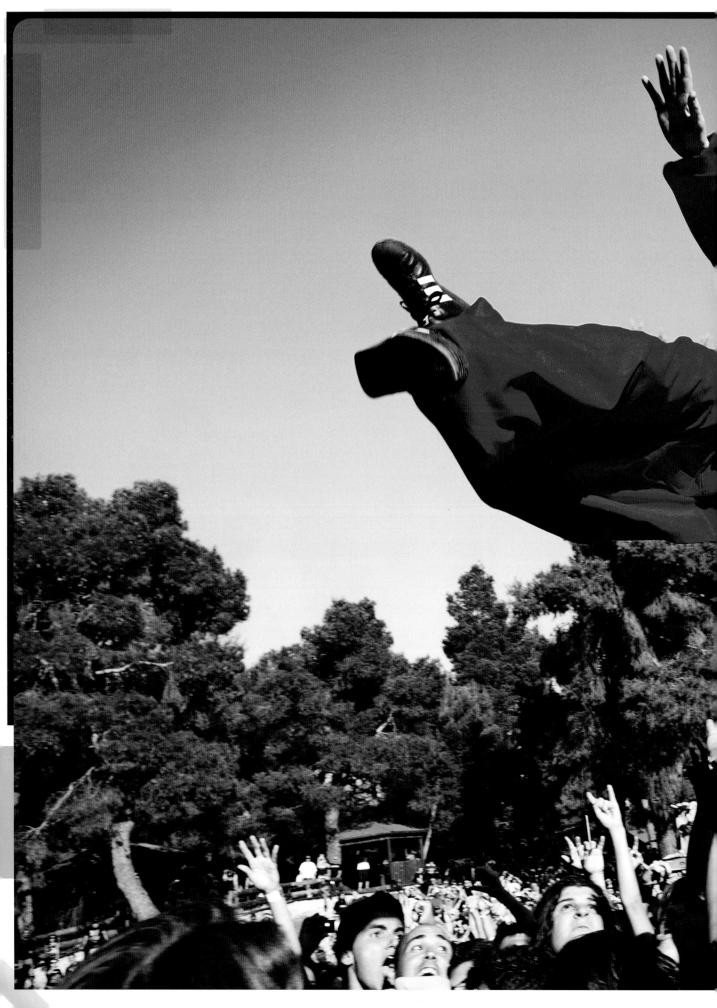

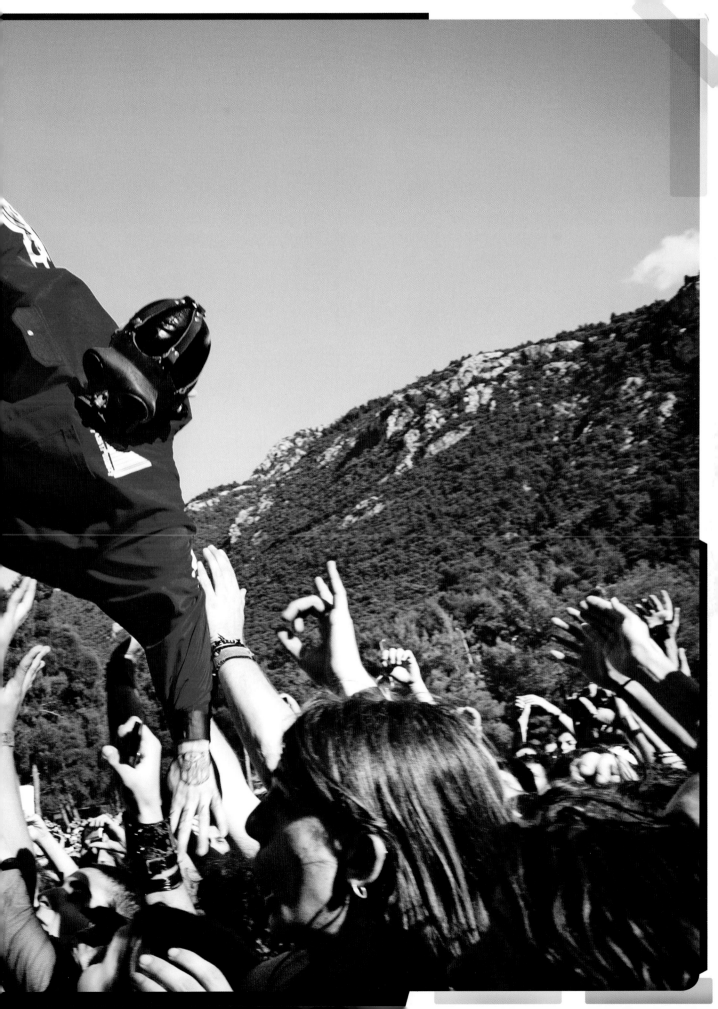

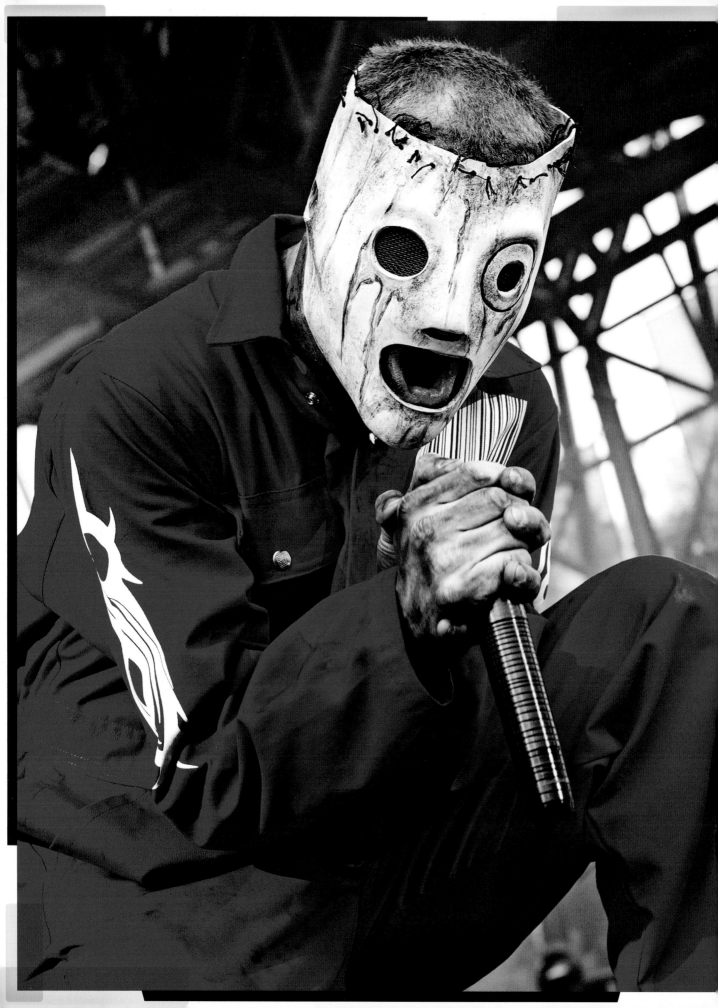

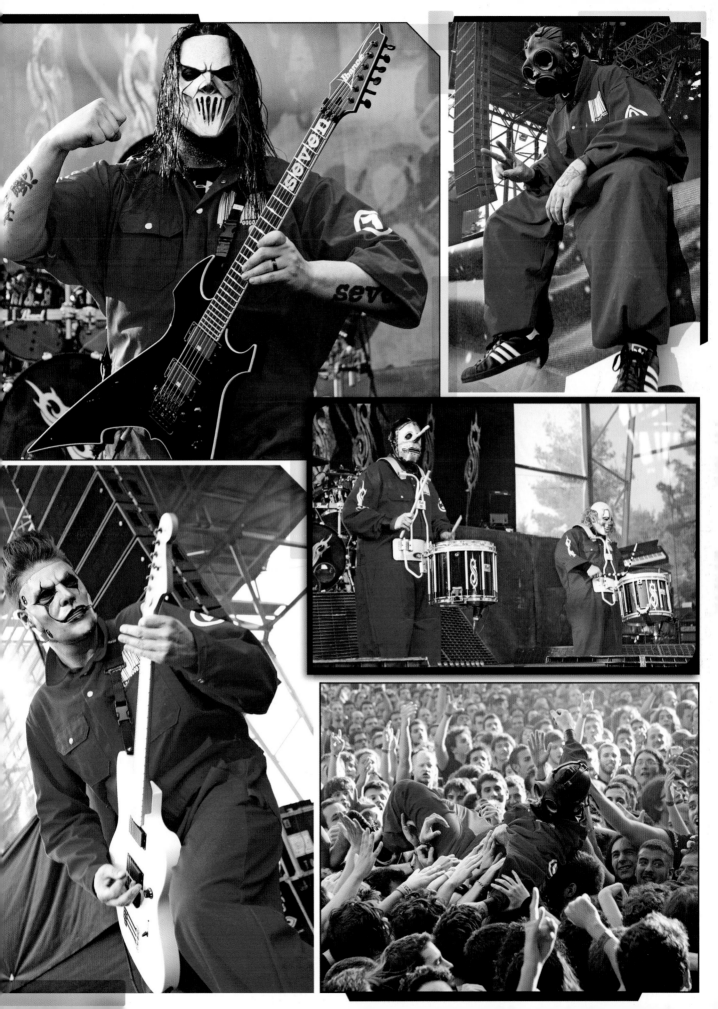

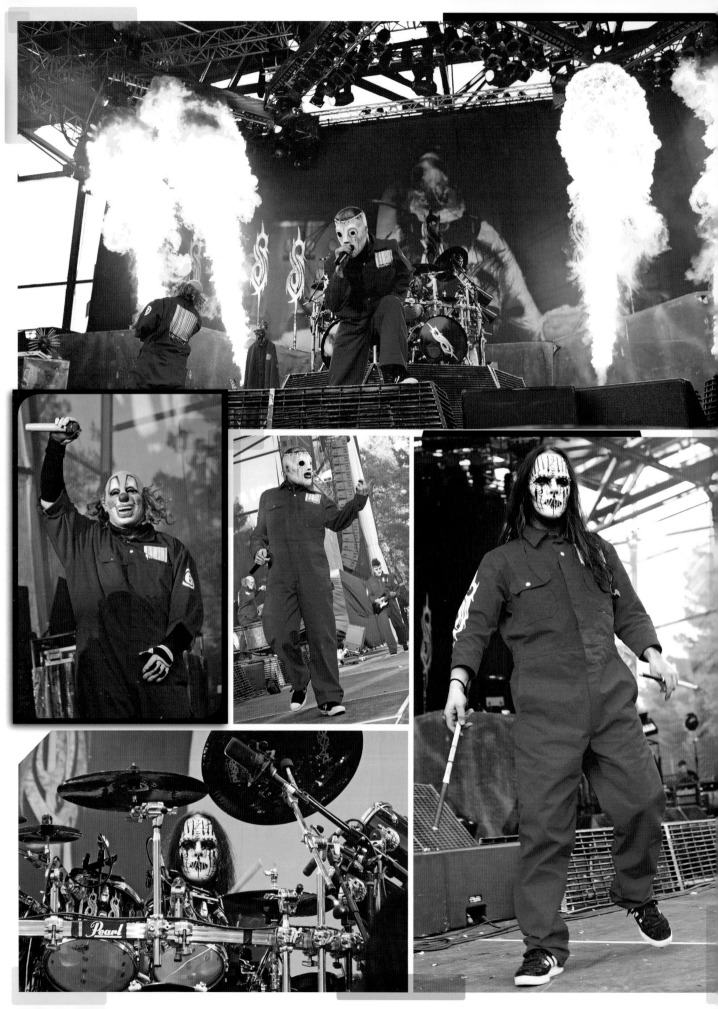

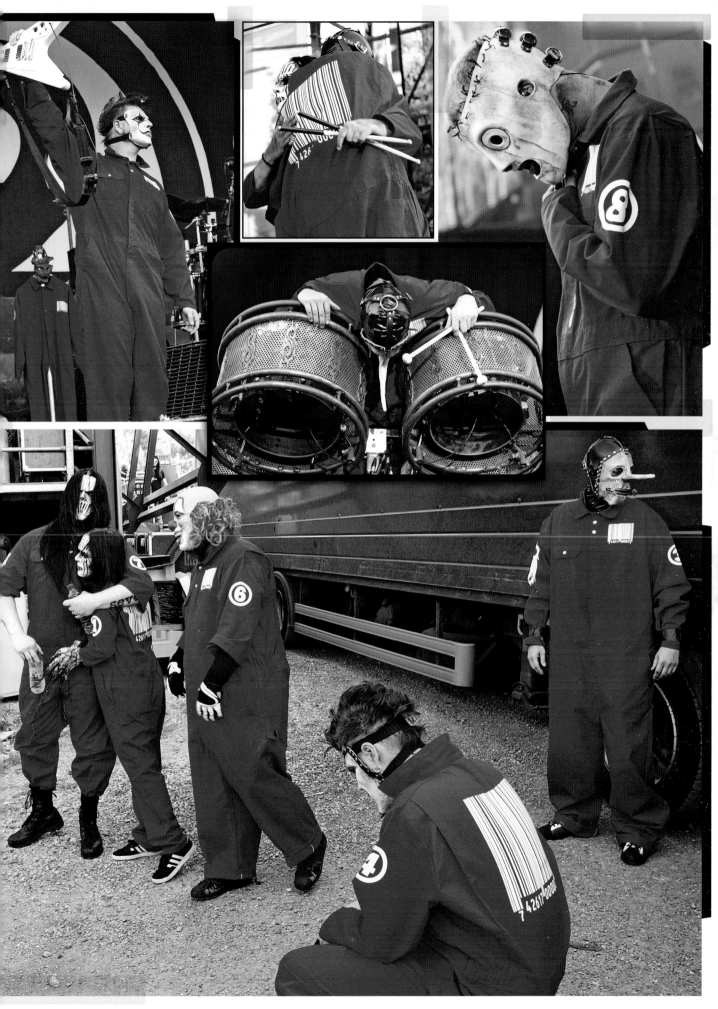

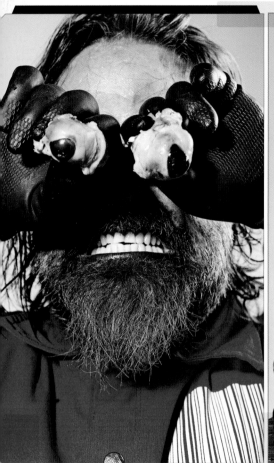

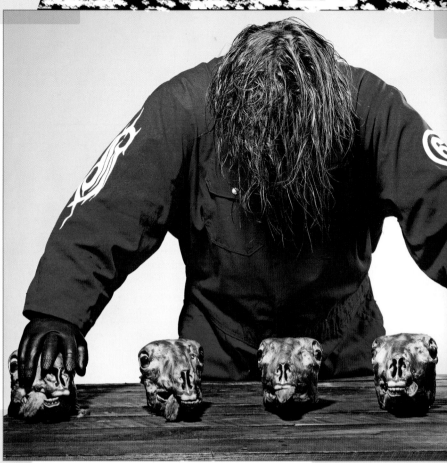

GOAT HEADS

LONDON, JULY 2011

TO MARK THE 10th anniversary of the *Iowa* album, *Kerrang!* magazine arranged for me to shoot Clown with some goat heads. I remember he seemed disappointed that the British goat is much smaller than its American cousin.

This turned out to be a very strange afternoon, with knives hammered into the skulls, and people on set randomly muttering "oh my God" as Clown came up with new and exciting ways to interact with the dead animals, including gouging out the eyes. Clown dared Michelle, their UK publicist, to do this. Michelle is made of pretty tough stuff and armed with a spoon she popped out those eyes in no time.

I should point out that the goat heads were from a butcher and not killed as part of a Satanic ritual for the purpose of this shoot, or anything like that.

Just ask Scarlet at *Kerrang!*, who went to Smithfield Meat Market at 5am to buy them. Thank you, Scarlet!

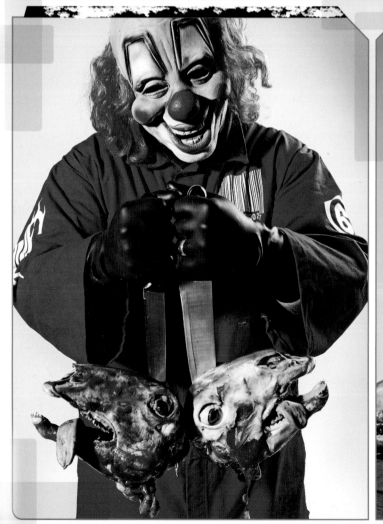

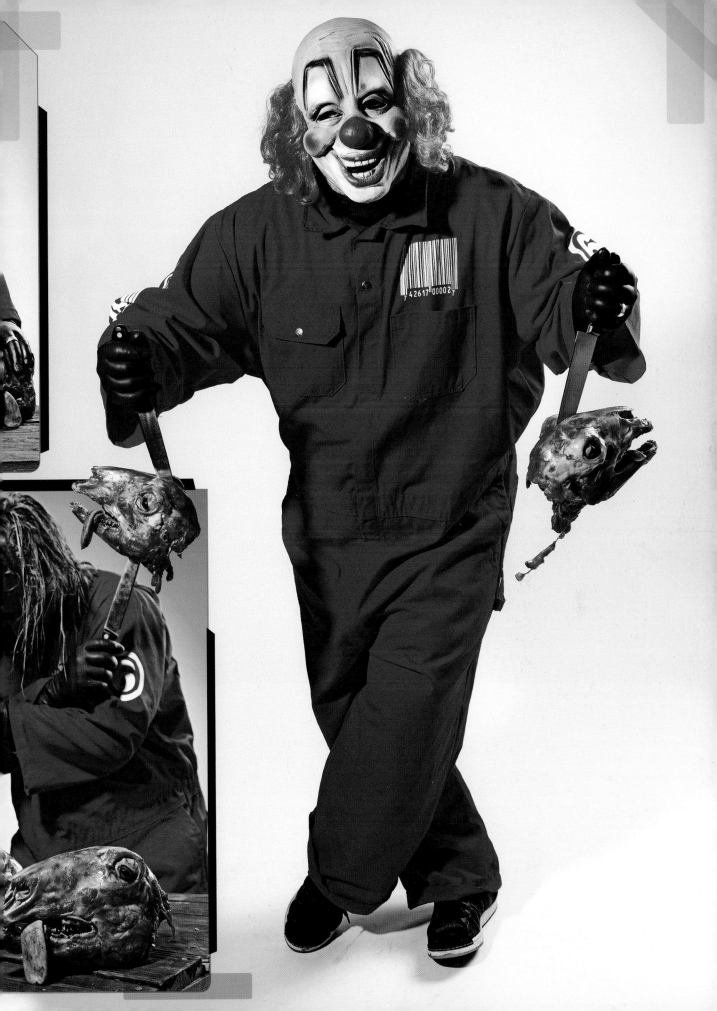

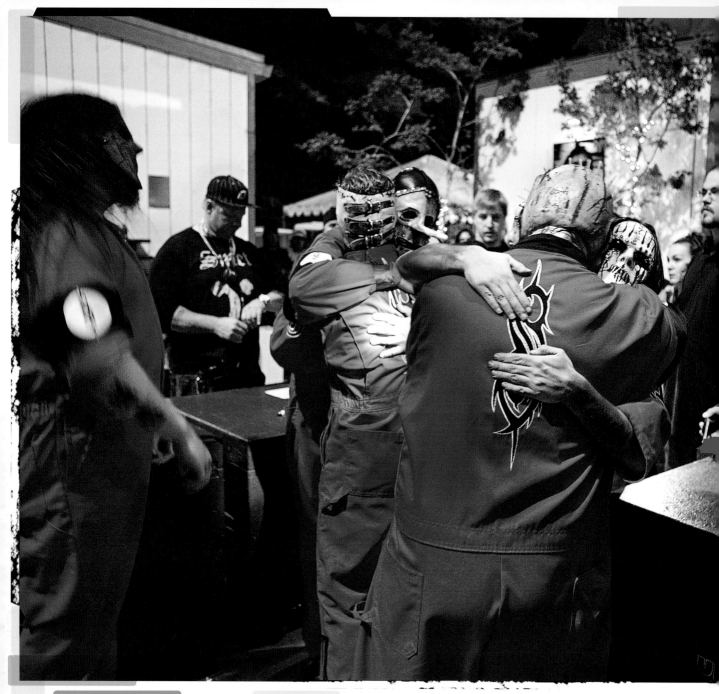

MAYHEM FESTIVAL 2012

SHORELINE AMPHITHEATRE, MOUNTAIN VIEW, CALIFORNIA. USA

I JOINED THE guys in the USA for a new shoot. This was a pretty big deal as this would be the first full band shoot without Paul. I was really flattered that they trusted me to do this. But as always with Slipknot the best laid plans tend to fly out the window! Jim was off sick with a burst appendix (turned out it was pretty serious and could have been life-threatening).

Although the band shoot was now off, I did get to take some dramatic solo portraits of the seven - Sid dangerously hanging upside down and a cover shot of Joey, Corey and Clown together.

Jim was not the only one with medical problems. Clown was suffering with fluid on his knee. When the onsite medic came to drain it off Clown insisted I capture the moment. I can tell you now that I am no fan of needles so I was glad to be hiding behind my camera. Clown then wanted me to take a shot of the used syringe, claiming loudly, "That is art, right there!" I am not sure if it is art or not - things get confusing when Clown is around!

The last time I saw Slipknot play was their first gig without Paul; now Jim was missing too the stage was looking a little empty. Not that there was any shortage of energy. It was yet another amazing gig confirming what I have known since 1999: THE KNOT IS UNSTOPPABLE!

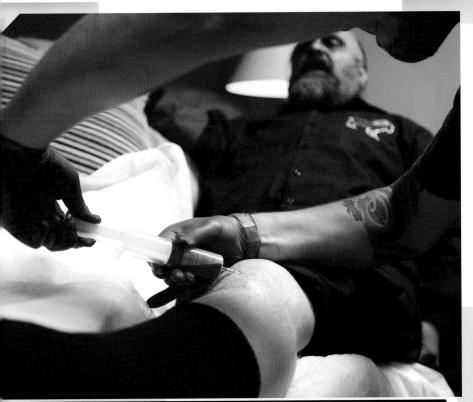
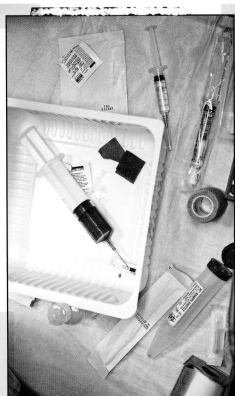
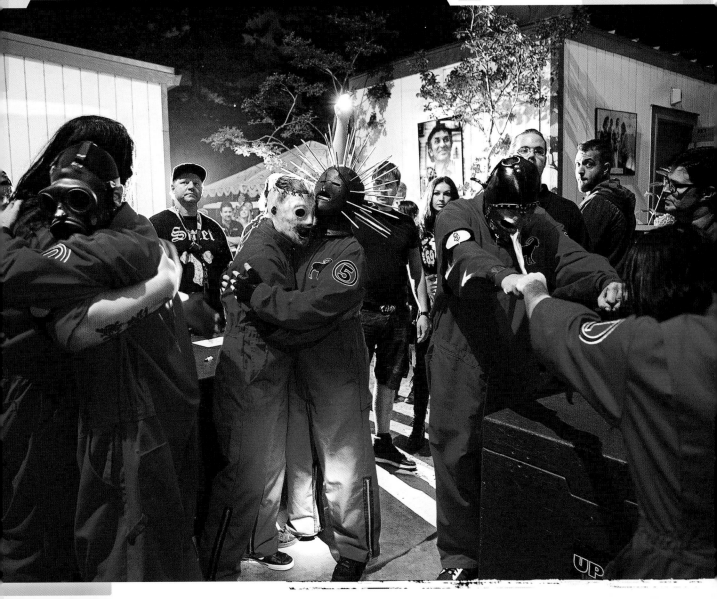

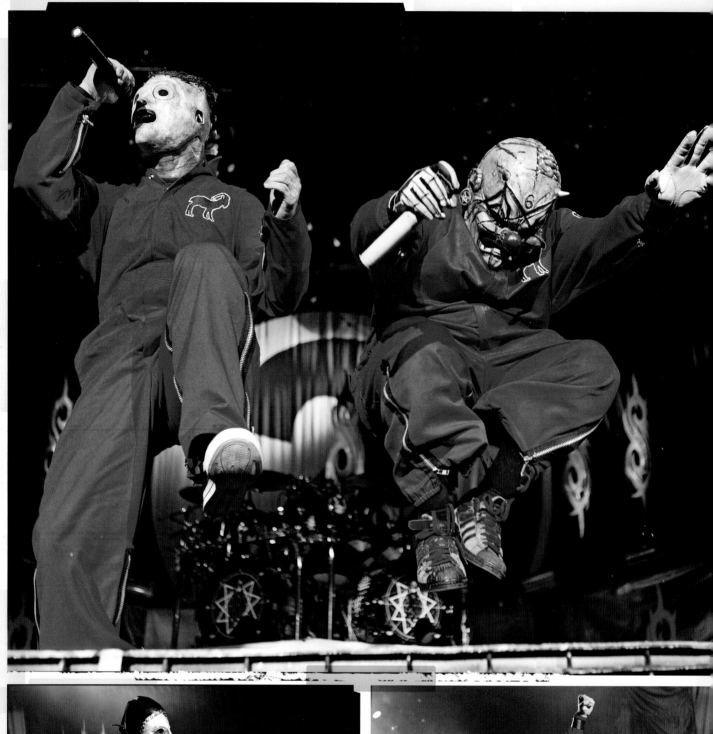
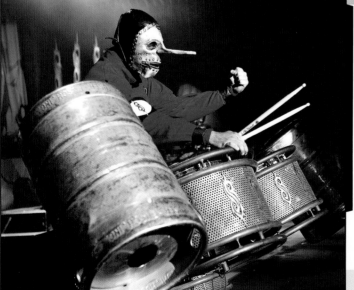
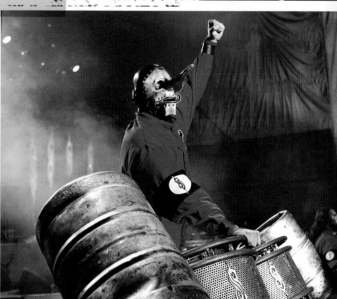

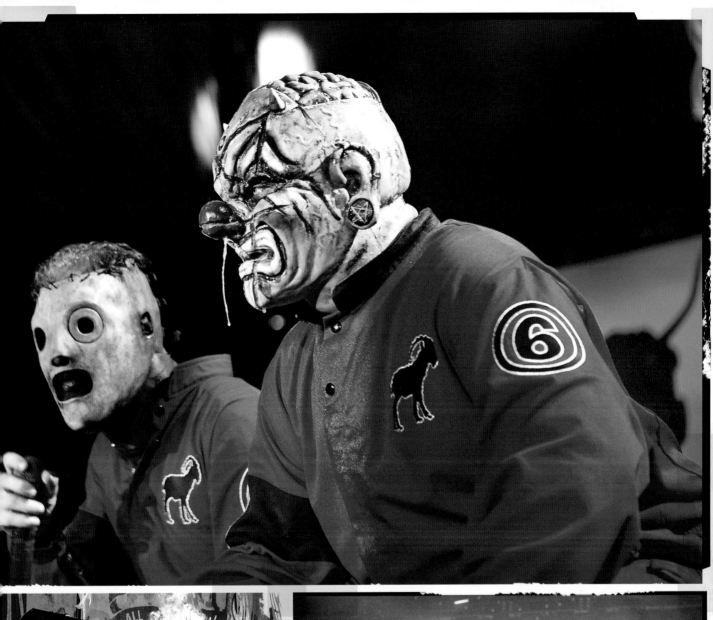
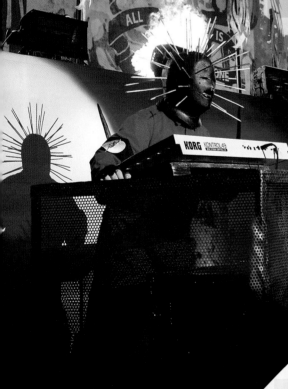
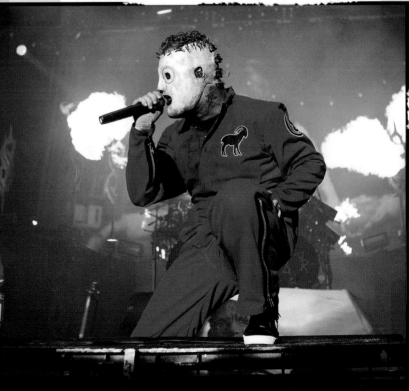

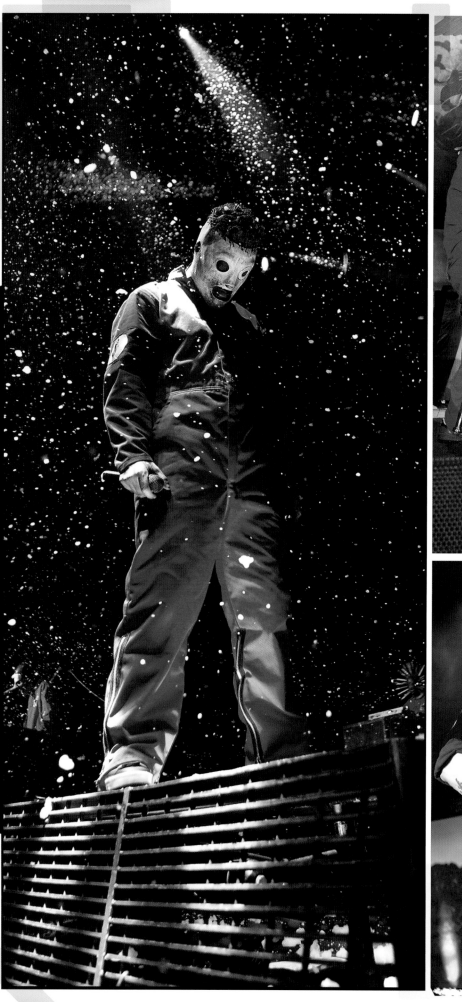
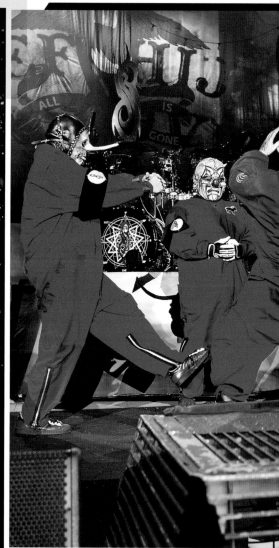
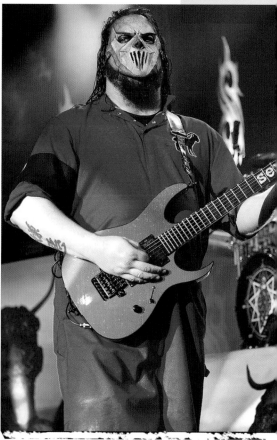

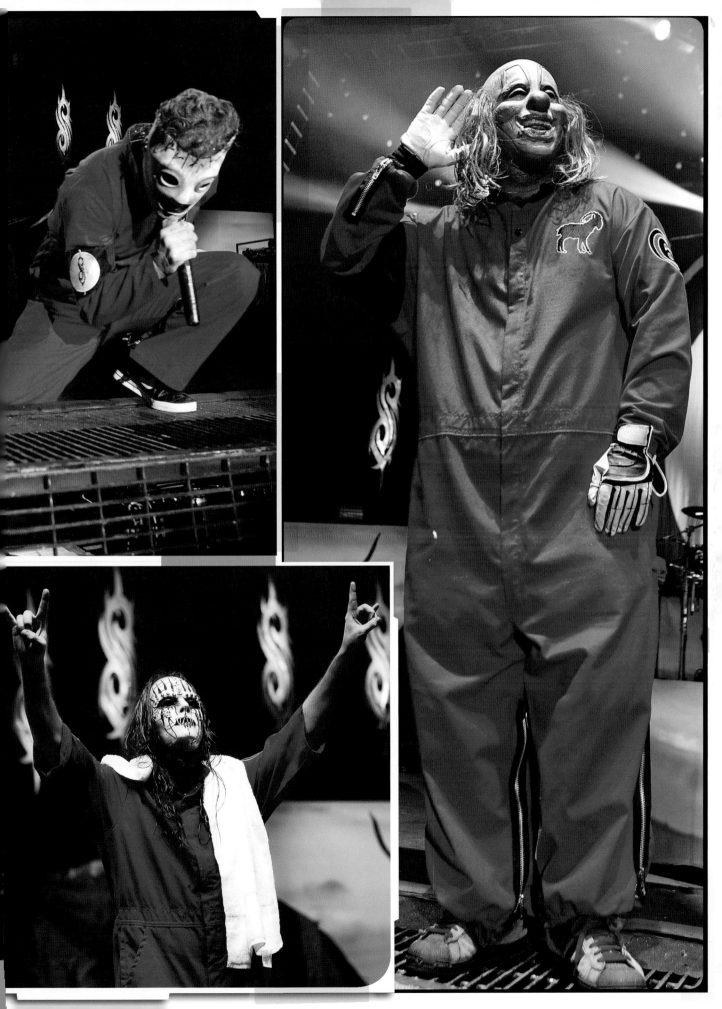

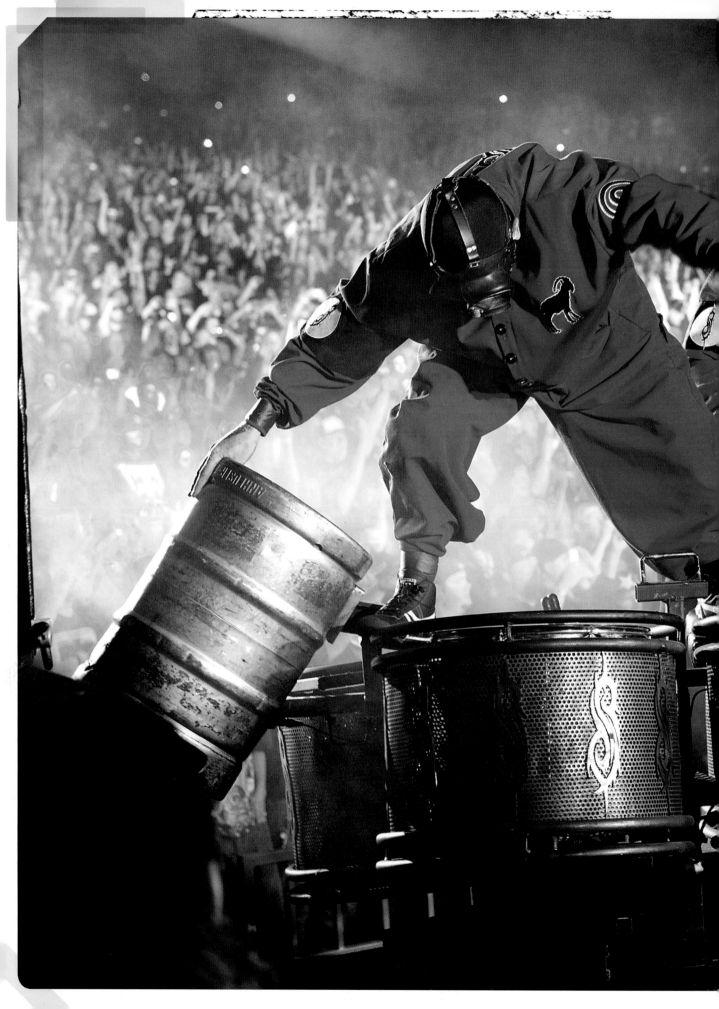

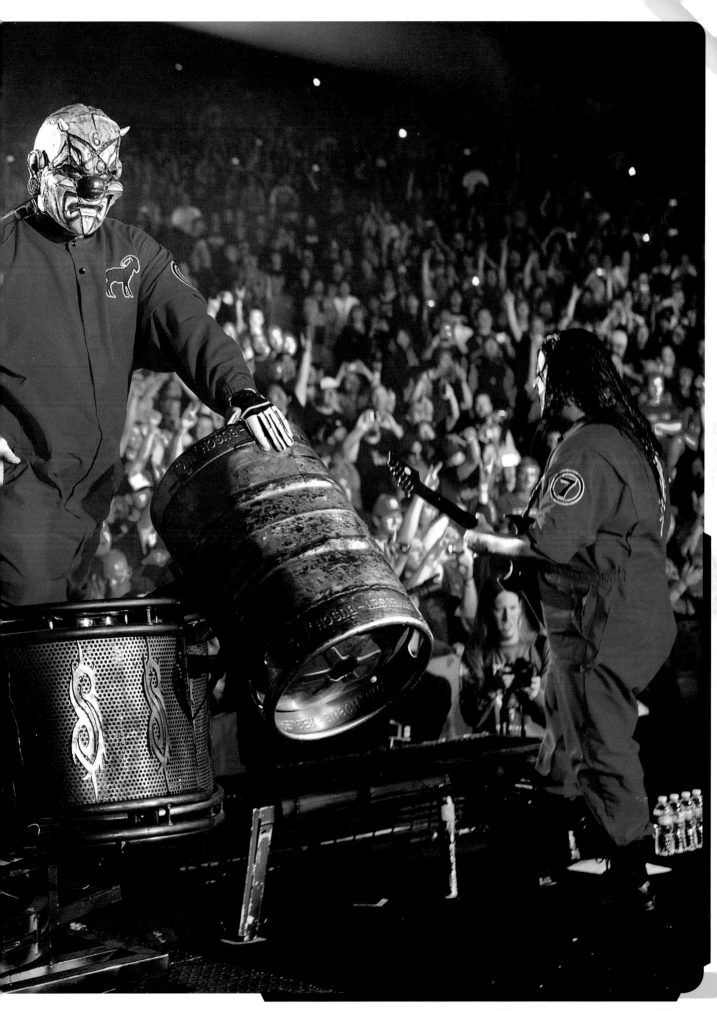

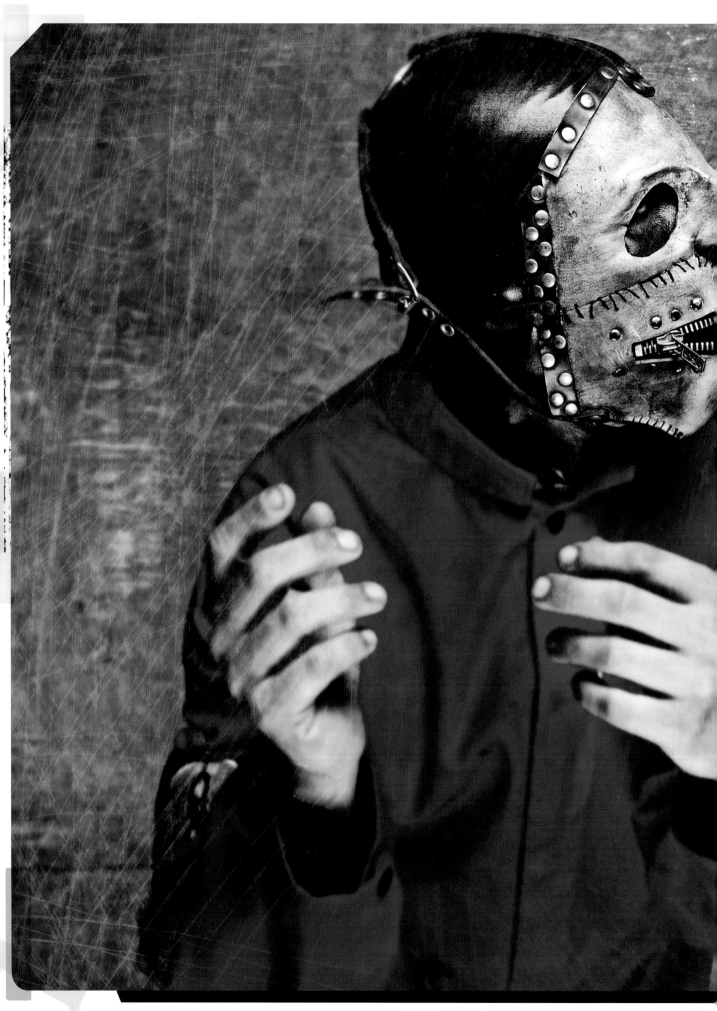

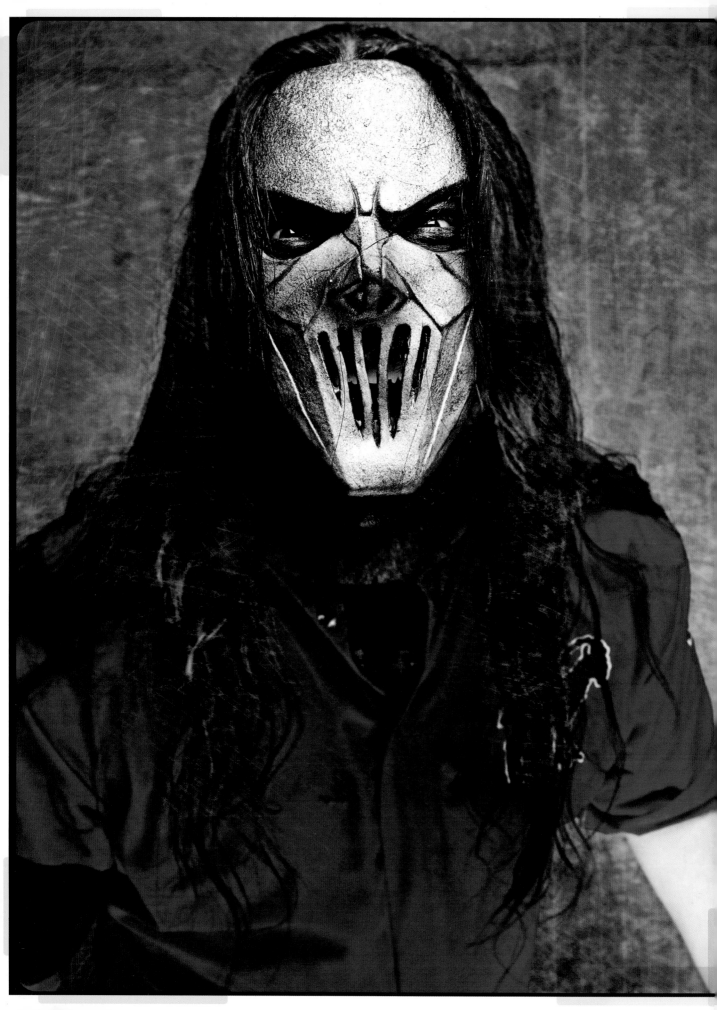

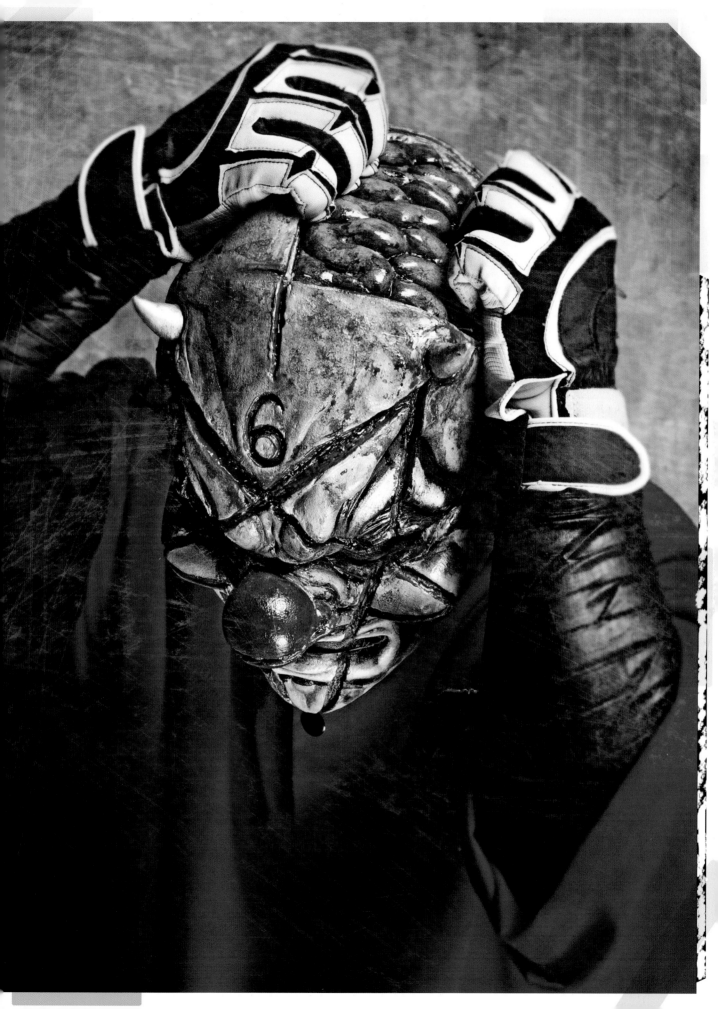

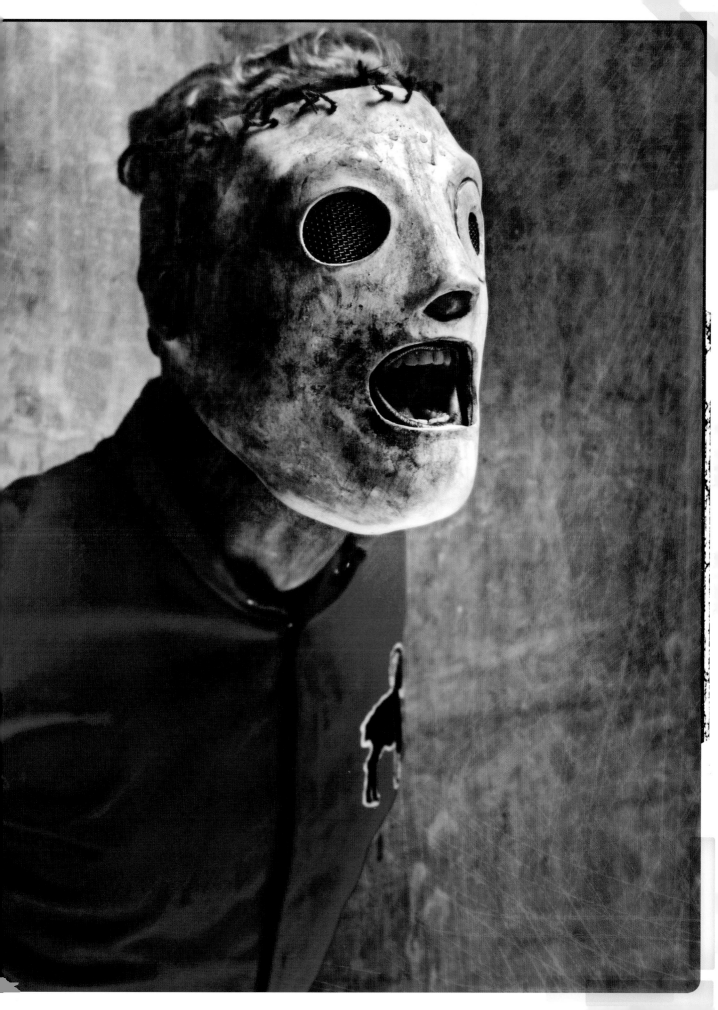

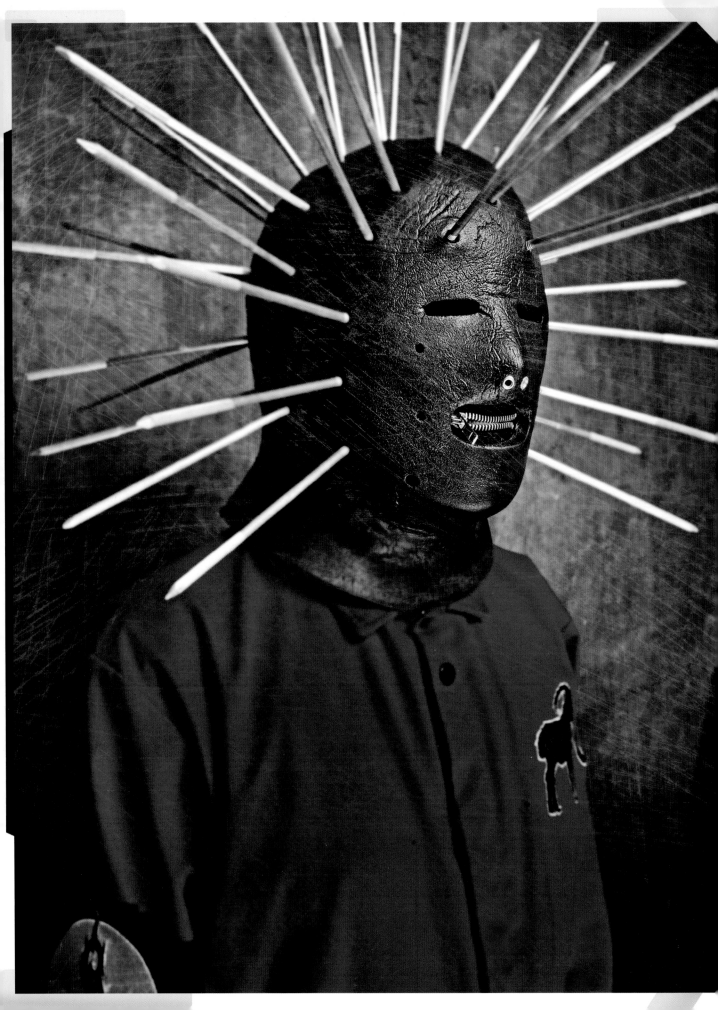

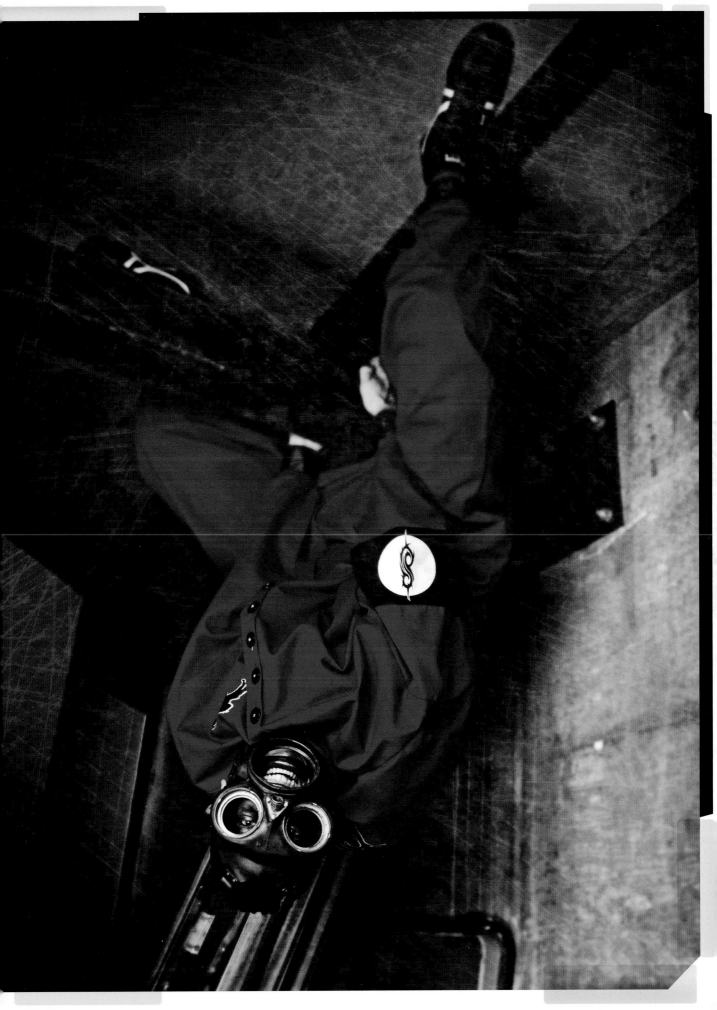

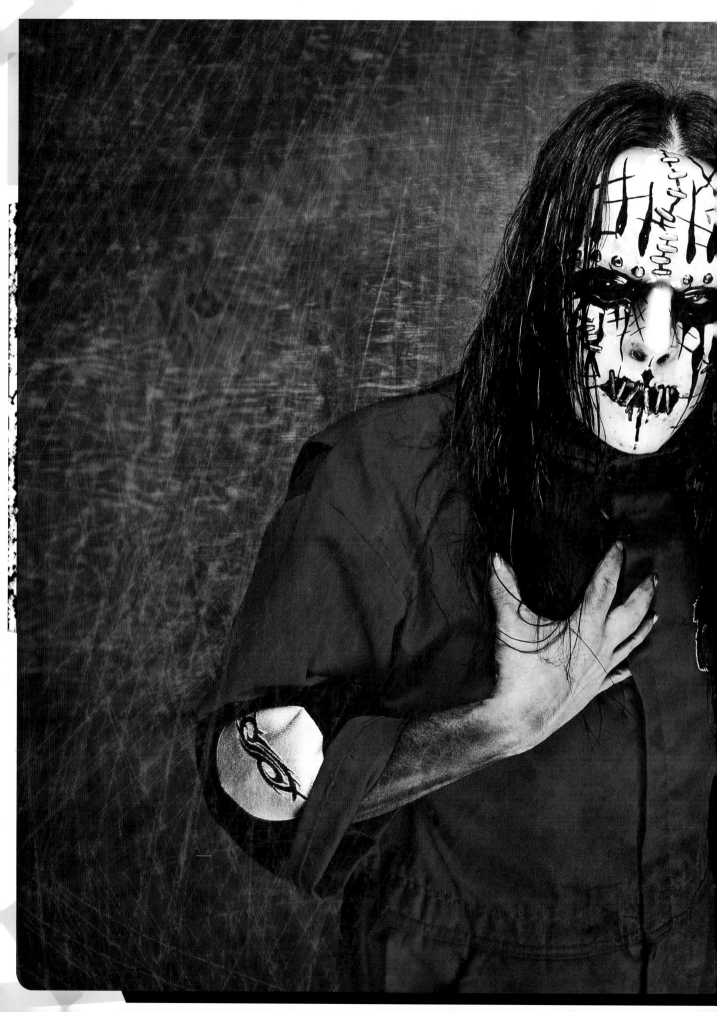

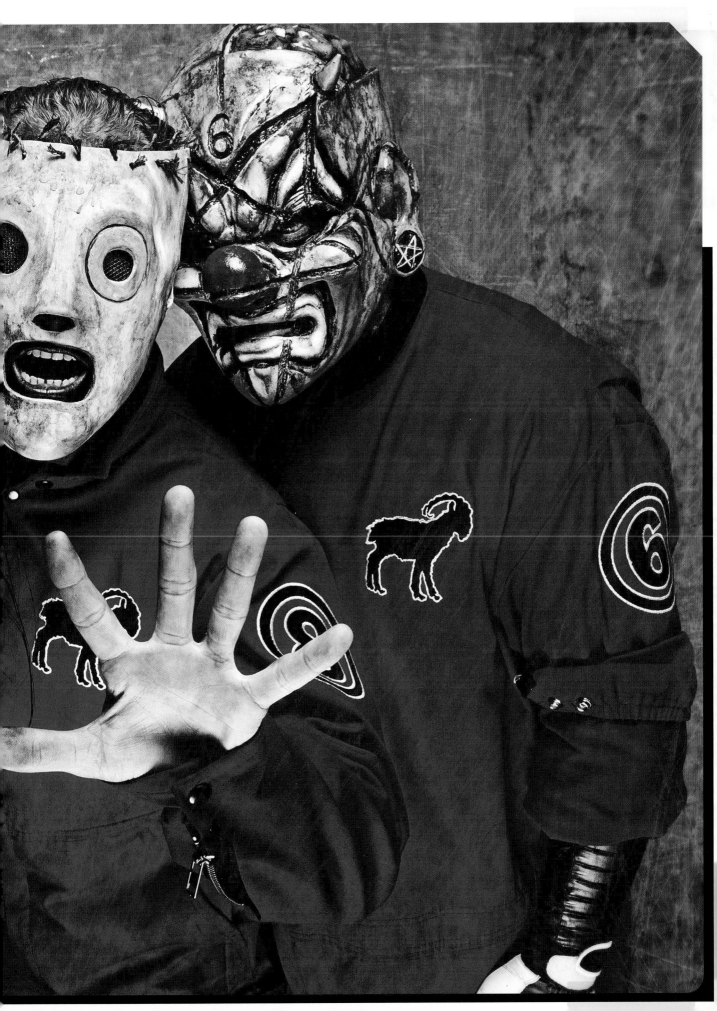

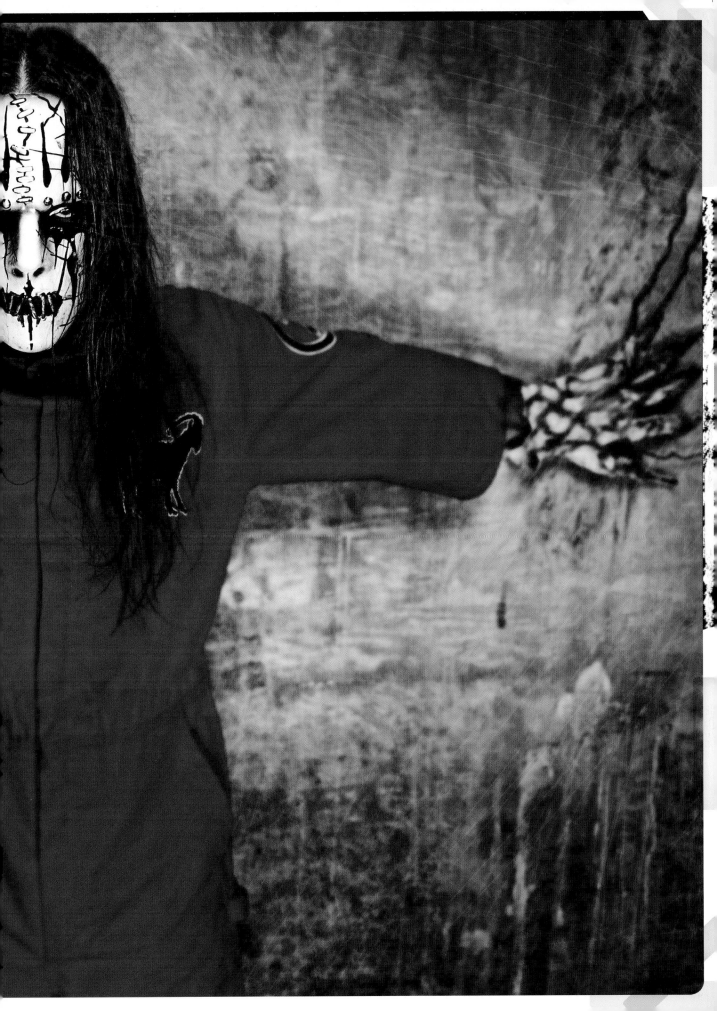

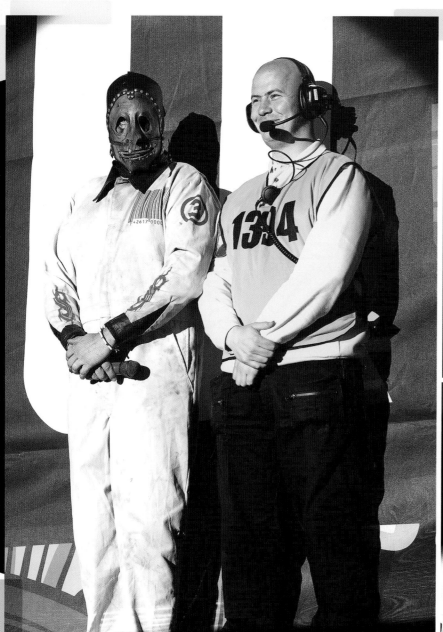

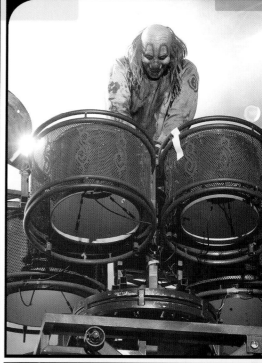

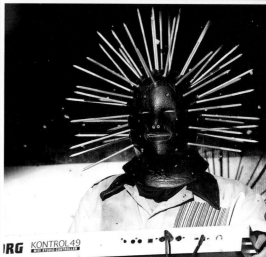

DOWNLOAD 2013

CASTLE DONINGTON, UK, 2013

AFTER A FOUR year absence the guys returned to Download Festival, this time dressed in white.

Amazing as the gig was, the highlight for me was Chris standing alongside a stage-security man and mimicking his pose. I'm sure Chris prolonged the guy's agony because he could see me taking photos...and laughing!

On a sad note, this was to be Joey's last UK performance with Slipknot.

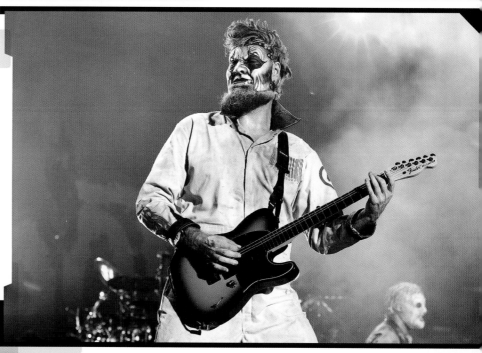

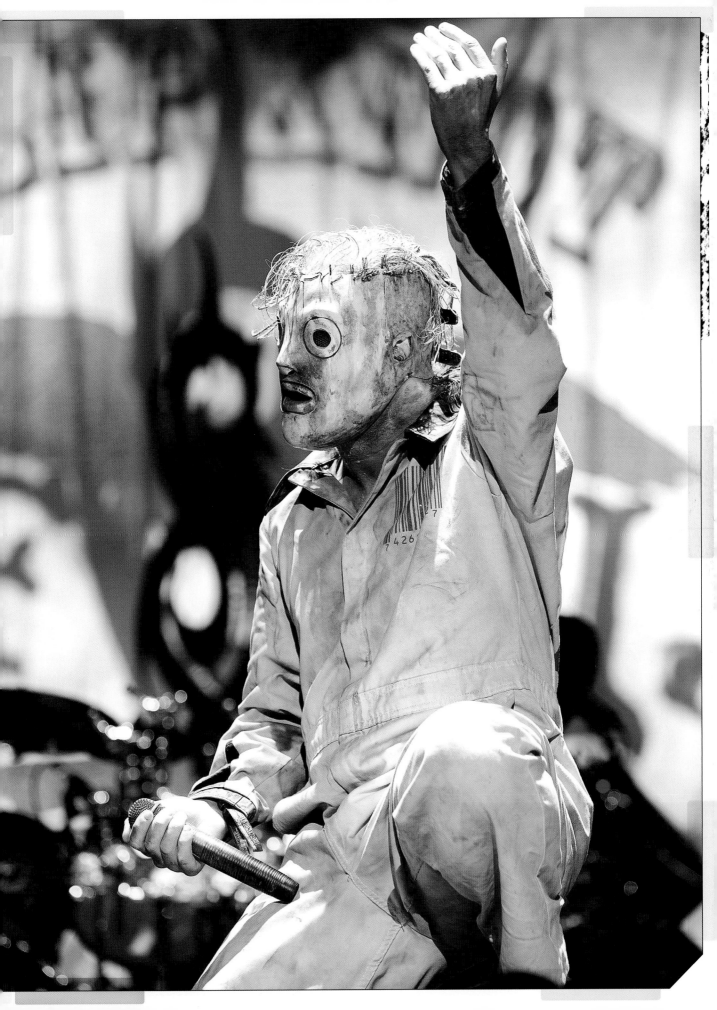

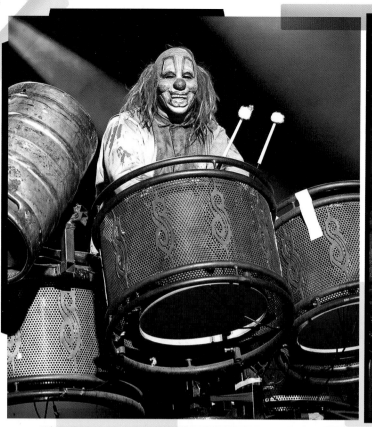
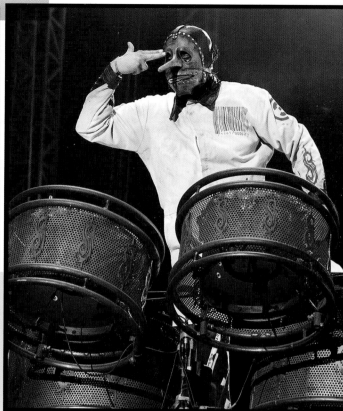
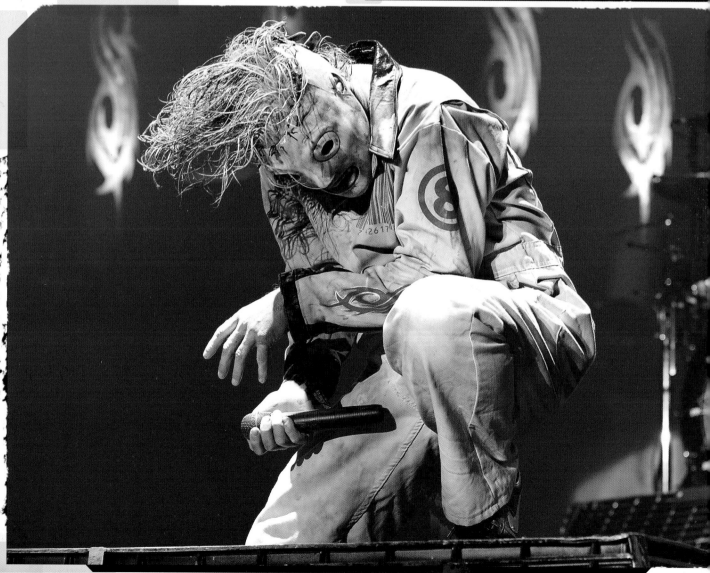

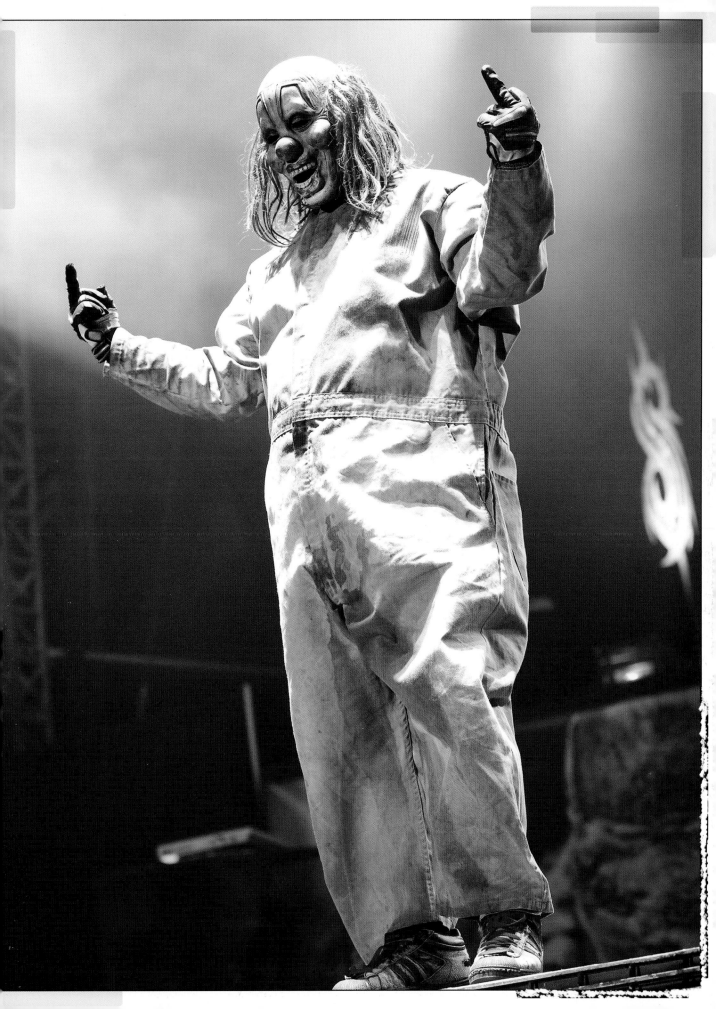

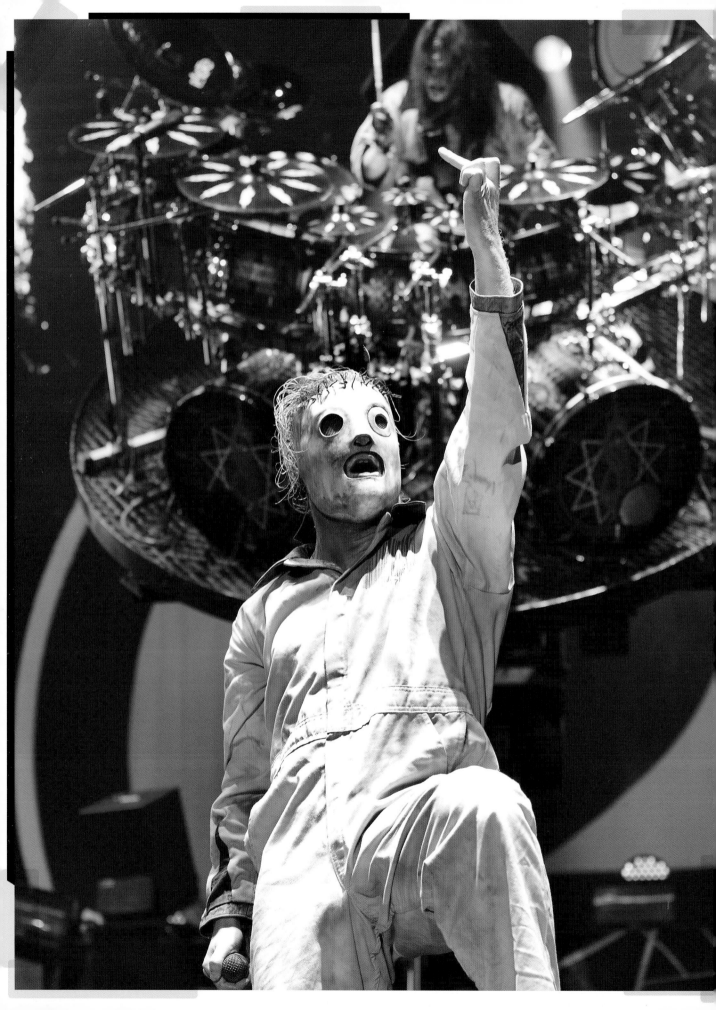

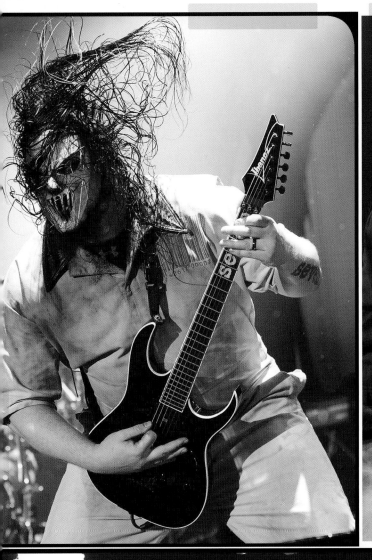
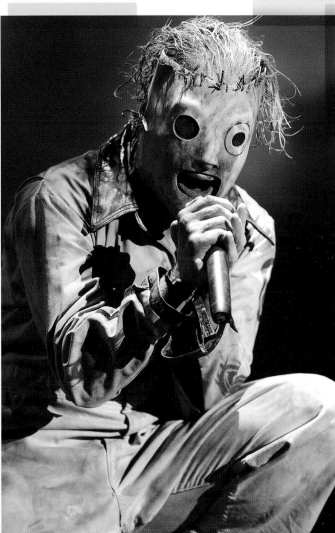
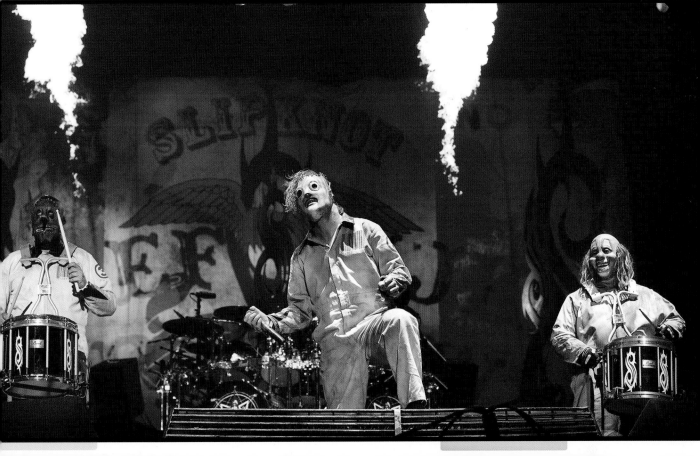

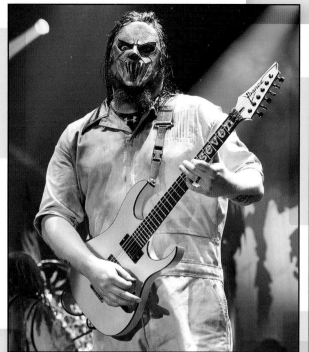

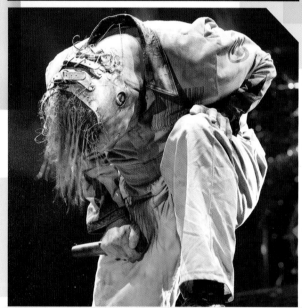

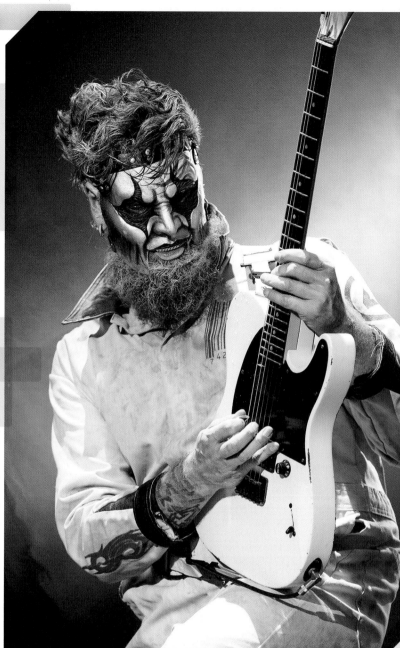

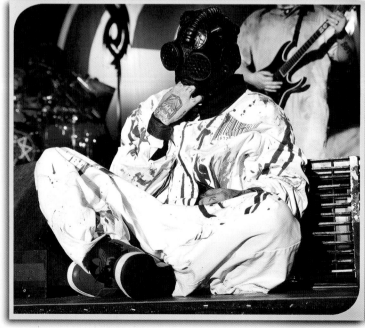

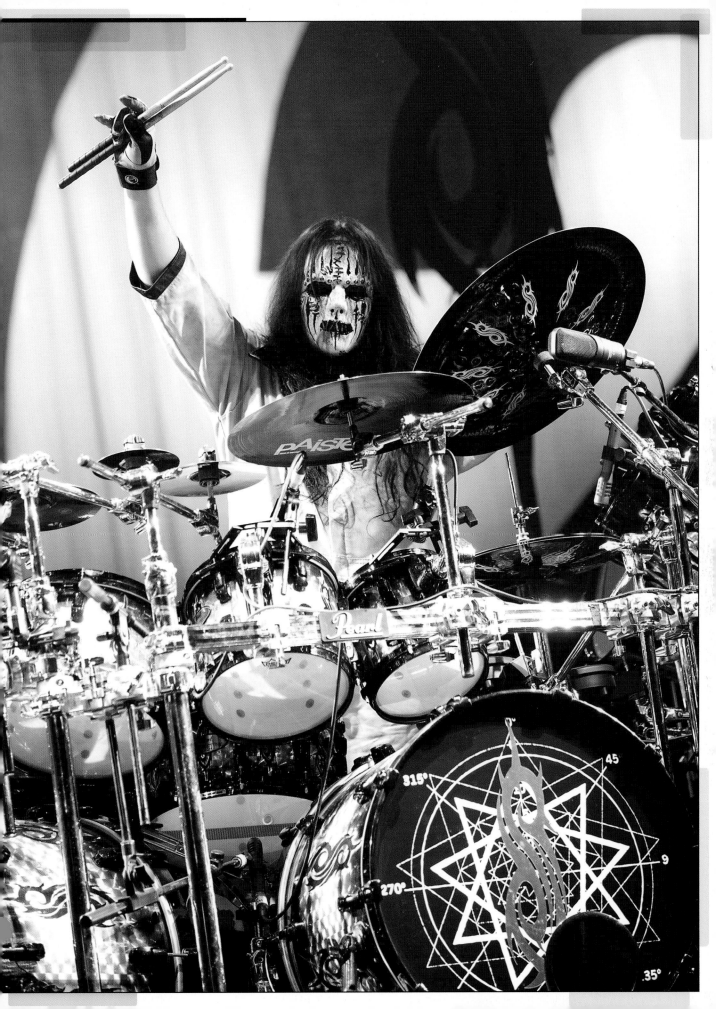

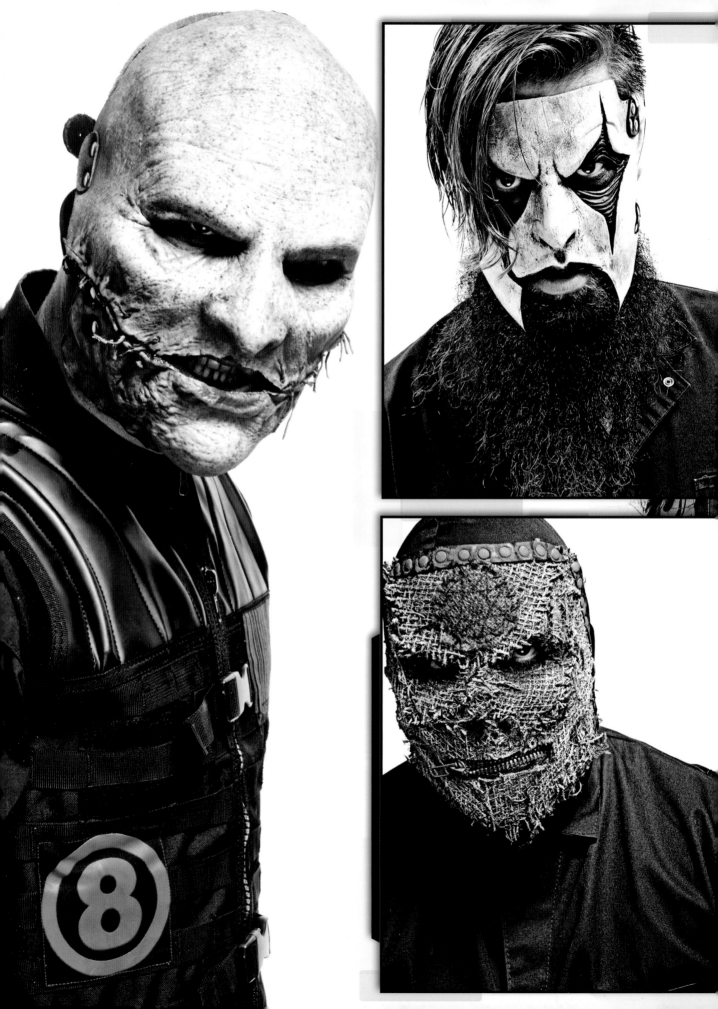

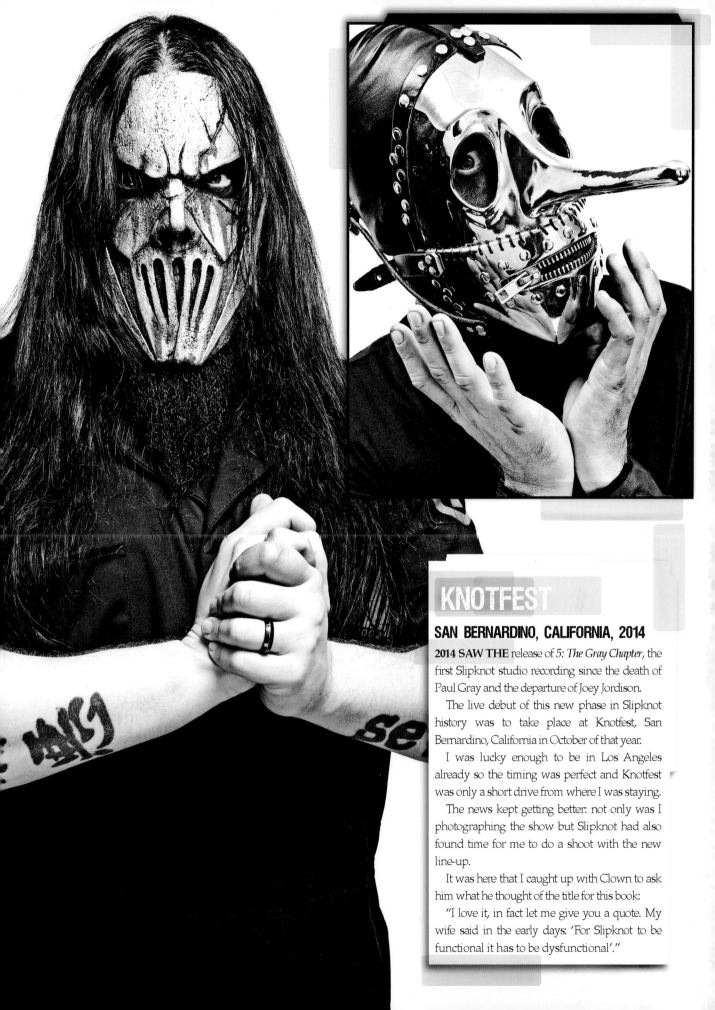

KNOTFEST

SAN BERNARDINO, CALIFORNIA, 2014

2014 SAW THE release of *5: The Gray Chapter,* the first Slipknot studio recording since the death of Paul Gray and the departure of Joey Jordison.

The live debut of this new phase in Slipknot history was to take place at Knotfest, San Bernardino, California in October of that year.

I was lucky enough to be in Los Angeles already so the timing was perfect and Knotfest was only a short drive from where I was staying.

The news kept getting better: not only was I photographing the show but Slipknot had also found time for me to do a shoot with the new line-up.

It was here that I caught up with Clown to ask him what he thought of the title for this book:

"I love it, in fact let me give you a quote. My wife said in the early days: 'For Slipknot to be functional it has to be dysfunctional'."

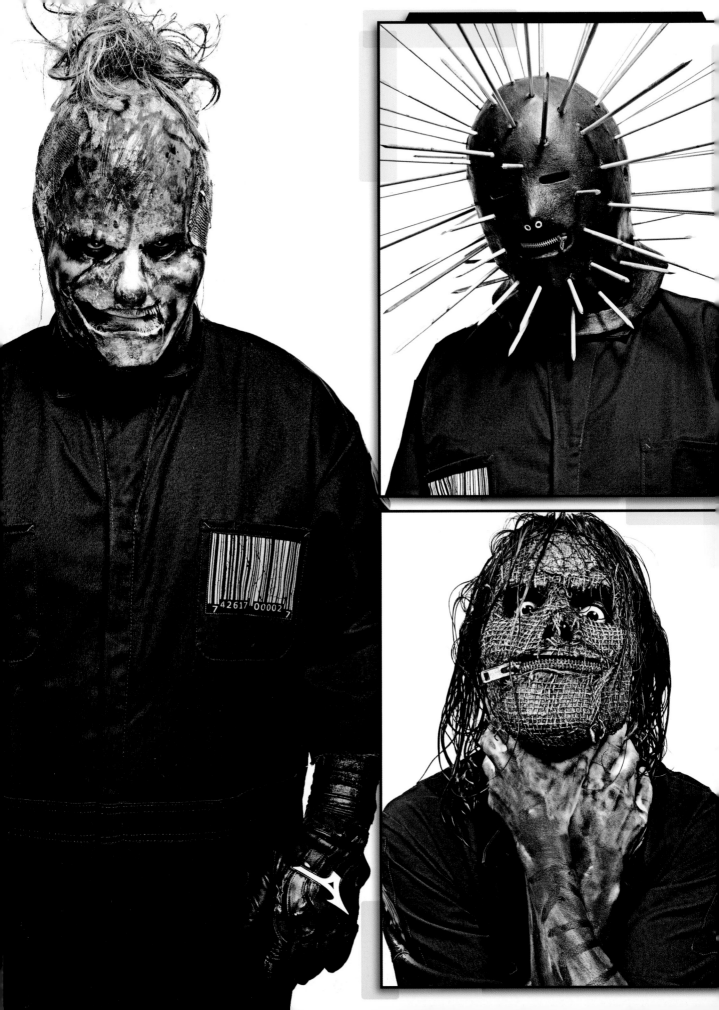

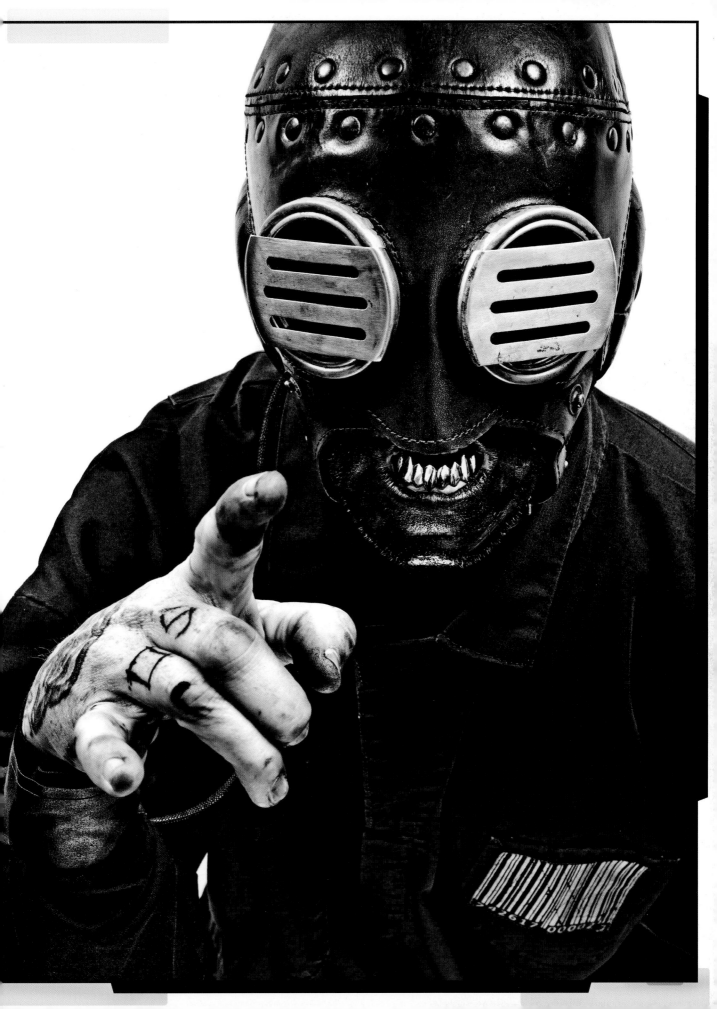

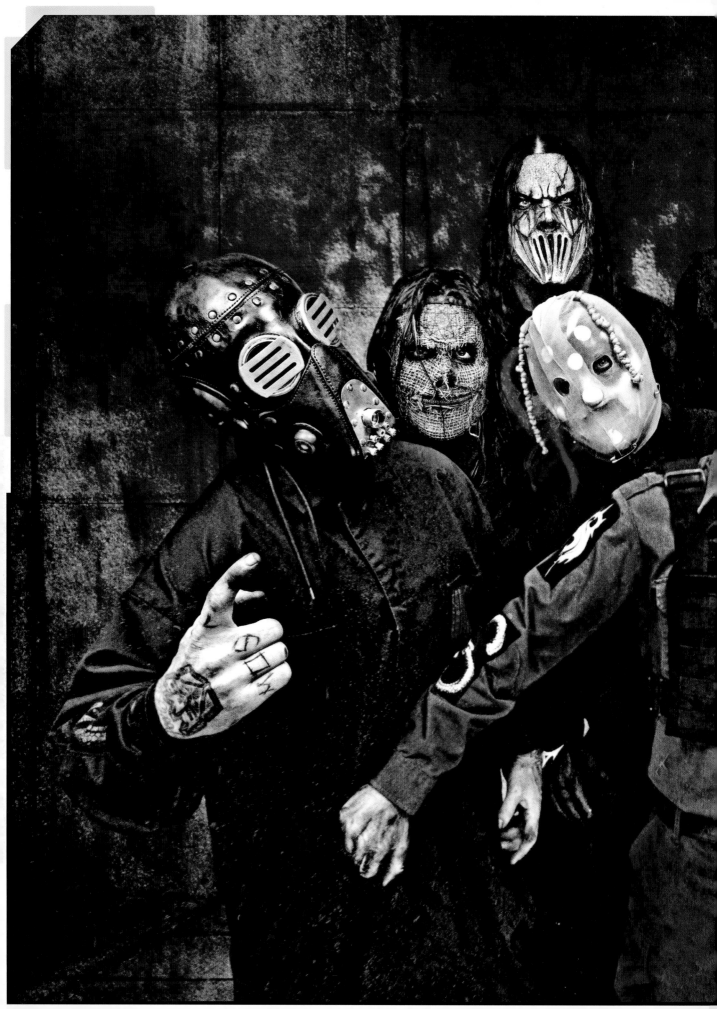

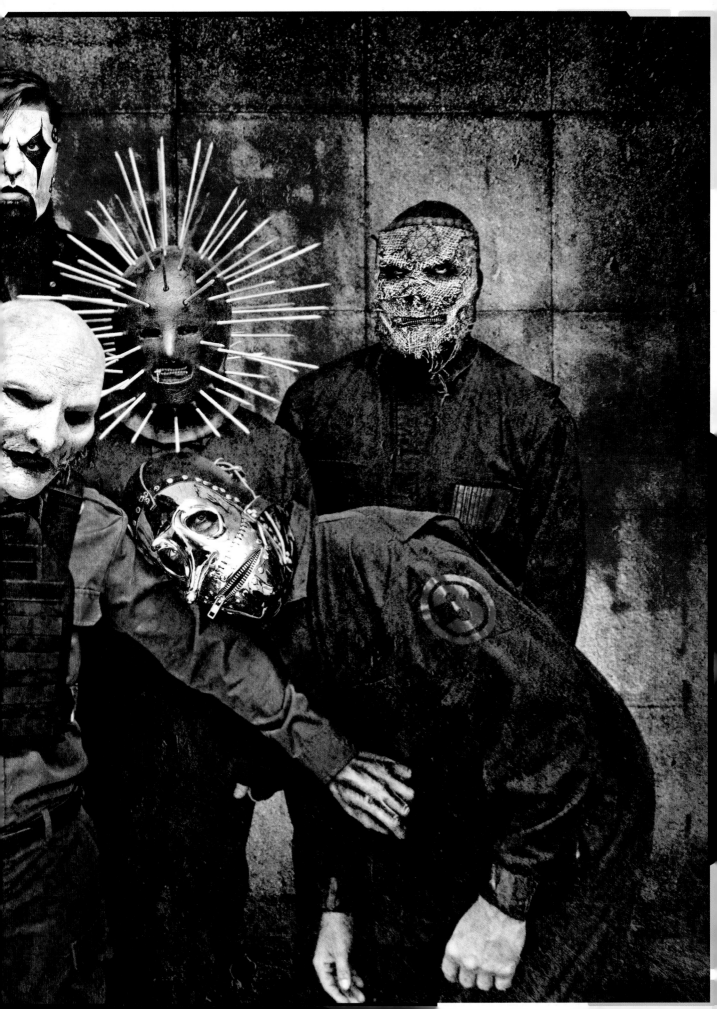

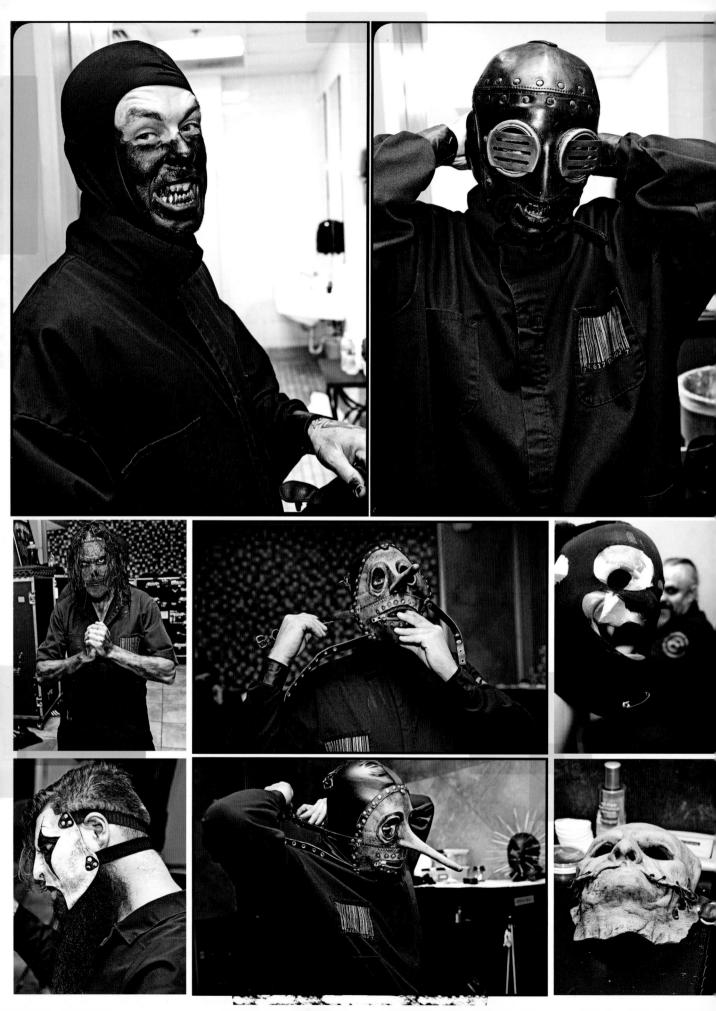

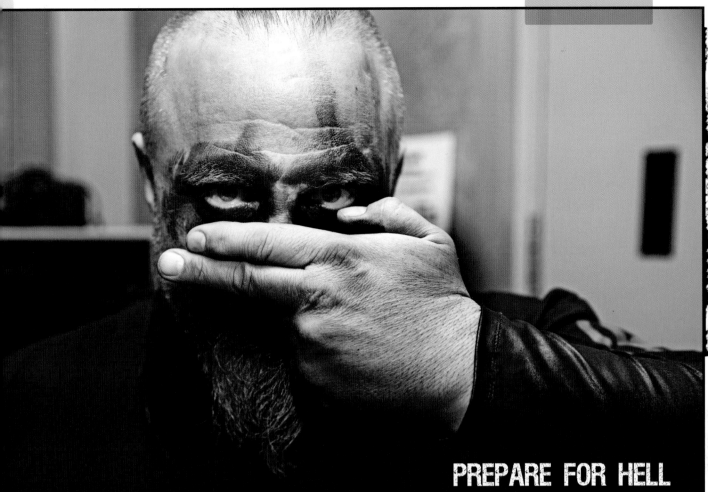

PREPARE FOR HELL

CHICAGO, DETROIT, USA, 2014

NOT LONG AFTER Knotfest and I was back in the USA for the *Prepare For Hell* tour. I joined them in Chicago and Detroit for an 'on the road' piece. Yet again I was given fantastic photographic access to the inner workings of the Knot both on and off stage.

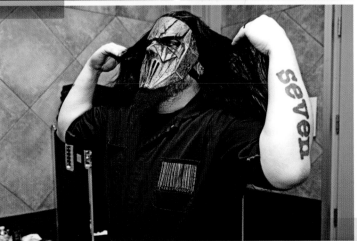

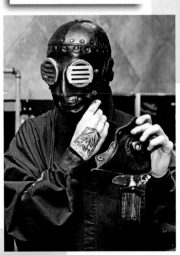

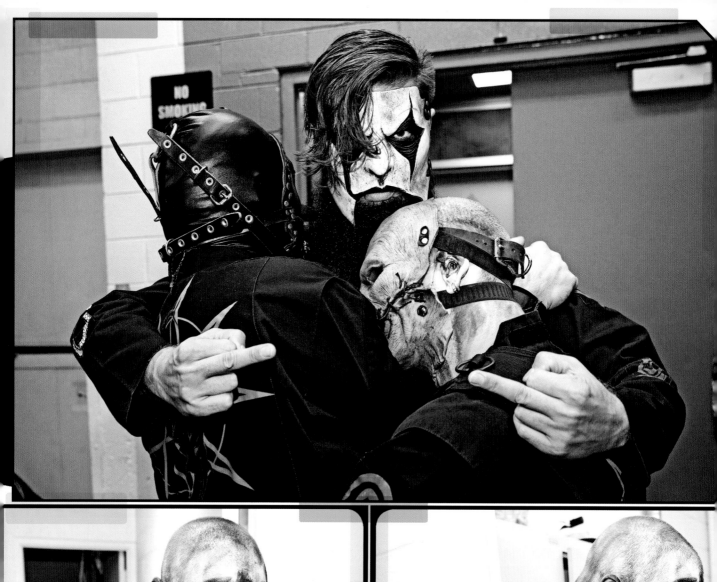

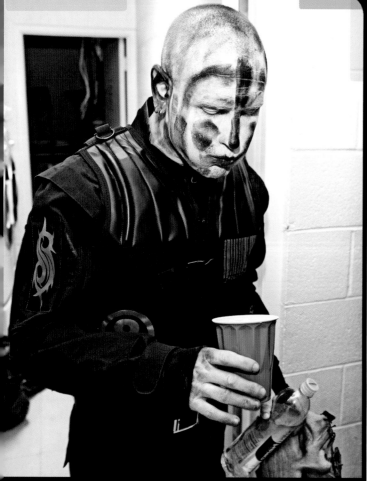

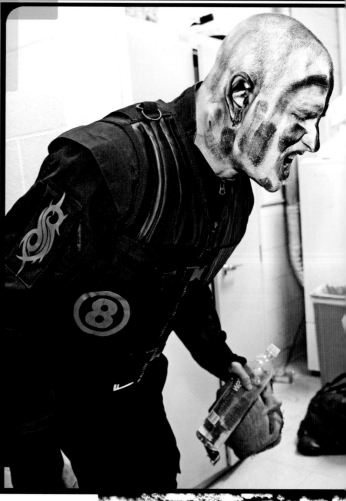

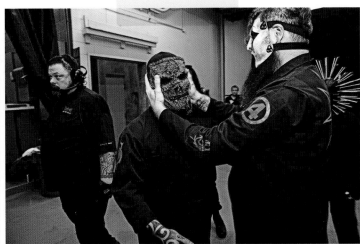
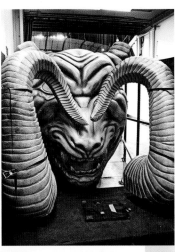
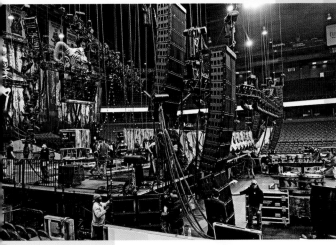
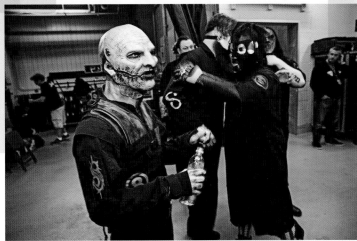
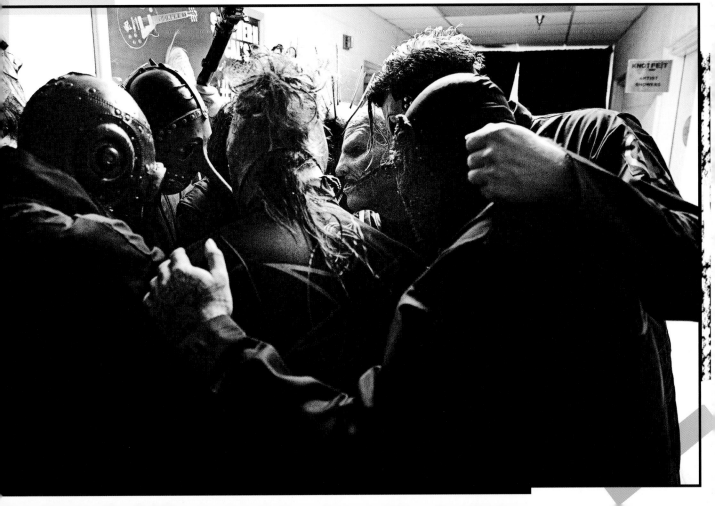

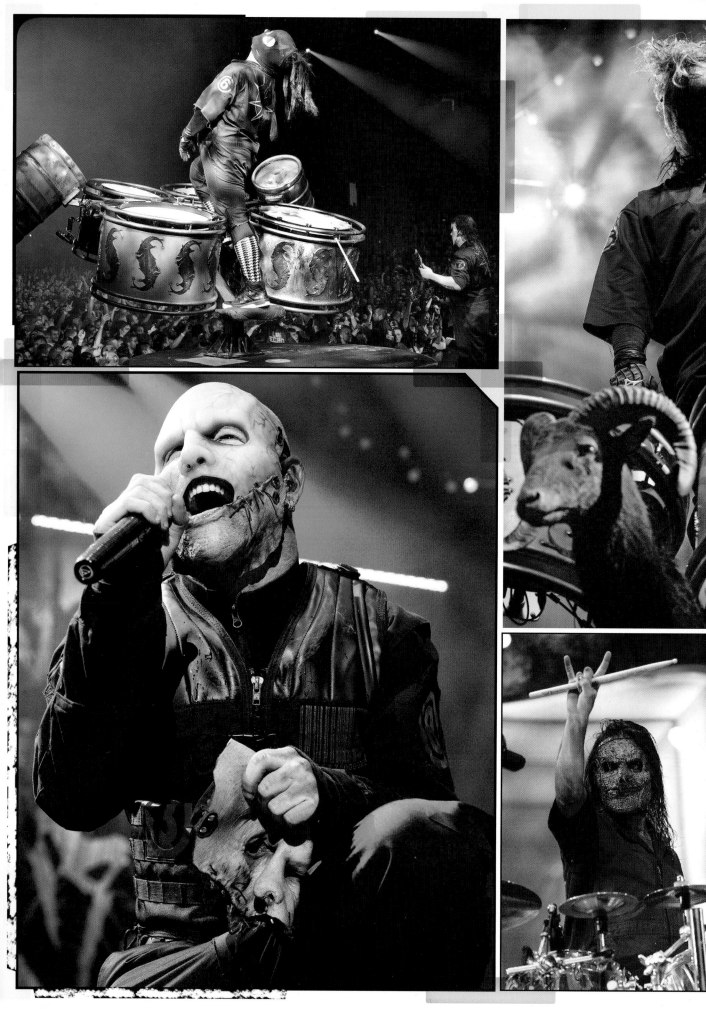

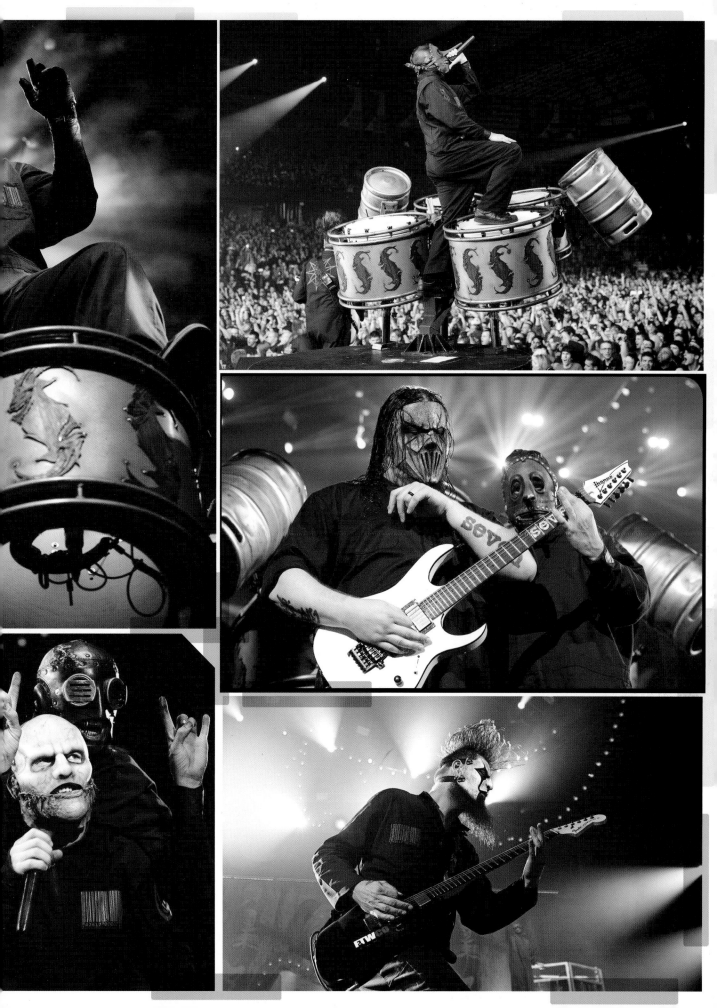

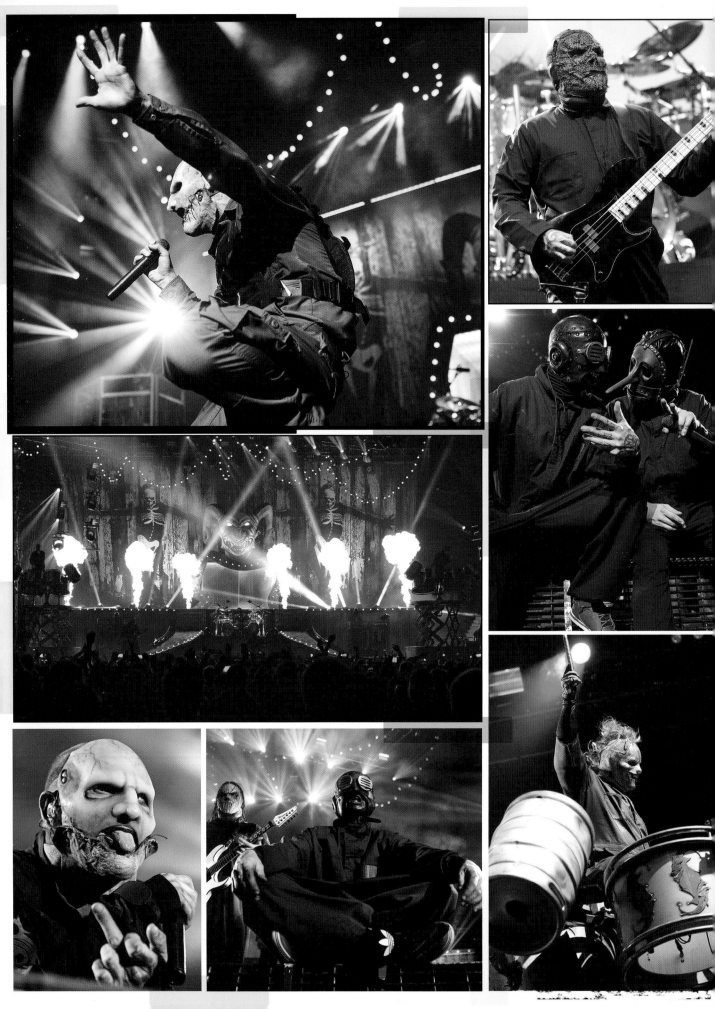

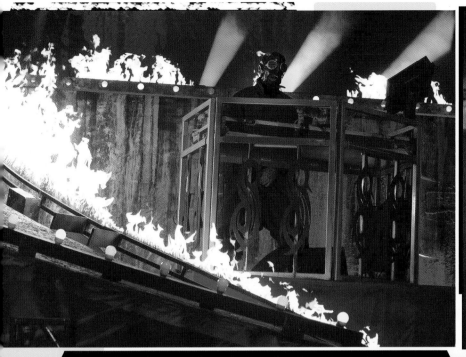

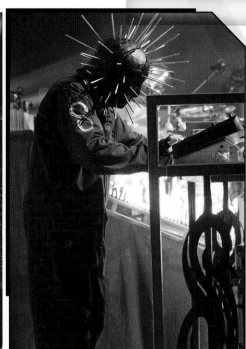

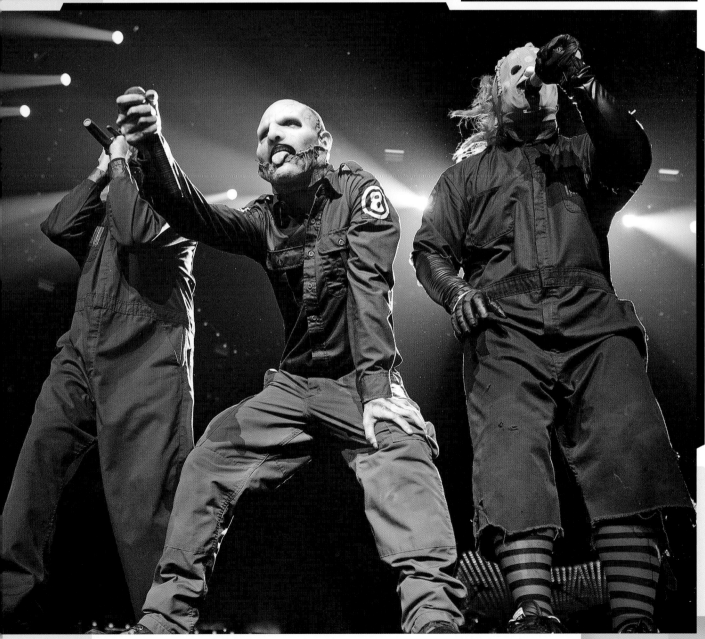

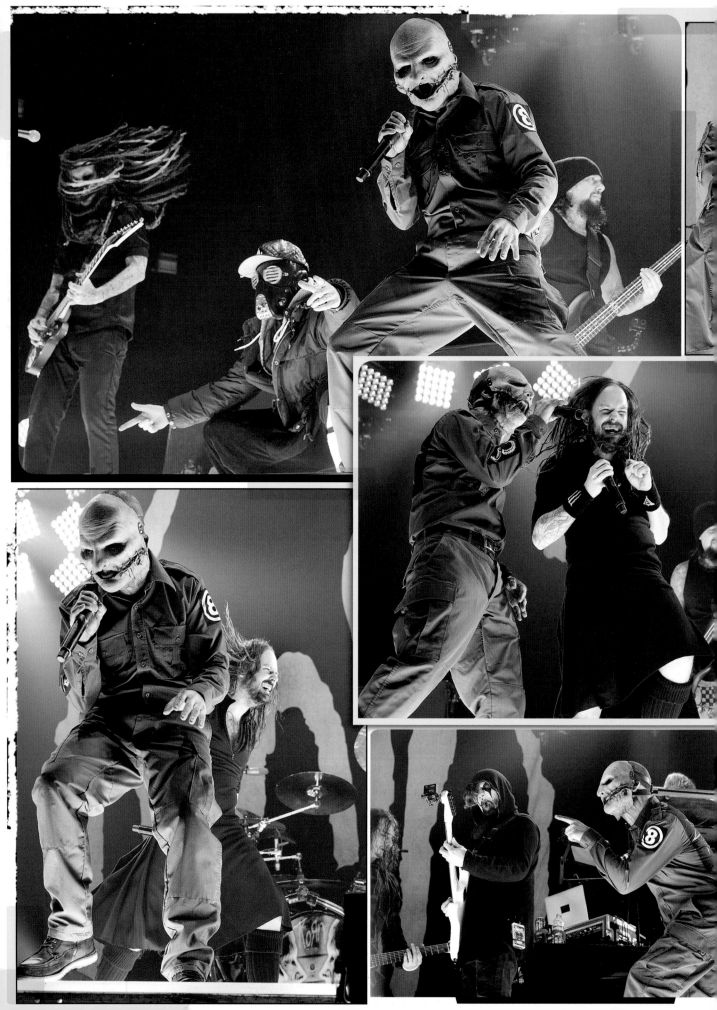

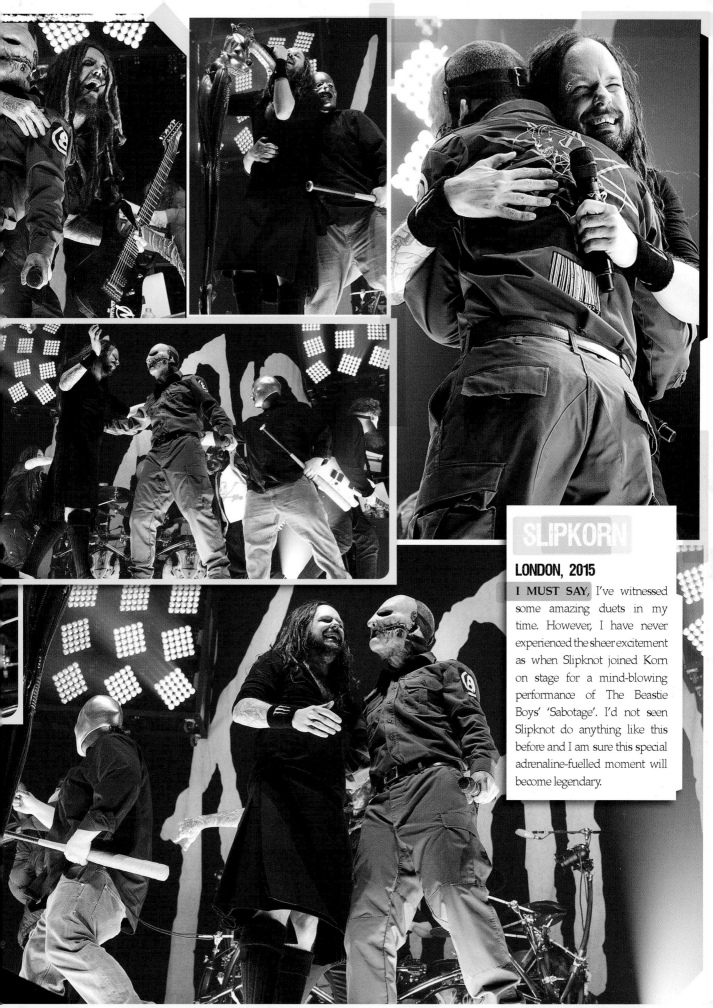

SLIPKORN

LONDON, 2015

I MUST SAY, I've witnessed some amazing duets in my time. However, I have never experienced the sheer excitement as when Slipknot joined Korn on stage for a mind-blowing performance of The Beastie Boys' 'Sabotage'. I'd not seen Slipknot do anything like this before and I am sure this special adrenaline-fuelled moment will become legendary.

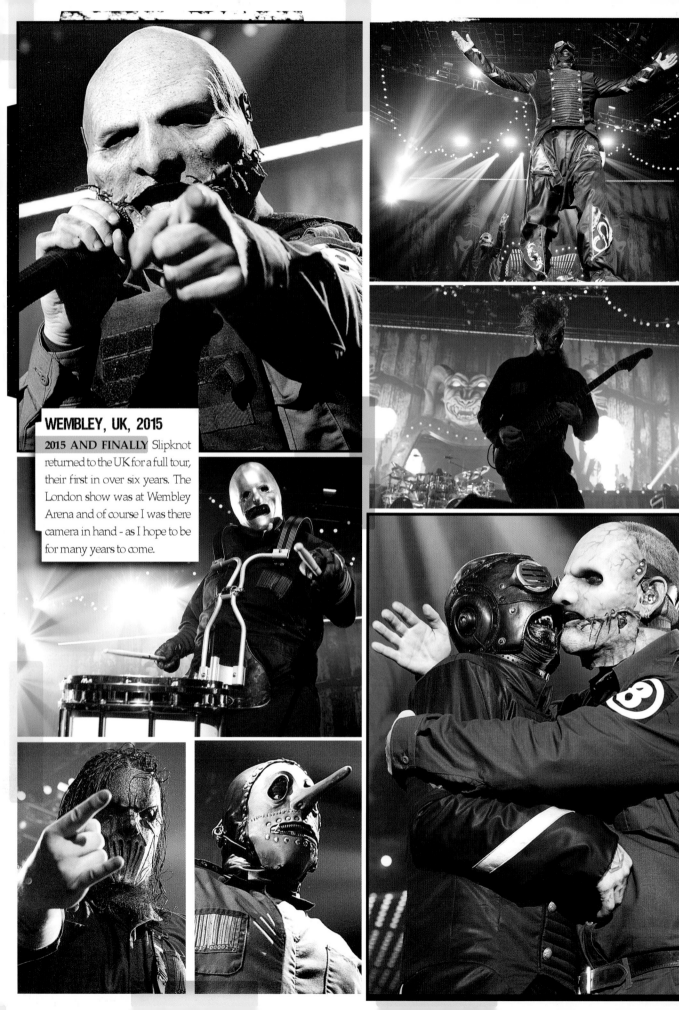

WEMBLEY, UK, 2015

2015 AND FINALLY Slipknot returned to the UK for a full tour, their first in over six years. The London show was at Wembley Arena and of course I was there camera in hand - as I hope to be for many years to come.

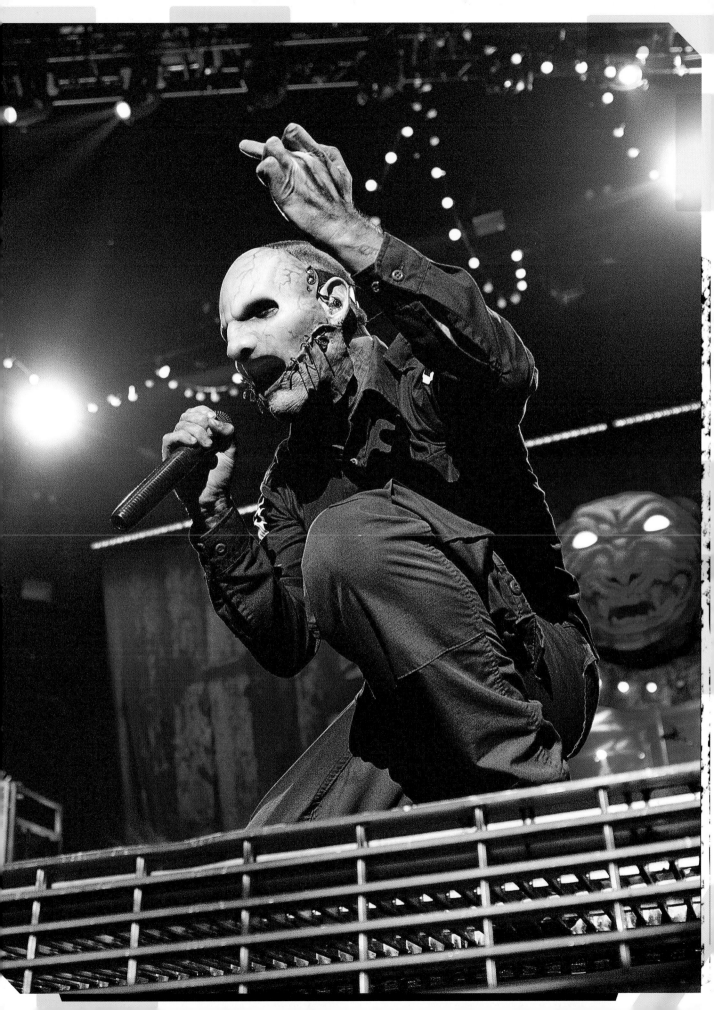

THANK YOU

Dysfunctional Family Portraits would not be possible without the tremendous help and support given to me by so many people. I will remain ever grateful.

There are possibly too many to mention, but here goes;

Firstly, The Nine, thank you for letting this British guy come along for the ride.

Cory Brennan, Bob Johnsen, Diony Sepulveda and all at 5B Management.

The Slipknot team past and present, especially; Daryl (Bobby Tongs) Arnberger, Martin Connors, Gary (Gaza) Garner, Geoff Head, Sean Kane, Helen (Hels Bells) Smith, Michael (Sully) Sullivan, Danny Nozell, Jai John, Ken Denson and Sol Engelhardt.

Stephanie Taylor, for always looking out for me.

Danny Corr, Maria Gonzales, Danielle Sameroff, Kirsten Sprinks and Sami Westwood.

Michelle Kerr, Slipknot's UK publicist at Cosa Nostra PR. I can't thank you enough. Every image in this book is a reflection of your help, organisation and cat herding skills.

All at Roadrunner Records.

Caroline Fish for commissioning so many shoots during her reign at *Kerrang!*, including my first date with Slipknot in 1999. For her amazing design skills on this book and for being such a great friend and confidante.

The family at *Kerrang!*
Editors past and present; Geoff Barton, Robyn Dorian, Phil Alexander, Paul Rees, Ashley Bird, Paul Brannigan, Nichola Browne and James McMahon.
All who've been instrumental with my shoots; Chris Anderson, Steve Beech, Lucy Bryant, Ryan Cooper, Nikki Hirst, Krusher Joule, Alison Joy, Jo Kendall, Laura Reid, Alex Shellim, Pamela Steuri and Lucy Williams.
An extra special thank you to Scarlet Borg for all the years of location hunting, prop finding and cake making!
Wing men/women; Matt Allen, Jason Arnopp, Steve Beebee, Tom Bryant, Sam Coare, Tom Doyle, Dave Everley, George Garner, James Hickie, Neil Jeffries, John Longbottom, Morat, Nick Ruskell, Mark Sutherland, Jennyfer J Walker, Chris Watts, Rod Yates, Simon Young, Ray Zell and all the other writers I've worked, travelled and shared a beer with.

Amanda Harries and Ian Winwood for transcribing my memories, anecdotes and experiences into actual, real words.

My mum, dad and sister for always supporting my dream of becoming a photographer.

David Barraclough, Matt Bourne, Mark Pickard, all at Omnibus Press and Jacqui Black for the introduction.

Kate Boenigk at Proud Galleries.

Danny Lenihan and all the guys at studio-flash.com for the great kit.

Finally, all the bands that have ever stood in front of my lens, all the music PRs who make this minor miracle happen and all the music photographers I have shared a pit with.